D1410868

Theories, Models, Methods, Approaches, Assumptions, Results and Findings.

Damien Hirst

Gagosian Gallery

Theories, Models, Methods, Approaches, Assumptions, Results and Findings.

Volume 1

Damien Hirst

Gagosian Gallery

Published on the
occasion of the
exhibition:
**Theories, Models,
Methods, Approaches,
Assumptions, Results
and Findings.**
Damien Hirst

Gagosian Gallery
555 West 24th Street
New York NY 10011
Tel: 212 741 1111

September 23 –
December 16 2000

Publication © 2000
Gagosian Gallery
and Science

The Hay Smells
Different to the Lovers
Than to the Horses
© 2000 Gordon Burn.

Revealing Reality
Within a Body of
Imaginary Things
© 2000 George Poste.

Designed by
Jason Beard
at Barnbrook

Edited by
Damien Hirst/
Jason Beard

Photography:
Mike Parsons

Project co-ordinators
for Science:
Hugh Allan, Jude Tyrrell,
Sian Thomas

Repro:
Dawkins Colour,
London

Printed by
Westerham Press,
England

Table of contents

Figs. 1.1 – Typical examples of the many anatomical
diagrams for the recording of external findings at
an autopsy

1. The Hay Smells Different to the Lovers Than to the Horses
Gordon Burn

This is what it's like. It's like: I'll do a magic trick, and I want it to be amazing. But if anybody asks me how to do it, I'll show them exactly how to do it. I want you to be amazed twice. Once you're amazed because it seems impossible, and then you're amazed because it's fucking easy. That's what I like – **Damien Hirst**. 1997

To amuse His Royal Majesty he will change water into wine. Frogs into footmen. Beetles into bailiffs. And make a minister out of a rat. He bows, and daisies grow from his finger-tips. And a talking bird sits on his shoulder.

There.

Think up something else, demands His Royal Majesty. Think up a black star. So he thinks up a black star. Think up dry water. So he thinks up dry water. Think up a river bound with straw-bands. So he does.

There.

Then along comes a student and asks: Think up sine alpha greater than one.

And Žito grows pale and sad: Terribly sorry. Sine is between plus one and minus one. Nothing you can do about that.

And he leaves the great royal empire, quietly weaves his way through the throng of courtiers, to his home in a nutshell.

Miroslav Holbub - *Žito the Magician*

When he opened a London office some years ago to deal with his proliferating outside involvements – restaurants, videos, a record label, album covers, books, films, TV commercials, interviews, litigation: everything that wasn't

Art, in other words – Damien Hirst called it 'Science'. It says it on a brass plaque fixed to the wall, next to the plaques of the other strictly whitebread businesses in Bloomsbury who share the building: 'Science'. It's what you hear a voice announce every time you phone: 'Hello, Science'. The 'Science' logo is two spots – a detail of the parent 'Damien Hirst' logo made familiar through the series of spot paintings that take their names from psychotropic drugs, and the most successful example of the brassnecked branding of an artist in the dour ('provincial, marginal, literary, cute' – Robert Hughes) history of art in Britain.

To anybody who has followed his career, the bright blameless twinned spots of Hirst's office logo ineluctably suggest nostrils or eyes or other human holes. This is because in the last few years the Hirst iconography has entered the common consciousness so completely in Britain that even people with only a passing interest in art are likely to be familiar with his – *whey-hey!* – orificial fixation ('Come to my big opening!'), and with statements like the following: 'I remember once getting terrified that I could only see out of my eyes. Two little fucking holes. I got really terrified by it. I'm kind of trapped inside with these two little things to see out of'.

The other reason that we might associate pretty, abstract signs on a sheet of headed business paper or compliments slip with baser human referents in an almost

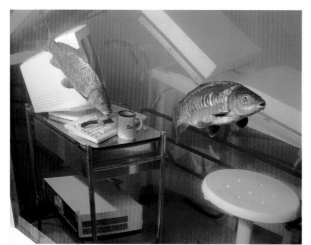

Figs. 1.2 and 1.3 – Love Lost. 2740 x 2130 x 2130mm

Pavlovian way is because Hirst has been relentless in placing medical science – forensics, pathology, gynaecology, pharmacology – at the core of what he does. Almost uniquely among artists of his generation, he has committed himself to working in the space between science and art in much the same way that artists of the older generations have been trying to act in the gap between art and life that Robert Rauschenberg first laid claim to in the late-1950s.

Like writers such as Don DeLillo, Richard Powers and others, who have acknowledged the poetic lure of modern jargon from science, sports and Madison Avenue in their fiction, Hirst located an unlikely poetics in the boilerplate prose of the scientific paper and pharmaceuticals catalogue, and in the disease- and death-tainted artefacts of the mortuary, the pharmacy and the lab.

Isolated Elements Swimming in the Same Direction for the Purpose of Understanding. The Physical Impossibility of Death in the Mind of Someone Living. Anaesthetics (and the way they affect the mind and body). Looking Forward to a Complete Suppression of Pain. When Logics Die. As titles, these were not only unusually resonant and intelligent in themselves; they announced the arrival of an artist different and brave enough to use contemporary science to clarify, celebrate and enhance the range and depth of his work.

In this Hirst stood apart from the normal run of 'Artistic Minds' (as Miroslav Holub described them) whose 'primal and direct communication with the nature of man and things is still seen as an alternative and more genuine path of human creativity, opposing the analytical,

cold and cynical scientific approach. Frequently', Holub went on, 'we find that artists believe, at least in private, that they are fundamentally opposed to this science, to inimical science which is designed to endanger their minds, their aims and their ways of life'.

Holub was a scientist – a distinguished immunologist – as well as a poet. Like the poet and doctor William Carlos Williams (who famously stated that 'The poem is a machine made of words'), Holub felt no sense of contradiction between his two callings. In fact, he believed that a scientific idea – 'reduced to its components, verified and sieved, criticised and revised by scientific observation' – had a great deal in common with the more self-consciously 'creative' utterances belonging to 'the so-called creative professions': 'Both the scientific and poetic communications are a function of condensation of meanings, of the net weight of meaning per word, of inner and immanent intensity. Opposed to other written communications, they are – at their best – concentrates, time-saving devices'. Throughout his life, Holub wrote against the (perceived) breach – 'the romantic disjunction' – between the poetic impulse to imagine and the scientific gift for accurate observation; 'between free invention and strictly rational reflection'. Put another way (to quote Holub quoting the Polish writer Stanislaw Jerzy Lec): the hay smells different to the lovers than to the horses.

Francis Bacon said repeatedly that he was committed to 'the brutality of fact'. Echoing this, Damien Hirst has said he likes 'the violence of inanimate objects'. Typically this has meant everyday objects – formica'd tables, office chairs, ashtrays – being bifurcated and mutilated in predetermined, precise ways in a symbolic enactment of the 'hurtability' of human beings. At other times, the violence has resided in Hirst's choice of object – most characteristically, medical apparatus and equipment with the power to lift pain and its attributes out of the body and make them visible. Duchampian readymades have been transposed from the morgue and the operating theatre to the gallery on the basis of the cold cargo of dread and terror that they carry.

Sometimes I Avoid People (1991) consists of two coffinated glass cases, one vertical, one horizontal. Each case, which contains departments for the storage of bodily waste, is supplied with medically useful gases – oxygen, nitrogen, an oxygen and helium mix – from a range of colour-coded cylinders. *Naked* (1994) is a glass-fronted

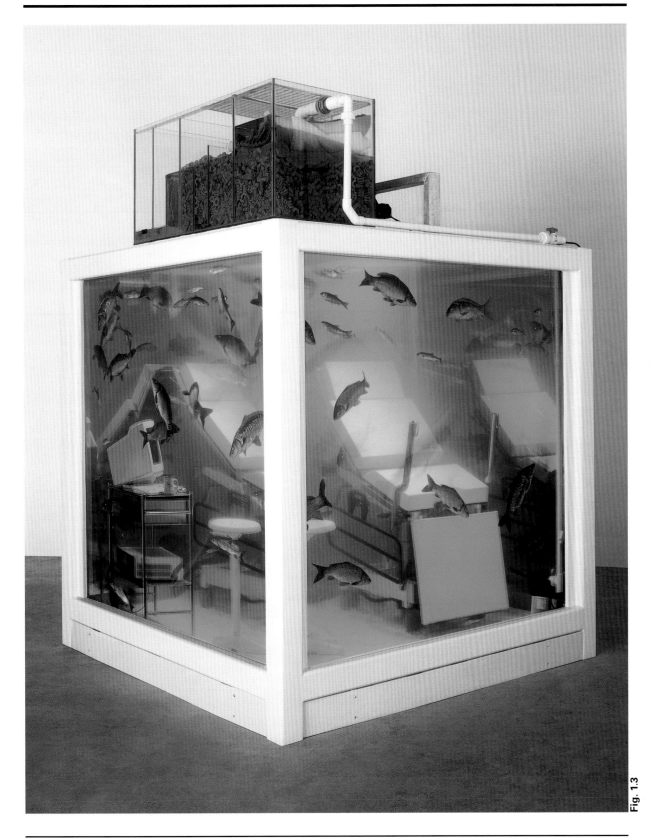

Fig. 1.3

The Hay Smells Different to the Lovers Than to the Horses

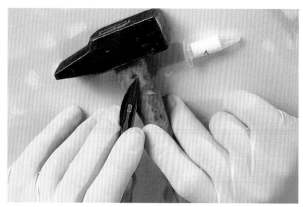

Fig. 1.4 – A forensic scientist removes dried blood from a hammer using a scalpel. Blood is taken for genetic fingerprinting or to determine blood grouping. The dried blood is reconstituted with saline solution and then mixed with different antibodies to see which of them cause the blood to clot.

steel cabinet containing scalpels and bone-saws and other cold intruments of the surgeon's violently invasive trade. In *He Tried to Internalize Everything* (1992-94), an anaesthetist's black rubber mask and Halothane dispenser and a swivel chair whose back has been grievously broken – cut through the spine – are encased in one of Hirst's signature twin-celled, glass-and-steel vitrines.

These things are the furniture of our bad dreams, and of the death rooms. The direction of Hirst's work has always, notoriously, been towards death and dwindlings. He has said, 'I like creating emotions scientifically'. His 'inanimate objects' characterised, by their hypothermic, sterilized, hospital 'wipe' aesthetic, are among the last things seen by many people in their earthly lives. His disinhabited dumb boxes speak of modern death in tiled hospital rooms, and silent technologised removal. They speak, that is to say, of how death has become increasingly mediated; of how the technological media, which enormously reinforce and heighten the illusion that death happens only to others, have put a distance between us and our own dying.

Wittingly or not, this is another area of interest that Hirst shares with a postmodern writer like DeLillo. Discussing DeLillo's novel, *White Noise* (1984), the American academic Michael Valdez Moses has noted that one of its themes is how 'the technology of the hospital functions as an extension of the public media, of television'. He quotes the following passage:

You are said to be dying and yet are separate from the dying, can ponder it at your leisure, literally see on the X-ray photograph or computer screen the horrible alien logic of it all. It is when death is rendered graphically, is televised, so to speak, that you sense an eerie separation between your condition and yourself. A network of symbols has been introduced, an entire awesome technology wrested from the gods.

It makes you feel like a stranger in your own dying. The latest pieces of medical equipment to be brought by Hirst from the hospital into the gallery are the gynaecological examination couches, incorporated into the two new (living) fish installations in *Theories, Models, Methods, Approaches.... Lost Love* and *Love Lost* are two gynaecologists' offices entirely submerged in water. In one, hundreds of jewel-like African river fish swim around the forceps and past the coat-stand and through the stirrups of the couch. The fish in the other are big black carp that, even before the piece was ready for shipping, had started to impose themselves on their surroundings. In time, everything – the adjustable stool, the white examination coat, the advanced technology – will be coated with green algae.

As with all of Hirst's most powerful work, these are sculptures that provoke a multiplicity of interpretations. They could be alluding, for example, to the nineteenth-century eagerness to open up the female body and see deeply into the secrets of creation, which was central to the process and method of science itself. This passion for observation and analysis among the Victorians was manifested first in the development of scientific, medical and gynaecological intruments. Alternatively, there are a number of broadbrush references to low-budget horror films and to cult slasher pictures in the new work. Hirst has admitted that the various messages in lipstick and blood (in *An Unreasonable Fear of Death and Dying* and *Figures in a Landscape*, for example) were prompted by similar messages in *The Exorcist* and *The Shining*. And so it wouldn't necessarily be a mile wide of the mark to hazard that the dreamy, gynae-centred narratives of *Lost Love* and *Love Lost* allude to David Cronenberg's creepy 1988 film, *Dead Ringers*, in which the twins, Beverley and Elliot Mantle, invent a large intrument for gynaecological surgery, the Mantle Retractor. 'Gynaecology is such a beautiful metaphor for the mind/body split', Cronenberg once said. 'Here it is: the mind of men – or women –

trying to understand sexual organs'. The duality of mind and body has been one of Hirst's most persistent themes. And a second quote from Cronenberg chimes suspiciously well with Hirst's avowed motives for making these unnerving, hypno-trippy twin chambers.

Cronenberg: 'The... reason gynaecology weirds men out is that they are jealous. They've never gone into why. Men who put their fingers up their girlfriends can turn around and say the concept of gynaecology is disgusting. What are they talking about?... What makes gynaecology icky for people is the formality of it. The clinical sterility, the fact that it's a stranger... Everyone agrees to suppress any element of eroticism, emotion, passion, intimacy'.

Hirst: 'Those sculptures [*Lost Love* and *Love Lost*] are pretty direct. There's something really simple. If you've got a gynaecologist's office under water with fish swimming about, then there's something fishy going on. An' fishy fannies come straight after that. *I* think. In the logic

of it. I quite like the idea that the doctor's had to take his watch and his rings off [they are part of the furniture of *Love Lost*], so that you get the doctor's personality into the hand that's going to finger about with you down there. The woman's got her shoes on the floor, and there's the coat and the handbag. So there's a hugely sexual element to it. An' women smell of fucking kippers'.

The performative, gross-out, slyly provocative part of Hirst's personality is the other side of him that is given reign across much of the new work. It accounts for the sense of a layered existence inside the most complicated and debris-littered (and probably autobiographical) of the sculptures. *Lost Love* and *Love Lost* in particular, it seems to me, can be read as a paradigm of the artist's personality (and, in many ways, of the practice of science itself).

Science (like art) is traditionally regarded as a combination of intention and surprise. 'In working', Francis Bacon once said, 'you are really following this kind of

Fig. 1.5 – Forensic fly samples. Reference box of preserved flies (top) and their larvae (bottom) used in forensic analysis. These flies are attracted to carrion such as human corpses. The number and type of insects found on a long-dead corpse, as well as their stage of development, can aid in determining the time of death.

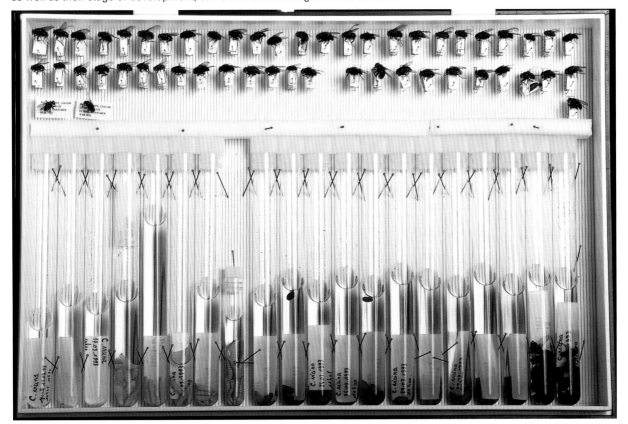

As we unlock, unravel, there is a possibility that we will see an order and an organization in nature and existence that can only be explained by recourse to a God. On the other hand, we may not. I mean I'm an agnostic, I think at the end of the day you come to religious belief through faith. You cannot scientifically prove the existence of God, and if you could, then there would be no such thing as religious faith. So at the moment there are two spheres very wide apart – religion and science – but in unravelling the brain there is something religious about the quest; you really are looking at the nature of creativity.

Professor Anthony Clare – Psychiatrist

Fig. 1.6 – Hymn. 6096 x 3352 x 2133mm

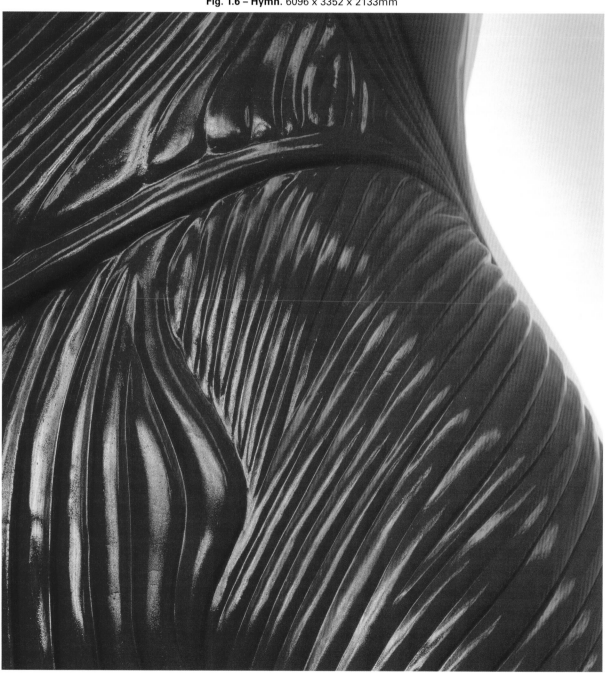

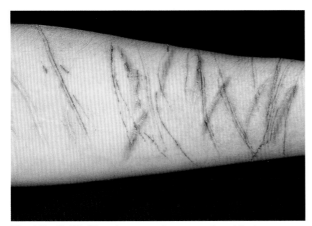

Fig. 1.7 – Self-inflicted cuts on the arms of a girl who alleged an assault. The wounds are uniform, shallow, and oriented in the same direction, the plane being that most convenient for infliction by each alternate hand.

Fig. 1.8 – Defence injuries: laceration of the finger. Such injuries confirm that the victim was conscious during the attack and that it was not made covertly while the victim was unaware.

cloud sensation in yourself, but you don't know what it really is. And it's called instinct'. Sol LeWitt goes further. 'Irrational thought', he advises in *Sentences on Conceptual Art*, 'should be followed absolutely and logically'.

In this exhibition, *A Way of Seeing* and *The Way We Were* tell how the rigour, the relentless objectivity, the heroic caution of science constantly come under threat of being undermined by human thought-habits: by superstition ('magical thinking'), say, or emotive distortion. Hirst has commented in the past that the spot paintings could be what art looks like viewed through an imaginary microscope: 'A scientific approach to painting like the drug companies' scientific approach to life'. And the scientist in *A Way of Seeing*, cocooned in his clean, well-lighted box, breathing in, breathing out, is intent on looking at this abstract, atomised version of the world – a world supported by the most minute entities, such as the messages of DNA, the impulses of neurons, and quarks, and neutrinos wandering through space since the beginning of time.

A fully technologised being himself, and therefore a realisation of the dream of modern technological science – the conquest of the final natural limit, death – Hirst's animatronic man is a modern exemplar of rigid, consistent and unchanging intellectual control. Only the sand and the sea-side paraphernalia in the outer corridors of the vitrine suggest that he is missing the breezy and blowy, non-objective world; the seas and beaches.

In stark contrast, the Hammer horror nocturnal experimenter that we are meant to deduce from the ancient laboratory equipment and the other props stored in the melancholy cell of *The Way We Were*, is the embodiment of what happens when dispassionate scientific method inadvertently admits mystical elements and human wishful thinking – what the science writer Stephen Jay Gould calls 'hope'. (In *Something Solid Beneath the Surface of Several Things Wise and Wonderful* we witness the incursion happening mid-title.) It is as if, Hirst seems to suggest, we keep our Dark Ages permanently with us, both in our societies and in our individual psyches, ready at any moment to undermine the painstaking evolution of the mentality and methods implied by science.

In *A Way of Seeing* we are presented with a cool room dedicated to the proposition that the world is comprehensible, controllable, everything correctible. (The cigarette ash in the ashtray – always a locus of horror for Hirst: the horror underlying everything; the horror that can overwhelm everything at any moment – offers the only clue that this might not be the case.) *The Way We Were*, on the other hand, is a hot environment – literally, thanks to the old single -bar electric fires leaking their warmth; and metaphorically, thanks to the scientist's over-heated, almost Guignol-like imagination, rooted in the unruliness and dishevelment of life.

I think we are to infer that *A Way of Seeing* and *The Way We Were* are interior landscapes. They have this in common with two of the other paired pieces, *Lost Love* and *Love Lost*, in which the dreamscapes of the fishes – the pretty darting fish and the glooming phallic fish – envelop and transform the actuality of the world.

In *White Noise*, DeLillo's narrator, a college professor, has the following small-hours conversation with his wife:

'You have a vague foreboding', I said.

'I feel they're working on the superstitious part of my nature. Every advance is worse than the one before because it makes me more scared'.

'Scared of what?'

'The earth, the sky, I don't know'.

'The greater the scientific advance, the more primitive the fear'.

Postmodern society is supposed to have become fully demystified and secularized. But, like DeLillo, Hirst illustrates for us what Horkheimer and Adorno termed the dialectic of enlightenment, the paradoxical way in which scientific enlightenment reverts to new forms of mythology.

As Valdez Moses has pointed out, the concluding passage of *White Noise* reveals the quintessential post-modern environment, the supermarket, to be completely saturated with the aura of the sacred:

The terminals are equipped with holographic scanners, which decode the binary secret of every item, infallibly. This is the language of waves and radiation, or how the dead speak to the living… Everything we need that is not food or love is here in the tabloid racks. The tales of the supernatural and the extraterrestrial. The miracle vitamins, the cures for cancer, the remedies for obesity. The cults of the famous and the dead.

The patina of accumulation is something that has interested Hirst from the beginning. He has spoken often in the past about the profound impact that Mr Barnes had on his life and his working practice. Mr Barnes was Hirst's neighbour when he was a young student, newly arrived in London. Mr Barnes was a magpie collector, an obsessive hoarder of all the ephemera and detritus of his life. Then one day Mr Barnes disappeared, and Hirst let himself into the house to find out what had happened to the old man.

'It was like going through layers of time', he has said of what he discovered. 'From the top to the bottom it was piles and piles of collected shit, like every toothpaste tube he'd ever used rolled up and stored in bags. Everything was collected and had a place, alarm clocks, and god knows what, heads from statues he'd found in graveyards, everything you could imagine, even money in parcels. I couldn't get to the things underneath immediately, but as you ploughed through it and got to the bottom I found a more and more organised man. It was like going back through his life, sixty years of time in one room'.

The action of the world on things became one of Hirst's driving obsessions. Time passed, and he started to use the worthless bits of flotsam that he'd retrieved from Mr Barnes's house to make small, Schwitters-like sculptures. For somebody who had always found trying to paint an ordeal – 'I could never paint. I was always terrified by a white void. I just couldn't choose what to paint there' – the collaging offered a lifeline back to art. 'With the collages', Hirst has said, 'I found I could work with already-organized elements. And in *Freeze* (the group show of his

Figs. 1.9 – Victim of asphyxia by hanging. The ligature was fashioned from shoestring (right) and sweatshirt cord. The deceased lay face down, at an angle below the bed rack (left), and tied the ligature to the support of the bed rack. He then hung himself with his hands tied in front of him.

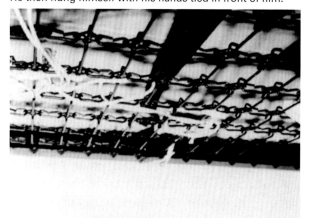
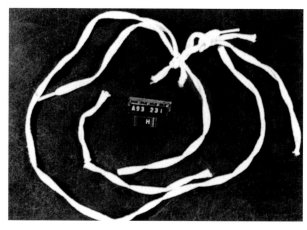

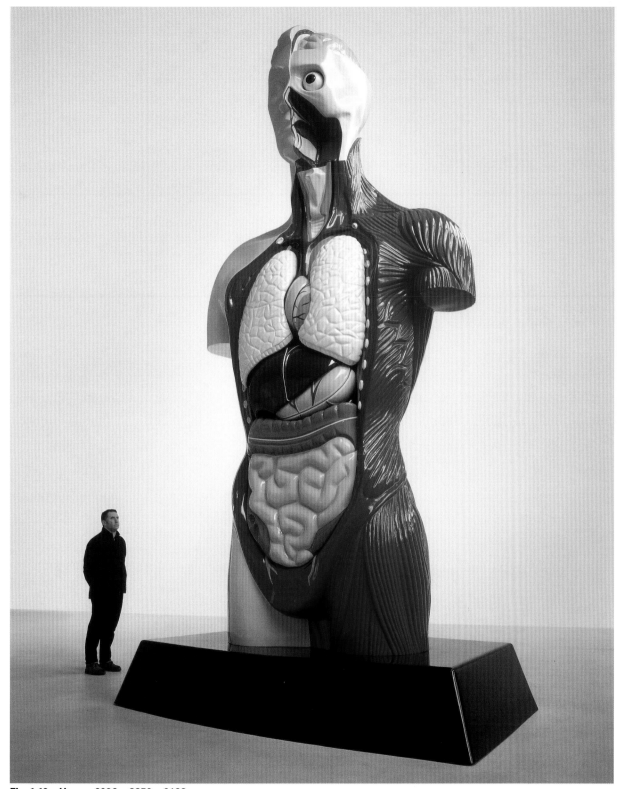

Fig. 1.10 – Hymn. 6096 x 3352 x 2133mm

contemporaries at Goldsmiths College that he organised in a disused warehouse in south-east London in summer, 1988) the artists were kind of already-organized elements in themselves. I arranged them'.

A group show by young New York-based artists at the Saatchi Gallery in London at the end of 1987 – *New York Art Now* included work by Ashley Bickerton, Jeff Koons, Robert Gober, Peter Halley and Haim Steinbach – had a galvanising effect on Hirst and many of the other British artists of his generation who have since come to prominence. The commodity sculptures of Koons in particular (he was still in his vacuum-cleaner and floating basketball phase), but also the slicked-up, deadpan work shown by Bickerton and Steinbach, helped Hirst towards the possibilities that he's still excavating. Except that, instead of Hoovers and lava lamps, the found objects that he chose to 'recontextualise' included surgical instruments and pharmaceuticals cabinets; also the internal organs of cows, bulls' heads, fish, a fourteen-foot tiger shark, and a number of farmyard animals – cows, a calf, a lamb, a pig – suspended, either bisected or whole, in formaldehyde (the *Natural History* series).

As early as 1992, though, Hirst was adding to 'minimalist' work, that prided itself on an almost antiseptic clarity, other works that were more opaque and even, on a couple of occasions, dared a narrative element. In place of the

poetic-associative, largely abstract combining of collage, he brought objects together so that they conspired to suggest a linear reading – a 'story'. *The Asthmatic Escaped* (1992), for example, depicts just what you would expect from the title: one half of a large vitrine contains a tripod camera; the other half contains a pair of jeans and dirty trainers discarded on the floor alongside an asthma inhaler.

In the same year, he showed a large vitrine installation which was clearly meant to depict the suicide of a young woman. The glass walls of *She Wanted To Find The Most Perfect Form of Flying* are semi-obscured with blood, and blood stains a chair, a table and various scattered items of clothing. Only a white coat on a hanger, reminiscent of the white lab coat in *Lost Love*, has escaped the carnage. (Interestingly, a goldfish swimming in a bowl and the personal effects of a woman, giving a clue to her personality, are further links between the blood bath of *The Most Perfect Form of Flying* and the site of conception that is the ostensible subject of *Lost Love* and *Love Lost*. 'I can make art about love but I don't know how I'd deal with sexuality', Hirst once said. 'It always turns into murder for some reason').

'He started off putting things on his desk for functional reasons, like everybody does in their life', Hirst has said of Mr Barnes. 'And then he put so much on the desk that it became an object in its own right, and then the room itself became an object. At some point it stopped being functional and became art. Art without a viewer'. A number of pieces in *Theories, Models, Methods, Approaches…* have obviously been allowed to accumulate in this way; to grow cumulatively like fungal matter.

The result is that, shorn of their minimalist lack of affect, the vitrines of *Concentrating on a Self-Portrait as a Pharmacist*, *The Way We Were* and *From the Cradle to the Grave* have started to look less like the transparent cages of Bacon, and more like transparent huts or sheds – vernacular structures found in back gardens and yards, where the cast-off stuff of life tends to multiply and moulder.

In *The Way We Were*, the surface of a vitrine has been broken for the first time, and articulated with the handles of swords. The swords themselves have a nostalgic charge that is in keeping with a work assembled from knocked-about remnants of the past. They are redolent of the magicians' boxes of vaudeville and childhood television, into which the magician's assistant disappeared, to be spun and apparently pierced and penetrated with sabres, only to emerge unscathed. The actual figure in *The Way We Were*

Fig. 1.11 – Note the dry dark reddish ligature abrasion mark of the neck caused by the shoelaces (Fig. 1.9) which were used as the weapon.

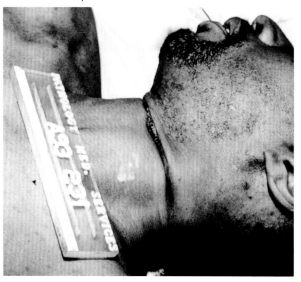

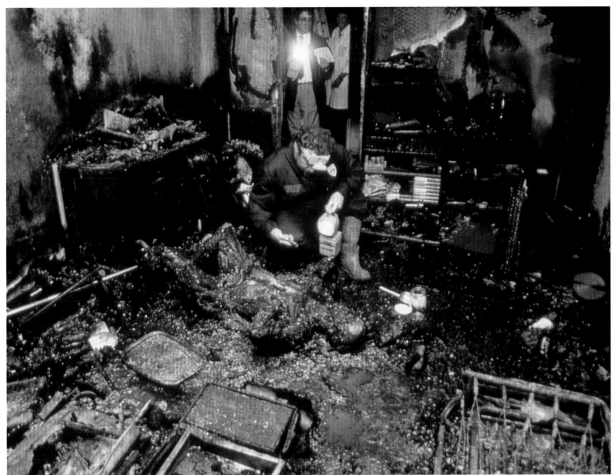

Fig. 1.12 – A forensic scientist studies a burnt corpse. Dead bodies in fires pose a problem for pathologists and investigators. Radiography should always be carried out to rule out firearm injuries.

– a crippled-child collecting box of the kind that used to stand outside post offices and chemists' shops in the pre-war years – recalls the 'column' that used to stand at the centre of Kurt Schwitters' *Merzbau*; it was surmounted by the cast of a child's head, taken from Schwitters' own son after he died in infancy.

'The past is hidden somewhere outside its own domain in some material object which we never suspected', Proust wrote. 'And it depends on chance whether or not we come upon it before we die'. There are reminders of Proust here, and also of collage-period Cubism, in the way Hirst makes a kind of expressive lyricism and hermetic poetry out of tatters and *tchotchkes* and less-than-skip-quality junk.

It took fifty years and Robert Rosenblum to 'contaminate a bit the pristine air that Cubism had earlier been breathing by indicating the abundance of witty, topical, and, at times, even smutty double and triple entendres in the work of Picasso and Braque. The incorporation of (often sensationalist) newspaper fragments and other 'visual offences culled from urban life and popular culture' into their still lives, and Picasso's well-documented delight in true crime and cheap detective stories, find their equivalents in the lurid 'red-top' newspapers that crop up as compositional elements in several of Hirst's new works and – especially – the stroke books and pulp paperbacks that are semi-submerged in the theatrical gore of *An Unreasonable Fear of Death and Dying*. The can of 'Charm' air-freshener ('Nature's Way') standing on the blood-spattered cistern and the cable news spooling out on the television – it's a matter of time before the room meets itself in its first mention or possible appearance in a bulletin – are just further plebeian facts of modern life.

In an earlier version, the television shows a looped sample of what has become known as 'wild programming': a shark doing its shark thing in the open sea. This is of course a reference to what is probably Hirst's most notorious work, *The Physical Impossibility of Death in the Mind of Someone Living*. But it is also yet another emblem of how contemporary 'reality' has become completely mediated and artificial: cable nature, available twenty-four hours a day to the National Geographic and Discovery Channel subscriber. Heidegger's general term for this technological approach to the world – nature as the consumable product of consumer culture – is *Ge-stell* or 'Enframing'. By means of Enframing, which is the essence of technology, nature is 'revealed' to be at man's disposal, and in so doing is transformed into a *thing* which man chooses to consume at his convenience.

When he decided to make *The Physical Impossibility of Death…*, Hirst lifted the phone and placed an order for an adult shark with a shark hunter who was unknown to him and who lived in a town he had never visited, ten thousand miles away in southern Australia. It is something he has since said he regrets doing and would never do again. So the target of the word 'Die', finger-painted in blood on the bathroom door in version one of *An Unreasonable Fear of Death and Dying* could conceivably be seen to be the killer (the shark) rather than the implied (human) murderee. Hirst's contrition for what he now apparently regards as the pointless death of a living creature seems to be reflected in the filtration units over the *Lost Love* and *Love Lost* vitrine tanks which – sculptural qualities aside – are immensely more elaborate than anything that could be needed to simply deliver warmth, air and light. Unlike the insectocutor in *A Thousand Years* that zapped flies at random, fried and obliterated them, the plant of the fish pieces is there to keep the kinetic elements in shape and alive, and available for eternal scrutiny and inspection.

'More than once, after breaking a table full of glasses and china, he would sit conspicuously in a corner booth and play with the sharp fragments, casually making designs as his fingers dripped blood onto the table-top… [It was] a display so exaggerated, so singular, that people began coming on Tuesday nights just to see it; a display so memorable, so widely witnessed and reported, that for decades afterward, [his] reputation rested almost entirely on [it]'.

'He [then] stuffs his penis into a hot-dog bun and tapes it on, then smears his ass with mustard… He approaches the table and sits nearby, drinking ketchup and stuffing his mouth with hot dogs… Binding his head with gauze and adding more hot dogs, he finally tapes his bulging mouth closed so that the protruding mouth looks like a snout… He stands alone, struggling with himself, trying to prevent his own retching…'

These two descriptions – the first by two of Jackson Pollock's biographers, Steven Naifeh and Gregory White Smith; the second by a spectator at one of Paul McCarthy's

Fig. 1.13 – Site of suicidal falls.

☐ Cliffs ▨ High-rise car park ■ Home
☐ Bridge ▨ Other buildings

Table 1.1 – Apparent background to the suicides.

Background	Number of deaths
Psychiatric illness	44
Relationship difficulties	6
Chronic illness	5
Alcohol-related problems	2
Unemployment	1
Unable to cope with partner's death	1
Unclear	1

Table 1.2 – Unsurvivable injuries

Unsurvivable injury	Number of deaths
Complete rupture thoracic aorta	10
Massive injury to brain/brainstem	8
Massive cardiac disruption	4
Transected upper cervical spinal cord	2

messy, sacramental performances in the early-1970s — come perilously close to describing the Damien Hirst of contemporary London legend.

'I find myself becoming more and more yobbish', Hirst once said, 'when I expected to become more intellectual'. The new work *Death is Irrelevant* shows how the strategy he has applied in life has carried over to the art. It is what many people would see as a deliberate desecration of the wistfulness and quiet elegance of its precursor, *I want to spend the rest of my life everywhere, with everyone, one to one, always, forever, now* (1991). It is up to others to make links between *Death is Irrelevant* and Grünewald's or Bacon's crucifixions, or the bone-figure style of Picasso if they want. Hirst's task — apparently the latest stage in a developing aesthetic — is (he appears to be saying) to disappoint expectations of what his art should be by floating a turd in the proverbial punchbowl and subverting the pleasant appearance of things.

He has always candidly used drugs and drink as a way of isolating himself from banal experience and to bring him to something original or extraordinary in the moment that nobody else can see. He is a showman artist in the tradition of the Victorian decadents like John and Sargent. 'It's about expectation', he has said. 'It's theatre. It's about raising expectations and lowering expectations. It's very theatrical… I like to imagine that art is more theatrical than real'.

Hirst has developed a performance persona that is intended to both shore up and disconcert the hooligan genius reputation he has been cultivating now for the best part of a decade. And the role he has been touring for the last few years — the period of the gestation and completion of the work in *Theories, Models, Methods, Approaches…* — is that of the famous fuck-up, chaotic and wilful, and permanently, maddeningly out of his tree. To the point where it is often impossible to know (perhaps even for the artist himself) where 'theatre' ends and reality begins.

The eerie carnival that Hirst's life sometimes seems to have become (he has long been a staple of the gossip columns and a favourite of the voracious English tabloid press) is punctuated by performance-like acts that combine parody with self- and other-directed aggression and bathetic self-abasement. 'He wanted total fulfilment and satisfaction. But he didn't call it art. And that's why it gets to me', Hirst has said of the most important artistic influence in his life, the semi-derelict Mr Barnes. 'To ignore every-

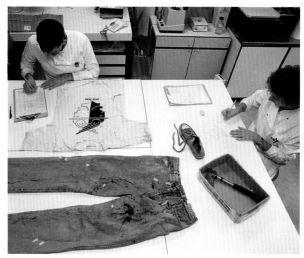

Fig. 1.14 – Forensic blood-sampling. Blood stained clothing (jeans, a t-shirt and a shoe) and an axe are seen. Modern amplification techniques allow DNA sequences to be taken from extremely small samples, such as a few spots of blood or a few hair follicles.

thing and get involved in this creative process, and it just merges into your life and your life merges into it, and that's it. It's a complete fusion of art and life… I want art to be life, which it never will be'.

'The aesthetic of aftermath' is an expression that has been used by the critic and curator Ralph Rugoff in connection with the work of performance-based artists such as Chris Burden, Cady Noland and Paul McCarthy, whose gallery practice involves the display of 'performance relics'. 'The aesthetic of aftermath' is a term that can be applied to certain sculptures in this show — *Figures In a Landscape* and *From the Cradle to the Grave*, for example — which reek of violence and which 'continue a tradition inaugurated by Pollock's action painting where, as Harold Rosenberg declared, the canvas was no longer home to a picture but to an event'. In an insightful essay on the work of McCarthy, Rugoff has continued:

This notion of the picture plane as an arena of evidence marks a conceptual shift in Modernism, a movement away from the autonomous art object to a growing focus on works or environments that bear the imprint of prior activities… an art of forensic traces and evidentiary values… Faced with an art object that is positioned as relic, clue, leftover or aftermath, the viewer is required… to connect the past to the present.

Concentrating on a Self-Portrait as a Pharmacist is an inventory of relics connected with Hirst's struggle with painting. Having cleared the studio of his assistants, he entered the shower-sized inner vitrine and performed the painting – or, more accurately, the sculpture of a painting. 'They're about the urge or the need to be a painter above and beyond the object of a painting', as he once said of the spot paintings. 'I've often said that they are like sculptures of paintings'.

Many writers have pointed out the similarity between Hirst's framing vitrines and what David Sylvester has called the 'spaceframes' – most commonly, the simple introduction of a rectangular linear frame around the human image – in Francis Bacon's paintings. Hirst has come to be seen as the natural inheritor of Bacon, and it can be no accident that the most legendary of his actings-out have happened at the Colony Room, a place indelibly associated with Bacon and the mythology of haute bohemian London. (When she opened the club in 1949 – it's really only a narrow, single upstairs room – the owner, Muriel Belcher, had paid Bacon ten pounds a week for a while to bring in his rich friends and generally tout for her.)

Fig. 1.15 and 1.16 – Lost Love. 2740 x 2130 x 2130mm

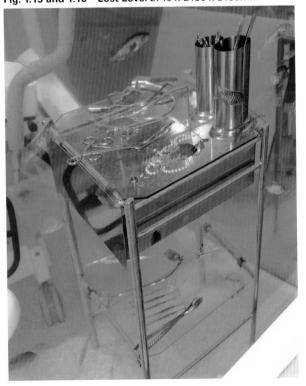

Damien clenched naked into a foetal position behind the bar in the Colony Room; Damien trouserless at the piano; Damien daubing a big black swastika on his chest... Why are these theatrical presentations of himself so insistently familiar? Answer: because they are (probably conscious) re-enactments of Bacon's 'inner scream'; of the convulsed and isolated 'rough beast' that Bacon returned to again and again in his painting, just as he was habituated to the perpetual twilight in the cramped 'interrogation green' Soho room with its dull gilding and its vicious gossip, which he internalised and reproduced obsessively as a hellish psychic landscape over the four decades of his career.

To this point, human absence has been as crucial to Hirst's endeavour as human presence was to Bacon's. 'Before', Hirst said recently, 'it was the lack of the human figure; an implication of absence. And – this is what makes it most poignant – of human absence from a man-made environment... Only objects are left – man-made signs which, in the absence of men, have become objects'.

Although, as Richard Flood and others have pointed out, Hirst has studiously avoided the human body in his work, he has been aggressive in his referencing of it, through inanimate objects, animal carcasses: surrogate humans.

Theories, Models, Methods, Approaches... marks a departure. Now the human presence – skeletal, mechanical, binbagged, prosthetic, painted – is real. This show is dominated by a human figure: the twenty-foot, six-ton bronze cast of a child's anatomical learning toy called *Hymn*. The fragility of existence has been Hirst's big theme from the beginning. It's why he puts things behind glass, and in formaldehyde in big steel and glass cases: to hold off the inevitable decay and corruption; as part of a futile effort to preserve them.

Casting human organs in bronze would seem to be a parallel process: a way of rendering them invulnerable; immune. 'Solidity – and people always look for solidity – I think is a great strength', Hirst has said. 'I love the idea of solidity. But to actually find solidity in my body means that I will be a skeleton'.

Time works its relentless erosion. 'Death subtends life, or underlies life', the pathologist, F.Gonzales-Crussi, writes, 'and the action of time consists in peeling away successive layers so as to render death ever more visible'. The bright nursery-coloured paint over the surface of *Hymn* is like skin; like skin, it will decay. All that is solid, as Marx wrote in *Capital*, volume one, melts into air.

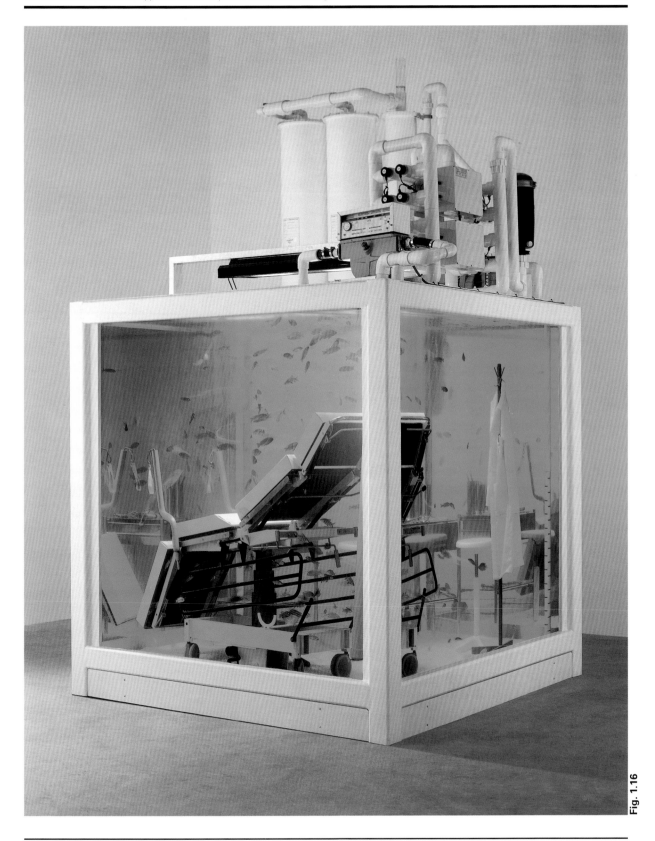

Fig. 1.16

The Hay Smells Different to the Lovers Than to the Horses + .21 0011-8532/90 0.00

Fig. 2.1 –The back of the head of a woman who was killed
by a blow with a piece of timber.

0011-8532/90 0.00 + .22 *The epidemiology of violence*

2. The epidemiology of violence

Summary A one-year prospective study was carried out to describe the epidemiological changes in interpersonal violence in Aarhus (Denmark) over a twelve-year period. Data was collected from the Accident & Emergency Department, the Department of Forensic Medicine and the local police and compared to previous studies carried out in 1981–1982 and 1987–1988. The incidence of violence was found to have declined significantly over the study period, but the severity of violence remained unchanged. The composition of pubs, discotheques and cafes might be an important factor in reducing inner city violence. Police statistics alone may give a false picture of the assault rate. All of these factors are discussed.

O. Brink

When comparing police crime statistics from various countries, large individual differences in crime rates in each country are noted. The variations are in part due to differences in legislation and data-recording procedures. Differences in crime rates may also be due to cultural dissimilarities and a different conception of violence.[1] In recent years Denmark has undergone an ever-increasing integration of populations and cultures across its frontiers. Through a better knowledge of violence in our neighbouring countries, it might be possible to understand the causes of violence more clearly and thereby be able to reduce or prevent it. Police crimes statistics and crime surveys are used frequently and often uncritically when demonstrating the extent of violence, but these methods have essential epidemiological limitations.[2] Previous epidemiological surveys that include information from hospitals and forensic medicine units have proved that they can contribute a more subtle description of violence that has occurred.[3–5] Unfortunately, the majority of these surveys are transverse, whereas longitudinal surveys are preferred because they show trends in violence.[2] We have thus undertaken a longitudinal survey in Aarhus – the second largest city in Denmark, with a population of 310,000. The survey is a continuation of two previous prospective studies carried out in 1981–1982 and 1987–1988 when epidemiological data of the victims was collected from an Accident & Emergency (A & E) department, the Department of Forensic Medicine and the police.[6,7] The purpose of the current study was to describe trends in the frequency and character of violence that occurred over a 12-year period in a well-defined Danish urban population, and if possible, to compare the results with the development of violence in other countries.

Materials and methods

In this dynamic cohort - study, the incidence of individuals involved in violence was recorded from August 1993 to July 1994. Recordings were based on persons who attended one of two A & E departments or the Department of Forensic Medicine in Aarhus, and who stated their injuries were due to interpersonal violence. We defined interpersonal violence as 'intentionally inflicted bodily harm, injury or death'. Self-inflicted violence was not included. The departments serve the municipality of Aarhus.

+ .23 0011-8532/90 0.00

Every person registered was interviewed and examined by the physician on duty. A questionnaire was filled out including details of age, sex, occupation, address, geographical site of the incident, casualty, assailant, severity of the injury and treatment received. After permission from the Ministry of Justice and the local police, data from the A & E departments was compared to data recorded by the police authorities over the same period. Information from obtained cases of violence, which were solely recorded by the police is used only as numerical data and included in the calculation of the overall incidence rates in this study.

All data from this study was analyzed and compared with data collected from the two previous and analogous studies undertaken 6 and 12 years earlier in the same area. The study design was unchanged. Social Security numbers were used to identify victims who had made repeated visits to the A & E departments.

The X^2-test was used for statistical analysis with 95% confidence limits.

Results

Over the 1-year period from 1993 to 1994, 1710 episodes of violence were registered. This was significantly less than those registered in the previous study periods ($X^2 = 96.7$). The majority of these episodes of violence (1481) were registered either at the A & E department of the Department of Forensic Medicine. A total of 478 of these episodes were also reported to the police. In a further 229 assault cases, medical examination was not required and therefore the episodes were recorded only by the police. Simultaneously, with the decline in episodes of violence, there was a corresponding significant decline in the annual incidence rate from 6.5 assault cases per 1000 in 1981–1982 and 7.5 in 1987–1988 to 5.5 per 1000 in 1993–1994. Assault cases were responsible for 2.8% of all treatments at the A & E department during 1993–1994 vs 3.4% in 1981–1982 and 3.2% in 1987–1988.

The male/female ratio was unchanged (3.5) and the median age was 27 years males and 31 years for females.

There are areas where it is very important not to touch, or you touch very carefully, such as the brainstem, for example, the bit at the back joining the brain to the spinal cord: it's close to the nerves that work respiration and heart, so touching that roughly could mean that the patient might never breathe again. On the left side, just above the ear in right-handed people, is where speech is, and if you handle that roughly, the person may never speak again. So clearly one has to know one's way around and know the areas where it is relatively safe to make an incision to get into the brain to do whatever you have to do, and so a detailed knowledge of the anatomy and the physiology are a prerequisite.

Mr Alan Crockard – Neurosurgeon

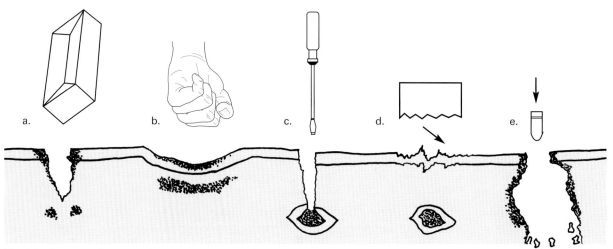

Fig. 2.2 – Patterns of injury. a. Laceration: splitting of skin by blunt trauma. Surrounding skin is macerated and skin bridges are present. b. Bruising: blunt trauma with no splitting of skin but tearing of the blood vessels in the skin lead to leakage of blood into soft tissues. c. Stabbing: sharp instrument penetration. The length of the wound bears no relation to the size of the weapon used due to the elasticity of the skin. d. Abrasion: tearing of the skin and soft tissue by tangential force. e. Bullet wound: small entry wound soot soiling surrounds the entry point. Underlying soft tissues are expanded due to gasses.

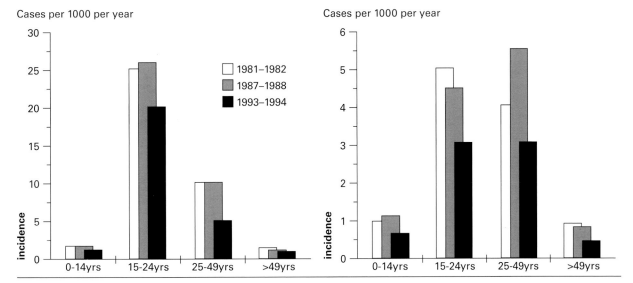

Cases per 1000 per year

Cases per 1000 per year

Fig. 2.3 – Age-specific incidence rates during the three periods (male victims).

Fig. 2.4 – Age-specific incidence rates during the three periods (female victims).

The decline in assault cases is most visible among young males aged 15–24 years, but the same group still accounted 42% of all assaults cases in 1993–1994. Incidence rates of female victims equalized for those aged between 15 and 24 and 25 and 49 years. In all periods studied, individuals of non-Danish origin were significantly more frequently involved in violence. Of all those recorded in 1993–1994, 1190 were of foreign origin compared with 4.5% in 1981–1982 and 6% in 1987–1988. Although the population of foreign citizens has gradually increased, the incidence rate of foreigners involved in acts of violence has actually declined from 13 cases in 1981–1982 and 14 per 1000 in 1987–1988 (not significant) to 11 cases per 1000 in 1993–1994.

Several individuals were repeatedly recorded. A total of 64 persons (5%) attended the A & E department more than once during the period of 1993–1994 with injuries resulting from violence. Another 66 persons (4%), who appeared as victims of violence in 1993-1994, were also registered as victims in 1987–1988.

The composition of the victims' occupations was unchanged compared with the previous studies. Most of the victims were skilled workers (24%) followed by students (12%), persons with a middle to high level of education (7%) and pensioners (5%).

The majority of the violence (50%) took place between the hours of 21.00 Friday night and 06.00 Sunday morning. There was an unchanged tendency which showed that

violence towards women was evenly spread over the first days of the week with a slight increase at the weekend, while violence towards men primarily took place during the weekend. The time of the day the violent episodes occurred was significantly different for men and women. Men were most frequently involved in violent acts from midnight to 06.00h, while women typically were involved from 18.00 until midnight.

A total of 2432 injuries related to violence were registered and examined. It was found that 811 (55%) persons had one injury, 389 (26%) persons had two injuries and 281 (19%) persons had at least three injuries. The type and localization of the injuries did not change significantly compared with previous years. Of all injuries, 34.2% were contusions/bruises, 16.8% abrasions, 15.6% lacerations, 4.8% incised wounds and 11.6% fractures. Blunt trauma caused 78% of all injuries; the most frequent injuries were caused by blows with fists, kicks, head smashes or blunt instruments. Bumps against wall of floor after falling and pushing accounted for 10% of blunt trauma. Of all injuries, 11% were caused by sharp penetrating objects – mainly broken drinking glasses and bottles. Stabs and cuts with knives cause 3% of all injuries. Guns were the cause of 12 injuries (0.5%). Five people died because of violence during this period. Compared with the surveys in 1981–1982 and 1987–1988, there were no significant changes in the mechanism of injury. The frequency of penetrating violence

Fig. 2.5

Fig. 2.6

...people have enormous expectations, particularly in the casualty department and high dependency areas like ICU (Intensive Care Unit) and coronary care. For instance, people read in the paper about heart or lung transplants, and wonder why we can't do something about their baby who has died, or their seventeen-year-old who has got a smashed up brain because he has come off his motor bike. Some reactions can be physically quite violent: banging

their head against the wall or smashing the table. They can be verbally very violent about the person who has died, very violent towards the staff because they haven't saved the person's life, or very violent towards another member of the family who may be there. They can scream or faint, or they can just say nothing and sit there in absolute silence. Some people cry a lot, some won't cry. It seems to depend.

Sister Susan McGuiness – Nurse

and the use of weapon remained unchanged. The severity of the injuries assessed on the basis of AIS remained unchanged. The majority of the injuries (90.8%) were graded to AIS 1 (minor injuries), while 7.5% were AIS 2 (moderate injuries), while 1.7% were AIS 3–6 (serious injuries – maximum).

A self-reported 73% of males and 50% of females drank alcohol shortly before the assault.

Victims' relation to the perpetrator of the act of violence remained unchanged. One-third of the violence against women was caused by a boyfriend or husband, 28% were caused by an acquaintance and 28% by a stranger. Violence against males was usually caused by unknown persons (48%) or an acquaintance (25%).

The location of the violence did not differ significantly from the two former studies. Location, however, did differ between men and women. After geographical stratification of the violence to 57 different parishes, we found that 40% of all violence took place in two inner city parishes – the area with the highest concentration of restaurants, discotheques and pubs. The incidence of street violence in this area was significantly lower in 1993–1994, while the inci-

dence of violence in pubs and discotheques was unchanged compared to 1981–1982 and 1987–1988.

Among the assault victims who came to the A & E department or were examined by a forensic medical examiner, 32% were also recorded by the police, representing an increase from 16% in 1981–1982 and 22% in 1987–1988. Police reporting is related to sex and to the location of the incident. One-third of the incidents occurring in the victim's own homes were recorded by the police, while 31% of street violence involving the males and 51% of street violence involving females, were recorded by the police. The greatest tendency to simultaneous police reporting was seen among persons victimized at their workplace.

Discussion

This study revealed a significant decline in the frequency of violence in Aarhus over the 12-year study period. At the same time, it was discovered that the pattern of violence with regard to degree of violence was unchanged. Young men in the age range of 15–24 years, in particular, experience less violence than was reported previously.

Increased violence according to police statistics is due to a greater tendency by the public to report the crime.

It is a paradox that despite the fact that this study documents declining assault rates, it has not influenced the Danes' fear of violence in the recent years. Opinion polls published in papers have shown that violence is one of the subjects that concerns the Danes most, especially among elderly persons.[8] Only a minority of the general population have personally experienced an assault in the street by an unknown assaulter, meaning that the fear of violence is more often acquired from what is heard or read. Increasing availability of all media, especially electronic, is contributing to this as the competition on news has been intensified through the years. Episodes of assault are exposed again and again in much more dramatic ways, leaving an

impression that violence is increasing and becoming more brutal. Additionally, the police have reported more violence during the study years, but results from the study show that this is due to increased incidence of reporting by the public. In 1981–1982, 16% of the victims treated at the A & E department reported the incidence of assault to the police, while in 1993–1994 the figure was 32%. When newspapers and politicians make statements about the violence in our society, it is more often than not on the basis of the police-reported violence. Unfortunately, they do not interpret the police figures appropriately and the conclusions might therefore turn out to be wrong.

The results from a survey in 1995 where more than 20,000 Danes were interviewed over the phone (similar to the British Crime Survey) support our results. It concludes

Fig. 2.5–2.7 – Theories, Models, Methods, Approaches, Assumptions, Results and Findings. 2 x 1220 x 1800 x 1140mm

Cases per 1000 per year

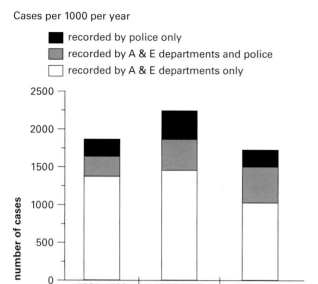

Fig. 2.8 – Number of violent cases recorded by police, Department of Forensic Medicine and A & E departments during the three registration periods.

that the risk of meeting violence or threats of violence in Denmark has remained unchanged over the past 10 years.[9] Now the police rates on crime are beginning to show a declining trend.[10] The question now is whether this positive development is a particular Danish phenomenon.

A study from Bristol in the UK by Shepherd, which examined the attendance of assault victims at a city centre Accident and Emergency department, compared recordings by the police between 1973 and 1990. From 1975–1990, attendance rates for assault victims in the A & E department increased 6-fold, but police statistics showed a 9-fold increase. Unfortunately there is no data from the period after 1990, but the 1996 British Crime Survey (BCS) shows a continual increase in violence in England and Wales from 1981–1995. According to the BCS,

domestic violence increased 3.4-fold, while violence among non-domestic acquaintances doubled. This is not in agreement with the development we have illustrated in Denmark.The conclusions from the BCS, also state that the increase may be due in part to respondents disclosing more incidents to interviewers. Shepherd states correspondingly that the heavy increase in police-reported violence in Bristol does not necessarily reflect a corresponding increase in frequency of violence but, rather, is due to an increased inclination by the public to involve the police. This similar inclination to involve the police is found in this study from Denmark. Melhuus describes a 1-year study from Norway, where 2545 victims were treated by Oslo Legevakt (Emergency Medical Services) in 1994. He found no clear indication that the amount of patients needing treatment for injuries caused by violence in Oslo has increased dramatically during the last decade.[11]

It must be emphasized that, particularly when comparing the frequency of violence, it is difficult to make direct comparison with other studies. Few studies using the same methodology with collection of data from A & E departments, departments of forensic medicine and police have been undertaken. Few studies are longitudinal. Therefore it is not possible to conclude whether the decline in the frequency of the violence since 1980s is only a Danish phenomenon.

With regard to other epidemiological characteristics of the assault victims that are described in this study, many common characteristics can be found in various studies despite methodological variations. It was found in this study that the average age of the male assault victim is 27 years, which is lower than for females, but the males on the other hand were 3.5 times more often recorded with injuries related to violence. In an A & E department survey from Bergen in 1994–1995, Steen and Hunskar report that 76% of assault victims were male and their average age was

Death never gets any better, it doesn't get any easier. You lose a bit every time. I had a patient last Friday die absolutely unexpectedly at home. He had been discharged from hospital the day before. He had a massive haemoptysis, coughed up several pints of blood and died within half an hour. So on Monday morning at 8 a.m. I had to go to the coroner's post-mortem at Epsom mortuary. And there was this guy whom I had known well over the previous month and thought that I was well on the way to helping

– got him into remission and so on – and I had to go and see him spread open end to end, top of his head off, brain out, and go through the organs looking to see what caused it. Now, if you know the guy and had been joking with him two days before, and you are then seeing him on the table, you cannot cope with that by ignoring it or laughing it off. Of course you lose a bit every time. I think if you don't, in our business, you want for out.

Dr Ray Powells – Leukaemiologist

Table 2.1 – Site of incident

Site of incident	Men	%	Women	%	Total	%
Home	83 (27)	7.2%	143 (49)	43.7%	226 (76)	15.3%
Private	77 (16)	6.7%	41 (12)	12.5%	118 (28)	8%
School	39 (6)	3.4%	6 (1)	1.8%	45 (7)	3%
Workplace	58 (34)	5%	17 (6)	5.2%	75 (40)	5.1%
Cafe	18 (7)	1.6%	1 (1)	0.3%	19 (8)	1.3%
Pub	103 (30)	8.9%	8 (4)	2.4%	111 (34)	7.5%
Discotheque	100 (35)	8.7%	12 (3)	3.7%	112 (38)	7.6%
Street*	143 (50)	12.4%	15 (7)	4.6%	158 (57)	10.7%
Street	302 (94)	26.2%	43 (22)	13.1%	345 (116)	23.3%
Other	77 (26)	6.7%	18 (6)	5.5%	95 (32)	6.4%
Unknown	154 (36)	13.3%	23 (6)	7%	177 (42)	12%
Total	1154 (361)	100%	327 (117)	100%	1481 (478)	100%

Figs. 2.9 – Looking Forward to the Total and Absolute Suppression of Pain. 3050 x 3050 x 3050mm

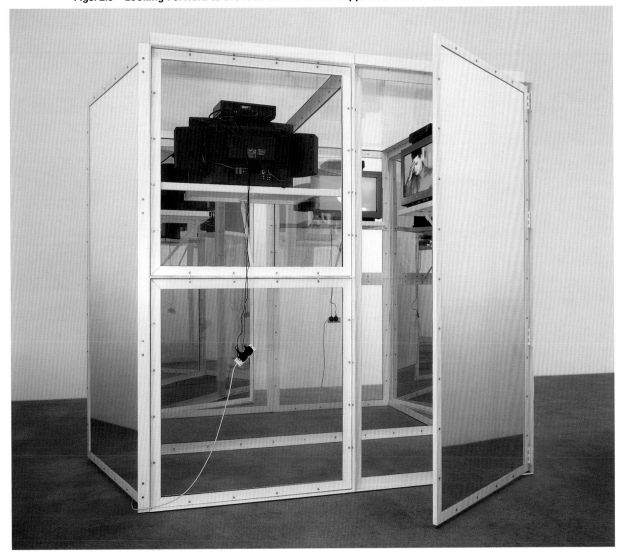

28 years. In 1989 in Bristol, UK, Shepherd found that 84% were males with an average age of 26 years and Payne-James & Dean in London, UK, found that 86% were males, with an average age of 30 years[4] (in clinical forensic medicine).

From 1981 to 1994, the number of immigrants and refugees living in Aarhus has tripled. Because the total population in Aarhus has not increased at the same rate, foreign nationals are thus more visible in the streets. Their presence is evident in police reports and at the same time they will be an increasing part of the assault victims who are examined in A & E and forensic departments. In return, the adjusted incidence rate of violence involving foreign nationals remained unchanged from 1981–1984. Such nationals have always had twice the risk of being involved in violence. We did not record their country of origin, but it is estimated that the greatest majority originate from countries outside USA and Europe. The same increased risk and background is seen for immigrants/refugees in Norwegian studies and in a study from Stockholm.[3, 11, 12]

City centre violence is a common phenomenon in larger cities and violence is often concentrated in a few city centre streets, where a large number of pubs are located.[14] Melhuus and Sørensen report that 50% of the males and 20% of the females were injured in Oslo city centre and, correspondingly, 41% of the violence in Bergen was localized to only three city areas. [11, 12] We found the same patter in Aarhus, where 40% of the violence was localized to two inner city areas. Since 1981, the number of public entertainment licences in Aarhus has increased from 400 to 490, and it is our impression that this increase has taken place particularly in the inner city area. Therefore, an increase in city centre violence could have been expected, but instead, the incidence of violence remained unchanged. One explanation might be due to local changes in the environment, and the number of the pubs in the city centre.

Simple public houses dominated the area in 1981, but visible changes have occurred during the past 10 years. Today the area is characterized by more 'stylish' bars and cafes, where consumption of cappuccino is just as 'legitimate' as consumption of beer. Nicer surroundings might attract 'nicer' people and might influence the level of aggression and number of violent events. In the findings of the present study, only 1.3% of all violent acts took place in cafes, while 16% occurred in 'old-fashioned' pubs or discotheques.

Several studies have shown a strong association between alcohol and violence.[4] In the present study, 73% of male victims and 50% of female victims had a self-reported alcohol intake prior to the assault. It cannot, however, be concluded that alcohol is the cause of violence or that violence will disappear if alcohol is restricted. This study suggests that the environment in which alcohol is served may be of importance. For example, restaurants are very seldom the site of violence, despite the fact that alcohol is served on the premises. Severe injury following an assault cannot always be explained by the influence of alcohol. In a survey of 2711 Norwegians, Rossow examined the impact of drinking alcohol and its connection to alcohol-related violence. It was found that overall alcohol consumption, frequency of being intoxicated and frequenting public drinking places had a significant effect on being injured by an intoxicated person. More surprising was the discovery that the more frequently that drinking takes place in public rooms, the less risk that intoxication leads to acts of violence. The study included an observation of the influence that the interior and atmosphere of the pubs, including the attitude of the staff, can make a difference in reducing the likelihood of violence. Frequent pubs visitors may consciously choose places with 'atmos-phere' that are seen to be 'less violent'.

Medical treatment in Denmark is free of charge, and the A & E departments in Aarhus are easily accessible and

...an illustration of how appallingly bad news is told is the use of cliches and jargon to avoid saying things like 'dying' and 'dead'. One doctor, he used to say, 'I'm afraid we've lost him', and time and time again people would say, 'Where have you lost him? Has he gone to x-ray?' We actively discourage the use of cliches and jargon here because it's a cop-out from the nurse and doctor's point of view, and it's stupid to use that kind of language when somebody's already disorientated. It is very difficult to generalize the behaviour of bereaved people. People are very disorientated, extremely confused, and often disbelieve the information you are giving them, particularly the news of a death. They're convinced that you have got the wrong person, it isn't actually their husband, wife, daughter or son. They are reluctant to accept the enormity of the situation. And extremely reluctant to accept that there are some things that we cannot do anything about.

Sister Susan McGuiness – Nurse

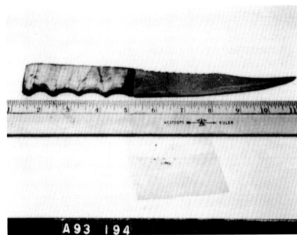

Fig. 2.10 – Victim of multiple stab wounds who died in surgery. Multiple stab wounds of the chest and abdomen. The serrated knife (right) used as a weapon.

operate 24 hours a day. When assault victims seek medical assistance, it might be primarily related to their injuries, and presumably the severity of the injuries affects the decision as to whether to seek medical help or not. If the severity of injuries in those attending the A & E department has changed at all, and the authors believe that they have probably become less serious, then our conclusion on less violence is strengthened. The report to the police from the victim might be exaggerated and influenced by many factors. These factors change over time.

Methodological differences in recording and defining interpersonal violence make comparison between criminal statistics and medical records difficult. We used the same study design and definition of violence during the three 1-year registration periods. The same definition of violence was used when we analyzed police records from the same study periods. By using the Social Security numbers of the victims, the authors were to match 100% of victims recorded both by the police and the A & E departments. We believe that data collected in this way throughout the three study periods are comparable and can be used to describe possible epidemiological changes in the study population.

Naturally, it is impossible to produce statistics which include all incidences of violence because a lot of violence takes place secretly. But when we become aware, from investigations of this kind, that 68% of the victims treated at hospitals do not report to the police and therefore are not included in the estimations used by the media and politicians, then it is our task to clarify the statistics. It is

essential to use the important information received from the victims and make it more visible and available. Unfortunately, Denmark has no continual recording of assault victims in A & E departments and cooperation between physicians and the police only occurred because of this study. In 1993 and 1997 the Government in Denmark produced a series of proposals and initiatives to prevent violence, and recently a secretariat of violence was established, which is intended to develop and implement campaigns to prevent violence. Despite the fact that the health services met most of the assault victims, none of the above-mentioned initiatives have openly established cooperation or contact with health professionals from the A & E departments.

We must recognize that violence is a public health issue. Golding goes as far as describing violence as one of the most important public health issues of today and, in line with this, the World Medical Association, in a resolution, encouraged the national medical societies to engage in prevention of family violence. The President of the Norwegian Medical Society recommends that physicians get more involved in the prevention of violence and try to expose the extent of the problem. We have not yet seen any statements or initiatives against violence from the Danish National Health Service.

Shepherd raised the issue of the necessity of a co-operation between hospitals and police in England. He proposes five reforms to bring agencies together on the issue of violence. Among other things, a national department to develop the strategies and make it easier for assault victims

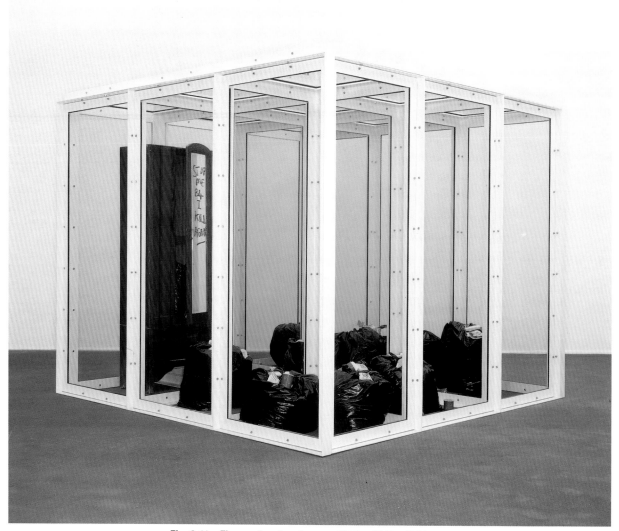

Fig. 2.11 – Figures in a Landscape. 2210 x 2740 x 2740mm

When somebody says to you, 'It is all pain', they are not only talking about their physical pain; they are talking about their loss of independence, they are talking about their worries about their family, they are talking about their search for meaning in their lives, they are talking about feeling depressed, isolated, and all the other things.

Death remains a mystery, and when you are with somebody at the moment in which the last breath is taken, even if they have been unconscious before, there is a difference. Often one sees the spirit get stronger in terms of endurance, because in crisis we move fast: in terms of reconciliation, in terms of living a lifetime in three weeks, as you come up to the crisis of dying, people can sort out rotten old family problems that have been hanging about for years. I have seen so many times the spirit becomes stronger as the body becomes weaker that it is impossible to see an ending at the moment of death.

Death can be seen in a positive way, but I am not detracting from the anguish of parting. What is difficult is when you hear that crying the moment that somebody dies, which is different in quality from any other times, and you see the anguish of parting. I know something about the awful emptiness of bereavement, and that comes back to you.

Dame Cicely Saunders – Hospice Director

On a physical level, death in an A & E department or a resuscitation area is often very traumatic. People end up here because something tragic and unexpected has happened. Say they've been involved in a road traffic accident, then because of the circumstances of the death, the person may be very smashed up and may not look very nice; they may be burnt, or mutilated, or whatever, and you may need to do some quite invasive procedures, i.e. a central venous line into the chest, or intubating them, putting a tube down into the lungs, where you may actually sever a capillary – and there will be plenty of blood around. So sometimes people don't look too nice or beautiful. You try to maintain their dignity by keeping their anatomy covered up, but keeping them covered up isn't the priority; the priority is to get their heart beating again and to get them breathing.

Sister Susan McGuiness – Nurse

who attend A & E departments to report the incident to the police. Health professionals should encourage this much more. Shepherd further suggests that current information from the A & E departments should be integrated in local prevention strategies and standardized statistics from A & E emergency departments, and which can be a supplement to the BCS, should be established. The proposals which Shepherd is making should not be limited to England only.

Conclusion

Patterns of violence do change. This is supported by the significant decline in the incidence of violence in Aarhus during the study period. This 12-year period saw a decline that can be primarily ascribed to males between 15 and 24 years. The composition of pubs, discotheques and cafes might be an important factor in reducing inner city violence. Police statistics alone might give a false picture about assault rates. International studies are needed; these should use similar methodology and definition of violence.

A more comprehensive statistical foundation could be made by combining hospital medical records, forensic medical examiners' recordings and police records. This approach is therefore recommended.

References

1 Ember C, Ember M. Issues in cross-cultural studies of interpersonal violence. Violence Vict 1993; 8: 217-218, 233

2 Shepherd JP, Ali MA, Hughes AO et al. Trends in urban violence: a comparison of accident department and police records. J R Soc Med 1993; 86: 87-88

3 Strom C, Nordenram A, Johanson G. Injuries due to violent crimes: a study of police reported assaults during 1979, 1982 and 1985 in a police district of a suburb of Stockholm, Sweden. Med Sci Law 1991; 31: 251-248

4 Payne-James J, Dean P. Assault and injury in clinical forensic medical practice. Med Sci Law 1994; 34: 202-234, 206

5 Roberts G, O'Toole B, Lawrence J et al. Domestic violence victims in a hospital emergency department. Med J Aust 1993; 6: 307-310

6 Shroder H M, Petersen K K, Eiskjaer S P et al. Epidemiology of violence in a Danish municipality. Changes in the incidence during the 1980s. Dan Med Bull 1992; 39: 81-83

7 Hedeboe J, Charles A V, Nielsen J et al. Interpersonal violence: patterns in a Danish community. Am J Public Health 1985; 75: 651-653

8 Andersen L J. Waiting list for admission to hospital and interpersonal violence concerns us most of all. Jyllandsposten 1997 Feb 9

9 The extent and character of violence in Denmark. Review of the 1995 Crime Survey (Report) Rigspolitichefen, Copenhagen, 1997: 1-90

10 Criminal offences reported. Crime trends and casualties in road traffic (Report) Rigspolitichefen, Copenhagen, 1997

11 Melhuus K, Sørensen K. Violence 1994 – Oslo Legevakt. Tidsskr Nor Laegeforen 1997; 117: 230-235

12 Steen K, Hunskar S. Violence in Bergen. A one-year prospective survey from Bergen Accident and Emergency Department. Tidsskr Nor Laegeforen 1997; 117: 226-229

13 Shepherd J P, Shapland M, Peace N X et al. Pattern, severity and aetology of injuries in victims of assault. J R Soc Med 1990; 83: 75-78

14 Shepherd J P. Surgical, socio-economic and forensic aspects

An Unreasonable Fear of Death and Dying

Jobs and Roles of a Mortuary Technician

The following is an example of an average working day of a morbid anatomy technician, and is a useful general reference/checklist:

1. All the mortuary refrigerators are to be thoroughly checked, ensuring all details of subjects are entered in the mortuary register. Entries must include name, age and diagnosis. Those bodies for dissection must be weighed and measured, and the relevant details entered in the register.

2. The identity of the body must be carefully checked and the correct documentation must accompany it at all times, along with a signed document granting permission for the autopsy.

3. The dissection tables must be carefully prepared. The pathologist's clothing must be ready and all relevant equipment laid out in an orderly manner. The file containing all those details listed above and the medical history of the patient must be on hand. Blank weight charts should be ready and labelled with the details of the body. The organs are later weighed and recorded here by the technician. Various aspects of the dissection are carried out by the assisting technician; including the removal of the brain, and the weighing of the organs.

4. Upon completion of the dissection, all equipment must be cleaned, sterilized and prepared for the following day. All labels and forms should be checked thoroughly for legibility. A system must be set up for any re-ordering of equipment and chemicals. This is solely the responsibility of the technician. Cremation certificates and certificates of freedom from infection are normally handed out by the technician.

5. The technician will usually be asked to take part in demonstrations to students as well as deal with all visitors to the site, including Medical staff, police officers etc. This re-enforces the need for the mortuary technician to have a broad understanding and training in various areas.

1. Understanding hygiene

The study of all types of infection and a general understanding of micro-organisms is essential. A technician must be constantly aware of the threat various infections have on the living body (hepatitis, tuberculosis). Precautions must be taken to control the spread of any infection: a) tissue samples must always be taken from the corpse, to establish whether any infections are present, and b) a close inspection of the history of the corpse should identify any hereditary illnesses – which could lead to infection.

2. Anatomy and physiology

A&P is a vital part of the early studies of a mortuary technician. Although a general study and knowledge of the whole anatomy is essential, the teachings in this case should lean more towards areas relating to his future work (i.e. skull, brain, spinal cord etc.).

DATE......................................TIME......................ADDRESS.................................
...
NAME...SEX..............................AGE.............................
...
IDENTIFIED BY..
...
OTHERS PRESENT..
AIR TEMP...CONDITIONS......................................

Fig. i – A diagram of the scene shown overleaf. The important details found that need to be recorded, are listed at the top of the diagram. The term 'conditions' refers to weather conditions.

Fig. 3.1 – Adam and Eve (Banished from the Garden).
2210 x 4270 x 1220mm

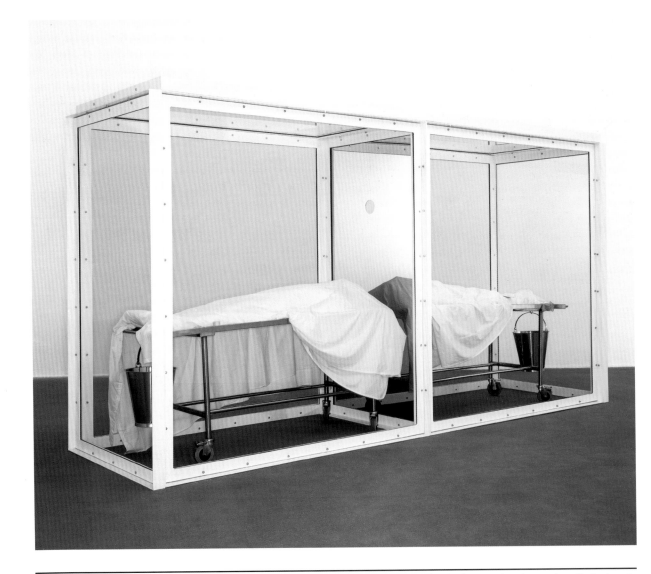

3. The role of an operating microscope in medico-legal practice

Summary This article describes our experience in the use of a binocular surgical microscope at autopsy for the in situ forensic examination of various types of mechanical skin wounds. The microscopic image was visualized on a closed-circuit television monitor, and colour photographs and video recordings were simultaneously obtained from the monitor. With abrasions, small epidermal tags, which play a key role in the determination of external force direction, were clearly observed. With lacerations, crushing of the epidermis was observed at the wound margin, and continuous bridges of connective tissue and/or blood vessels were also found within the wound cavity. With incised wounds, the epidermis was intact up to the wound margin, and there was no continuous bridge within the wound cavity. Using these differences, it was, therefore, simple to distinguish lacerations from incised wounds. Ligature marks due to hanging were clearly observed, with petechial haemorrhages and minute abrasions readily seen in the lesion. For stab wounds caused by a single-edge knife, the morphological difference between the two ends of the wound caused by the sharp blade and the blunt side could be distinguished. It was also possible to confirm the identification of unknown cadavers by observing old wound scars using the operating microscope. Abnormal lesions of the blood vessels, such as a mechanical tear of the vertebral artery (the origin of a subarachnoid haemorrhage) and the atherosclerotic stenosis of the coronary artery, were detectable. In addition, the microscope was useful as a teaching aid to colleagues and medical students to study the nature of the wounds during or after the autopsy. We believe that this system presents advantages in terms of education and training of forensic pathologists and physicians, as well as crime investigation officers.
T. Kondo, T Ohshima

Wound examination is of prime importance in forensic pathology, and forensic pathologists are often asked to give an opinion on how a wound was made and by what means. The nature of the wound can be misinterpreted when the examination consists of only gross observation. It is, therefore, desirable to establish a wound examination procedure in order to detect and record the type and nature of wounds more accurately and objectively. Modern diagnostic instruments, now routinely used in clinical medicine, can also be applied in forensic pathology to supplement gross examination. An operating microscope is now used routinely in many surgical specialities, and this has inspired the authors to use the instrument for forensic wound examination. We believe that wound examination using the operating microscope has the following benefits over simple magnification of wounds:

1. Minute changes of the skin structure, or the wall of the blood vessels, are more clearly detected.
2. The microscopic image can be simultaneously documented on a television monitor installed in a room remote from the examination room.
3. Colour photographs and video-records of the microscopic image are obtained.

We present a description of a wound examination procedure employing a binocular surgical microscope on a variety of wounds, together with a discussion of its potential role

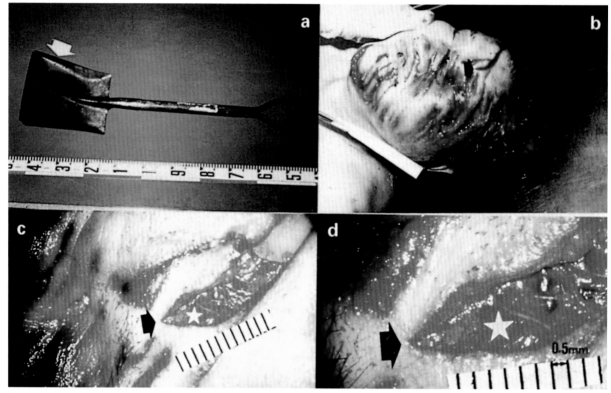

Fig. 3.2 – Laceration. a: The shovel used as the weapon is shown, and the arrow indicates the impact site of the shovel. b: Macroscopic views of the laceration (arrow). c, d: Macroscopic views of the laceration. Crushing of the epidermis is observed (arrows), and continuous bridging of the connective tissue and/or blood vessels is also clearly recognized (stars).

for forensic practice including the examination of living people, and the education and training of forensic pathologists, clinical physicians and police officers.

Materials and methods

Medico-legal autopsy specimens of mechanical skin wounds of known origin, including old healed scars and abnormal blood vessels, were obtained and observed. After macroscopic observation, the specimens were examined in situ using a binocular surgical microscope (TAKAGI Model OM-30U, Japan, magnification x 4.6-27.4) and the microscopic image was also visualized on a closed-circuit television monitor. Colour photographs and video-recordings were obtained from the television monitor at that time. Thereafter, the wound sites were excised and fixed with 10% formalin solution, and then embedded in paraffin for preparation of tissue sections (4–6m in thickness). The sections were stained routinely with hematoxylin–eosin (H–E) and Elastica-van Gieson (EVG) stains.

Abrasion

Epidermal ridges of normal skin were mechanically distorted at the site of blunt force, and a small tag of the epidermis (1.5 x 1.0 mm) was observed at one end of the abrasion. The dermis was directly exposed and bleeding. Histologically, the epidermis was mechanically detached from the dermis, and the papillae of the dermis were flattened.

Laceration

A laceration inflicted by a shovel is shown in Figure 3.2. Disarrangement of the ridge and grooves of the epidermis were observed at the wound margin. A conspicuous continuous bridge of small vessels and/or connective tissue was present within the wound cavity. The H–E-stained sections showed loss or detachment of the epidermis of the wound margin at the site of impact. The bilateral side walls of the wound cavity were irregular in shape.

In EVG- stained sections, curling of the disrupted end of the dermal elastic fibres was observed.

I'm less upset about death now. Some people should die. I mean, I'm not going to make them die, but they are sitting there, they're blind, diabetic, demented, they've got pneumonia, they have a colostomy bag, they've got nothing going for them, they don't understand what's happening to them, they just plead all night and all day to die, and they get a chest infection and you give them a course of antibiotics, and in some ways you feel you're being immoral doing that, but it's not really there for you to judge, it's just for you to help. But when they die I'm positively glad sometimes and it's only humane to feel that really.
Dr Richard Warner – Houseman

Ligature mark

A ligature mark made by hanging with a tie is shown in Figure 3.3. The morphological and qualitative differences between the undamaged skin and the mark were clearly observed when the operating microscope was used. The ligature mark was dry and brownish in colour, and the epidermal ridges and grooves at the site were abnormally distorted and condensed. Petechial haemorrhages and small abrasions were found within the ligature mark. Histologically, the epidermal layer was flattened and condensed and detachment of the keratinized layer was observed. In EVG-stained sections, discontinuous elastic fibres were observed, and curling of the disrupted end was then noted.

Incised wound

An incised wound made with a disposable safety razor with a fine blade is shown in Figure 3.4. Both walls of the wound were very smooth, and neither minute abrasions nor dis-arrangement of the epidermis at the wound margins were noted. Discontinuity of the connective tissue or blood vessels was observed within the wound cavity.

Histo-logically, the side walls of the wound cavity were very smooth, and the epidermal layer was completely intact up to the margin of the wound orifice.

Stab wound

A stab wound inflicted with a single-edge knife showed no continuity of the subcutaneous tissue. The 'cutting edge' end of the stab wound was sharply pointed, and the epidermis was intact up to that end of the wound. Histologically, there was no loss of the epidermis. In contrast, the 'non-cutting edge' of the wound was rounded and showed discontinuity of the epidermis accompanied by small abrasions. Histological examination revealed exfoliation of the epidermis at the wound margin.

Old wound scars

At the autopsy of a headless male cadaver found by the sea, microscopic examination revealed an 8 mm old healed scar, which was not clearly seen by gross examination, on the palmar aspect of the left thumb (Fig.3.5). Detection of this scar helped with cadaver identification (a 27-year-old male who had been reported missing 2 weeks previously).

With a female cadaver found at a lake, a V-shaped wound sutured with four stitches was observed on the lateral surface of the left thigh. Predominantly, as a result of the close observation of the laceration, the cadaver was identified as the body of a 60-year-old female for whom there was a medical record of surgical treatment for the wound.

Abnormal changes of the blood vessels

The body of a 48-year-old male who had been struck on the head with a fist by a 'friend' was examined. The victim had collapsed immediately after the blow and died in hospital from subarachnoid haemorrhage. Macroscopically, it was impossible to locate the origin of the sub-

Fig. 3.3 – Ligature mark. a: A photograph of the tie employed as the ligature. b: Macroscopic view of the ligature mark. c, d: Macroscopic views the ligature mark. Arrows indicate petechial haemorrhage within the ligature mark. One division = 0.5mm.

arachnoid haemorrhage because of abundant blood clot. Binocular microscopic examination, however, revealed a 1.5 mm mechanical tear in the left vertebral artery, which was the site of the haemorrhage. Histologically, there was no pathological lesion such as berry aneurysmal rupture and no severe atherosclerosis.

A 77-year-old male died of acute myocardial infarction. Macroscopically, stenosis of the left coronary artery was observed, and microscopically, the diameter of the intact lumen of the coronary artery was only 2 mm (that of the true lumen was 6 mm). Histological examination revealed severe atherosclerosis of the coronary artery in this case and coagulation necrosis of cells with leucocyte infiltration, showing a recent myocardial infarction.

Discussion

Schmidt & Kallieris reported that radiological examination was very useful in searching for foreign bodies, air embolism, hidden fracture and other internal abnormalities.

Fujikura et al performed post-mortem cerebral angiography to identify the origin of intracerebral haemor-rhage. Amberg et al recently reported that an endoscopic technique was recommended for the inspection of the fundus of the eyes, the external auditory meatus to the tympanic membrane and the naso- and laryngo-pharynx. Holczabeck & Depastas have used the operating microscope in forensic diagnosis and proposed that this procedure is appropriate for routine forensic practice as well as a research tool.

Abrasions are common findings in forensic practice and, in the most restrictive definition within forensic traumatology, are defined as superficial injuries which do not penetrate the full thickness of the epidermal layer. Thus, a true abrasion is not associated with haemorrhage, since blood vessels are confined to the dermis and below. However, due to the corrugated nature of the dermal papillae, in most abrasions, bleeding commonly occurs. Knight has decribed that epidermal tags raised by impact tend to accumulate at the distal end of the wound. In the

Fig. 3.4 – Incised wound. a: The weapon, a disposable safety razor with a fine razor blade, is shown (arrow). b: Macroscopic view of incised wound. c, d: Macroscopic views of the incised wound. Both ends of the wound are sharply cut, and the epidermis is completely intact up to the wound margins (arrows). One division = 0.5 mm.

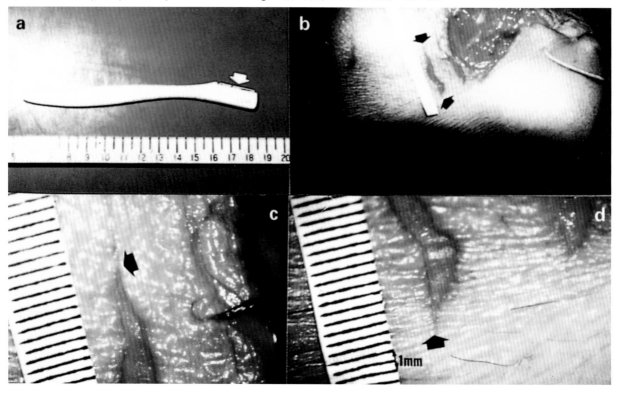

present study, epidermal tags were clearly recognized, and the direction of the external blunt force, applied at the abrasion site, could be determined easily.

Macroscopically, a laceration can occasionally resemble an incised wound. From the view point of forensic pathology, the former is made by the direct impact of a blunt object, and the latter by a sharp weapon. Laceration can, therefore, be distinguished from incised wound (in the absence of a history) by the following details; the presence of bruising and crushing of the wound margins, and continuous tissue strands, including fascial bands, vessels and nerves, in the wound cavity. In our study, the bruising or crushing of the wound margin and tissue strands were observed in the laceration wound cavity. However, with the incised or stab wound, there was neither crushing of the wound edge nor continuity of the connective tissues. Furthermore, the histological sections from lacerations presented loss of the epidermis at the wound margin as well as curling of elastic fibres. Incised wounds, in contrast, presented sharply cut elastic fibres. These findings show that wound examination with the operating microscope may be very useful in distinguishing between lacerations and incised wounds.

Knight states that the ligature mark caused by hanging is referred to as a 'hanging mark'. The hanging mark is frequently dry and brown, while the ligature mark caused by strangulation is likely to be reddish. In the present study, a so-called hanging mark was examined. Petechial haemorrhage, being one of the vital reactions, is often observed within the ligature (hanging) mark. The operating microscope clearly revealed the petechial haemorrhage within the mark.

Stab wounds, as compared to gunshot wounds, are more often seen in homicide cases in Japan, and the single-edge knife is the most commonly employed weapon. There have been a few experimental studies of the dynamics of stab wounds. It is well known that, in a stab wound by a single-edged knife, one end of the stab wound caused by the blade is sharply cut, forming a fine 'V-point', and the

Fig. 3.5 – An 8 mm long old wound scar, which was recognized on the palmar surface of the left thumb of a headless male cadaver.

other, formed by the blunt side, is rounded or even square-shaped, being associated, in fact, with minute abrasions. In addition, the experimental findings reported by Monahan & Harding suggest that it is possible to determine, using a microscope, whether damage to clothing was caused by a single-edge or a double-edge knife. In the present study, the microscopic examination of the stab wound revealed morphological differences between two ends of the wound damaged by the blade and by the blunt side, and the histological findings corresponded well with the microscopic findings.

Personal identification of unknown cadavers with advanced post-mortem changes was possible with the assistance of examination and location of scars using the microscope. In the case of the subarachnoid haemorrhage, the microscopic findings confirmed that the subarachnoid haemorrhage was traumatic in origin. Microscopic observation is also useful in the objective evaluation of the degree of stenosis of the coronary artery.

The examination of wounds in living people is of great relevance in all cases of assault. In rape cases for example, it may be very important to assess whether genital injury of the alleged victim is linked to a sexual assault. Slaughter & Brown examined living rape victims by the use of a

I mean, is there any grand scheme? The answer could very well be no. the original chances that produced a replicating molecule that was capable of making the odd mistake was all we needed, the rest just followed – by chance. It's like an enormous lottery with the chromosomes being the lottery numbers. There are very respectable scientists, for example

people like Fred Hoyle, who would say this is about as likely as a whirlwind blowing through a junkyard and putting together a Boeing 747. And Francis Crick has come to the view that maybe the first replicating molecules came from outer space.
Professor Sir David Weatherall – Molecular Biologist

Fig. 3.6 – Stab wound. a: Macroscopic views of the the stab wound. b: Photograph of the weapon, a single-edged knife (arrow: blade, asterisk: blunt edge). c: The end of the wound caused by the blade appears sharply cut (arrow). d: The end of the wound caused by the blunt edge is somewhat rounded and partially squared off; very minute abrasions are seen around the wound (asterisk). One division = 0.5 mm.

colposcope, and recognized that the ability to detect and document genital injuries by the use of colposcopic photography provided more valuable medical and legal informations than by the gross examination. The authors, therefore, consider that an operating microscope may be also useful in assessing how a wound is made and with which type of weapon in the examination of the living. Our experience in forensic pathology supports the case for consideration of this technique more widely in clinical forensic medical practices.

In our country, it is often emphasized that clinical physicians, as well as forensic pathologists and police officers, should receive training in forensic pathology, since physicians, in the course of their treatment of emergency cases, sometimes inadvertently mask or destroy the very wounds which may later become the focus of a forensic pathological and criminal investigation. A wound examination using an operating microscope has several benefits over simple magnification of a wound. In particular, the microscopic image can be directly documented on the television monitor installed in another room, meaning that colleagues and medical students can also observe and study the nature of various wounds or lesions at the microscopic level during examinations. In addition, the results of the wound examination recorded on video tape can be reproduced repeatedly even after the examination. Thus, such a system offers clear advantages in the instruction and training of all personnel who may be required to assess and give an opinion in the type and nature of a wound.

The authors consider that specific research should be undertaken in the examination of other wounds (for example a gun shot wound), to make the system more comprehensive. We are attempting to develop a quantitative analysis system of the degree of haemorrhage or changes of the skin surface structure through computed microscopic image processing.

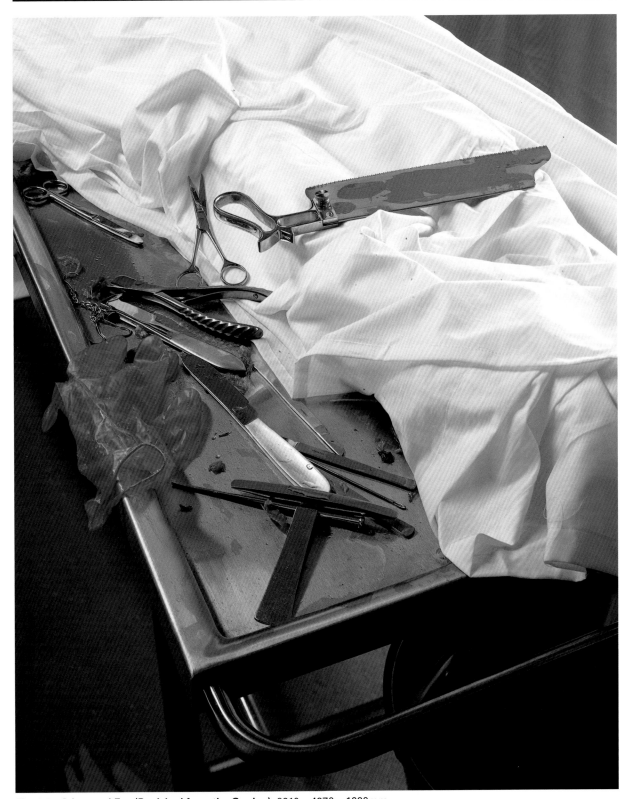

Fig. 3.7 – Adam and Eve (Banished from the Garden). 2210 x 4270 x 1220mm

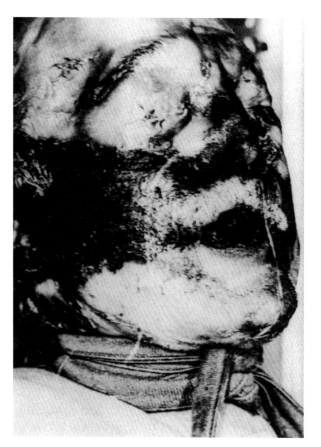 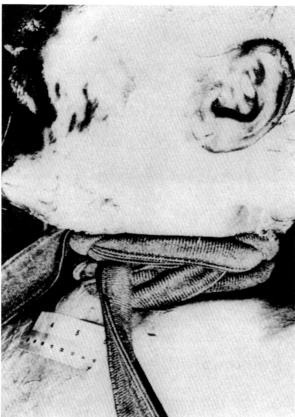

Figs. 4.1 – Anterolateral profiles of the neck to show the mode of application of a ribbed dressing gown belt used as a ligature and tied in a simple knot at the front.

4. Examination and significance of 'tied up' dead bodies

Summary Examination of dead bodies found with parts of the body tied or bound can pose a real problem for the investigators in that it may not be possible to differentiate between suicide, homicide or accidental death. This article reports five such cases.

M. A. Elfawal, M. H. M. Higazi

Committing suicide with the hands tied or bound together is uncommon, but there are many reported cases of accidental death as a result of auto-erotic activity where the hands and/or other parts of the body are tied or bound. In both situations, initial examination of the scene can give rise to suspicion of homicide, particularly if the hands are tied and the head or the face is covered. This paper reports five such cases in which the body was tied or bound up. In one case, a conclusion of suicide was clear. In two cases, suicidal death was the most likely conclusion, although accidental death could not be ruled out. In the other two cases, it was difficult to confirm whether the death was a homicide or an accident.

Case 1

A 23-year-old Indonesian housemaid spent an unusually long time in the bathroom on the day of the incident. The wife of the household became suspicious and called her husband. He broke open the door and found the girl apparently dead inside the bath tub. There was a ligature (head scarf) around her neck and attached to the shower unit that had been dislodged from the wall. Her two hands were loosely bound together by a cotton cloth, presumably prior to placing her neck inside the noose, which she had fixed earlier to the shower unit (Fig.4.2). The cloth was wrapped three times around her left wrist and then tied

before it was turned twice around the right wrist. The remaining free end of the cloth was turned several times around the part binding the two wrists in a complex manner forming a loose knot and then inserted between

Fig. 4.2 – The body of a young female inside a bath tub with hands tied, prior to suspension to the shower unit.

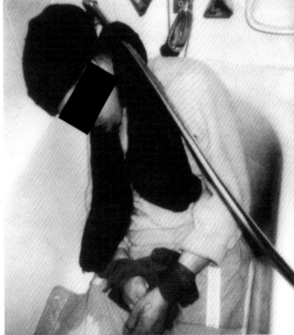

the cloth parts wrapped around the right wrist. The girl had spent about 2 months in Saudi Arabia and was working abroad for the first time in her life. According to witnesses (her employer and his wife), she was exceptionally quiet and was missing her family a great deal. Examination of the body did not reveal any external injury, apart from faint marks caused by the ligature around her neck and wrists. No petechial haemorrhages were present in the face, eyes or elsewhere. Dissection of the neck showed small areas of bruises within the subcutaneous tissues and muscle directly beneath and around the ligature. No injury of the thyroid cartilage, hyoid bone or cervical vertebrae was detected.

Case 2

A 35-year-old male Saudi Arabian was found dead inside a water tank within an old empty house, which was located very near to his home. The body was completely naked. Clothes containing personal identification papers and money were found beside the tank. A thin black cloth was turned around the neck and tied twice in a loose manner. The two long free ends of the cloth were passed down the front of the abdomen to both legs and tied firmly around the upper part of each leg. Both hands were free. The deceased was known to be suffering from depression. He had recently been married and had domestic troubles with, according to witnesses, marital sexual problems. External examination of the body showed slight abrasions over the anterior left shoulder region, the front of the left knee, in addition to pressure marks caused by the described complex ligature around the neck, front of the chest and both thighs and legs. Autopsy findings were consistent with drowning and revealed congestion of the air passages, lungs filled with frothy fluid and the presence of turbid water inside the stomach. Toxicological analysis was negative.

Case 3

The body of a 30-year-old single male, who shared a flat with other single males, was found in a state of advanced postmortem decomposition inside his bedroom. His head was covered with a plastic bag, which was held tight around the neck by a thick rubber band (Fig.4.4). Both wrists were tied from behind by means of a thick cotton scarf; the left wrist was tied firmly by one knot and the right wrist by a rather simple one (Fig.4.5). The body was fully clothed.

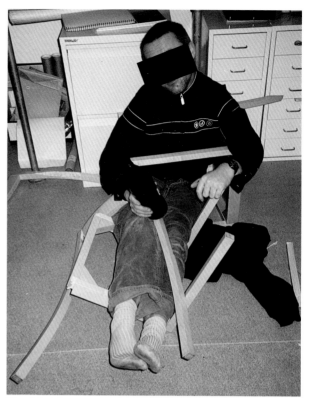

Fig. 4.3 – The scene of a homicide. Forensic photography provides a vital record of the position of the body before its removal for formal autopsy. The items surrounding the corpse may or may not have played some part in the crime.

His flatmates became suspicious after they noticed a foul smell coming from his room. The door was closed by unlocked. All windows were closed and the air conditioner and lights were on. No disturbance of the furniture was noticed. In his room, there was a cushion which had a small hole in its middle and was soiled by dry stains, which were proven later to be seminal in nature. It was thought that the cushion was used by the deceased for masturbatory activities. Death was thought to have occurred about 2–3 days before the time of examination. Postmortem examination of the body did not show significant changes, due to the advanced body decomposition. Toxicological investigations were negative.

Case 4

A 34-year-old Bangladeshi male who used to work as a company security guard was found dead inside the company building by workmates upon their arrival for work

one morning. The body was fully clothed. Both wrists were tied behind the victim's back and the legs were also firmly tied together. In addition, a hand towel was turned around the face several times and part of its terminal end was introduced into the mouth, although the nostrils were not covered up (Figs 4.9 & 4.10). The body was found in the prone position. The company safe had been broken into. External examination of the body showed classic signs of asphyxia, in the form of deep cyanosis of the face, petechial haemorrhages in the conjunctivae, face, neck and upper chest. Deep hypostasis was noticed in the frontal regions of the body. In addition, small bruises were found around the mouth and nostrils. Apart from pressure marks caused by the ligatures, no injury was detected around the wrists or other parts of the body. Postmortem examination showed congestion of the upper air passages. The lungs were severely congested, the surface containing multiple petechial haemorrhages. The neck structures did not show injuries or haemorrhages. Other organs were unremarkable.

Case 5

A Saudi Arabian male of about 70 years of age was found dead inside his house after his neighbours detected a foul smell coming from his house. The body was found to be bound extensively by two different kinds of cables (Figs 4.11 & 4.12). Both hands were tied together as well as the neck to the upper abdomen and the rest of the trunk. The hands were tied once more by the second cable to render ligation very tight. The legs were also tied together in the same manner, i.e. with the two types of cables. The cables

> There are times when I don't understand why people have to suffer quite so much. I just trust that it is going to be all right somewhere.
> **Dr Gillian McCarthy – Neuropaediatrician**

were attached to different parts of furniture located in different sites of the room, to ensure restriction of the victim's movement. The total length of both cables was around 70 metres. A hand towel was placed over the face, but was not tied. The body was lying in the supine position, fully clothed and was in a state of very advanced postmortem decomposition and deeply discoloured. The deceased lived alone and had a personal driver, an Indian who used to live in the same house. Postmortem examination of the body did not reveal significant findings because of the advanced soft tissue decomposition. However, no fractures were detected within the skeletal system. The postmortem interval was estimated at between 5–7 days.

Discussion

Dead bodies found with the hands or other parts of the body tied and bound inevitably raise suspicion about causation. Binding the wrists is generally an indicator of homicide, but it may also be seen in auto-erotic deaths as well as in some suicides. Inquiry into the circumstances of death, examination of the scene and the dead body, both externally and by thorough postmortem dissection, in addition to performing toxicological analysis, usually indicates the cause and manner of death. Omitting any of these investigations, particularly those of examination of the

Fig. 4.4 – The head is covered by a thick plastic bag held tight around the neck by a thick rubber band.

Fig. 4.5 – Both wrists are bound together behind the back by a cotton scarf.

Fig. 4.6 – Pathophysiological changes post mortem over time. Fig. a. Drop in core temperature. Fig. b. Onset and loss of rigor mortis. Fig. c. Onset of putrefaction.

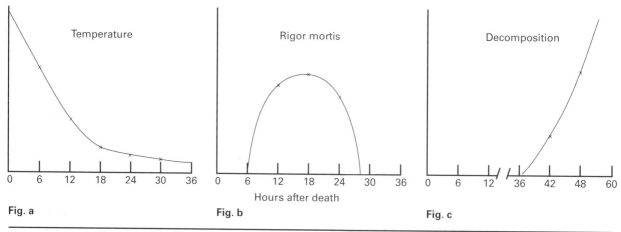

Fig. a

Fig. b

Fig. c

Figs. 4.7 – 4.8 – Concentrating on a Self-Portait as a Pharmacist. 2440 x 3050 x 2740mm

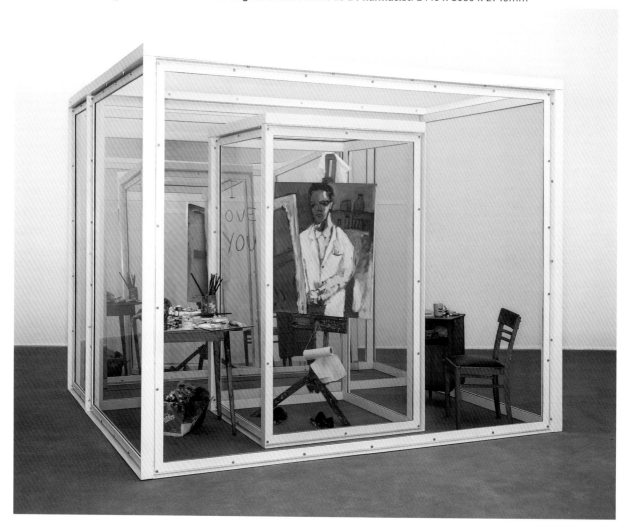

scene and toxicology, may well result in mistaken diagnosis of the cause and/or the manner of death. However, it is not always possible to ascertain the manner of death. It is not unusual to examine suicide cases masquerading as homicide and vice versa. Further, fabrication of circumstances surrounding fatal events is not uncommon. Suicides may be made to simulate homicide or accident and homicides may be disguised as suicides or accidents. At the same time, there are reports of accidental deaths, commonly involving auto-erotic activities, disguised as suicides. In certain conditions, the death scene features are subtle and the victim's motivation is unclear. In such circumstances, it may not be possible to exclude homicide or to differentiate completely between accidental and suicidal death.

In the first case reported here, all circumstances and autopsy findings pointed to suicide. The only injuries seen at postmortem examination were due to the ligature around the neck. Full toxicological examination was negative. The recent history of employment abroad and mental depression because of homesickness – a strong suicidal motive among the Asian population working in Gulf countries. It is suggested that the wrists were tied in order to prevent hand movement, in case the victim were to attempt to rescue herself at the last moment. There was no question of auto-erotic activity in this case; the victim was female, completely clothed and there was no sign of sexual stimulation or history of previous similar practice. The cause of death, therefore, was given as 'suicidal hanging'.

Adversely, the second case demonstrates many of the features commonly associated with sexual asphyxia. The victim was a young male, found completely nude, the activity took place in private, and although the upper limbs were free, ligatures were used to restrain the lower limbs (bondage). There are reported cases of auto-erotic death by unusual means including immersion. However, other features of auto-erotic activity were missing, such as pornographic literature or erotic objects, evidence of recent ejac-

Fig. 4.8

ulation and the padding of ligatures or use of webbing. The cause of death in this case was given as 'drowning' and the manner of death thought to be suicidal. However, the possibility of accidental auto-erotic death could not be excluded.

Many cases have been reported where death was due to suffocation by a plastic bag. Such asphyxial deaths are most commonly classified as accident or suicide and less frequently as homicide. It is claimed that older individuals tend to commit suicide by this type of asphyxial death more often than younger victims, who usually die during auto-erotic episodes. In the third reported case, in spite of the presence of seminal stains at the scene and the evidence of previous auto-erotic activities, it was not possible to confirm that recent ejaculation had taken place prior to death. The body was fully clothed and no seminal stains were detected around the genitalia or within the underpants. It is suggested that the sequence of events were as follows: the victim had tied his left wrist, then prearranged a loose ligature for the right wrist. He placed the plastic bag over his head and a rubber band was secured around it at the neck. The right hand was introduced through the pre-arranged ligature, which was tightened

The least enjoyable bits about the job are, in a word, shit. Because a lot of my patients have bowel disorders, you have to do examinations of their rectum, and I don't think anyone really takes a liking for faeces. And sometimes they may be passing lots of blood in their stools, or fat, they may pass black stools or white stools, or red stools. There's a general aversion to faeces even amongst the medical profession because it's horrible, unpleasant stuff to work with. Urine is bad enough. Most people like to work with blood because blood is nice and clean and you can centrifuge it and measure various chemicals in it. ...But the study of faeces is nothing like as advanced as the study of blood. Very few patients like collecting their faeces; we are trained from a very early age to get rid of it cleanly and decently, not to play with it, and this sort of indoctrination lasts for the rest of our lives.
Dr John Hunter – Gastroenterologist

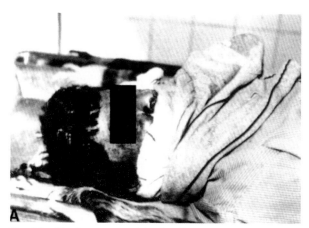

Fig. 4.9 – The lower part of the face is covered by a piece of cloth.

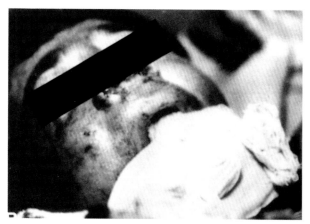

Fig. 4.10 – Part of the cotton cloth used for tying both wrists is seen inserted into the mouth.

over the right wrist. Both legs were passed forward over the bound wrists. The presence of the thick rubber band around the bag coupled with an absence of evidence supporting auto-erotic activity favoured a deduction of suicide as the most likely manner of death.

In cases 4 and 5, and unlike the first three reported cases, other person(s) had clearly been involved in the death. In the fourth case, all the circumstances pointed to a burglary and it was obvious that other individual(s) had tied the victim's wrists from behind, as well as his legs. The face was also covered by a hand towel, presumably to prevent the victim from screaming and not to suffocate him since his nostrils were not covered by the towel. It was not possible to confirm whether the assailant(s) had placed the body in the prone position. It was not possible to confirm whether death was due to obstruction of the external air orifices in that position, or by choking through the part of the towel found inside the victim's mouth. There are reports of deaths by choking in similar circumstances, where an object was thrust into the mouth, in attempt to silence the victim at the time of burglary and, unfortunately, caused the death. No one was arrested in connection with this incident. The cause of death was given as 'choking' probably as a result of manslaughter rather than intentional murder.

In the fifth case, police investigation revealed that the deceased was the sponsor for his Indian driver, who also lived in the same house. They both had planned to travel to India (presumably the same date of the incident), but the driver left the country alone to travel to India. It would appear that before leaving the driver tied the victim up very firmly by means of the two kinds of ligatures, in order to secure his immobilization so that he (the driver) could leave the country safely. As in case 4, a hand towel was placed over his face, but there was no possibility of choking. Because of the advanced postmortem decomposition, it was not possible to determine the exact cause of death. The victim could have died because of obstruction of external air orifices or, alternatively, because of starvation and dehydration.

Conclusion

Examination of dead bodies with parts tied or bound poses a real problem to the forensic pathologist. In such circumstances, it may not be possible to exclude homicide, or to differentiate between suicide and accidental auto-erotic death. A careful initial examination of the scene and investigation of the surrounding circumstances, including

I'm pretty well totally atheist and I think I always have been; certainly nothing has happened to me in the last few years has changed that. So many people die despite what you do, and I think we try and postpone death far too long. I increasingly have come to the view that when people genuinely say, 'If I get to be a cabbage, I would like to be helped to die',

I really do feel we've got to tackle that. It's the sort of thing you wouldn't let happen to a dog. It really should apply to humans; the load on caring relatives looking after terminally ill people is frightful. And on the whole I see death as being for a lot of people a tremendous release actually.
Dr Geoffrey Mair – General Practitioner

psychological history of the deceased, is essential. Autopsy examination of the body and toxicological analysis will provide useful information to determine the exact cause and manner of death. However, in a number of cases, it may not be possible to confirm the cause of death, or to describe the exact manner of death.

References

1. Goonetilleke U K D A. Two unusual cases of suicide by hanging. Forensic Sci Int 1984; 26: 247-253.

2. Thibault R, Spencer J D, Bishop J W, Hibler N S. An unusual autoerotic death: asphyxia with an abdominal ligature. J Forensic Sci 1984; 29: 679-684.

3. Blanchard R, Hucker S J. Age, transvestism, bondage and concurrent paraphilic activities in 117 fatal cases of autoerotic asphyxia, British Journal of Psychiatry 1991; 159: 371-377.

4. Byard R W. Autoerotic death − characteristic features and diagnostic difficulties. Journal of Clinical Forensic Medicine 1994; 1: 71-78.

5. Marsh T O, Burkhardt R P, Swinehart J W. Self-inflicted hanging with bound wrists and a gag. Am J Forensic Med Pathol 1982; 3: 367-369.

6. Hiss J, Kahana T. Fabricated homicide in Israel in light of the Intifada. Journal of Clinical Forensic Medicine 1995; 2: 189-194.

7. Polson C J, Gee D J. Injuries: general features. In: Polson C J, Gee D J, Knight B (eds) The Essentials of Forensic Medicine. 4 edn. Oxford: Pergamon Press, 1985; 137.

8. Vanezis P. Pathology of neck injury. London: Butterworths, 1989; 78-79

9. Adams V I, Hirsch C S. Trauma and disease. In: Spitz W U (ed.) Spitz and Fisher's Medicolegal Investigation of Death. 3rd edn. Springfield, Illinois: Charles C Thomas, 1993: 196-198

10. Smith S. Forensic Medicine. 8th ed. London: J&A Churchill, 1943: 169-193

11. Adelson L. The Pathology of Homicide. Springfield, Illinois: Charles C Thomas, 1974; 316-317

12. Di Maio V J M. Gunshot Wounds. Boca Raton: CRC Press, 1993; 293-302

13. Leth P, Westerby A. Homicidal hanging masquerading as suicide. Forensic Sci Int 1997; 85: 65-71

14. Henry R I F. Suicide by proxy: a case report of juvenile autoerotic sexual asphyxia disguised as suicide. A common occurrence? Journal of Clinical Forensic Medicine 1996; 3: 55-56

15. Gowitt G T, Hanzlick R L. Atypical autoerotic deaths. Am J Forensic Med Pathol 1992; 12: 115-119

16. Martinez A L P, Chui P, Cameron J M. Plastic bag suffocation. Med Sci Law 1993; 33:71-75

17. Haddix T L, Harruff R C, Reay D T, Haglund W D. Asphyxial suicides using plastic bags. Am J Forensic Med Pathol 1996; 17: 308-311

18. Kurihara K, Kuroda N, Murai T, Shinozoka T, Yanagida J, Matsuo Y, Nakamura T. Homicidal choking mistaken for suicide. Med Sci Law 1992; 32: 65-67

Fig. 4.11 – The body is extensively bound by two different kinds of cables (photographed at the mortuary).

Fig. 4.12 – The body at the scene of the incident, found fastened to different items of the room furniture.

Fig. 5.1 – Death is Irrelevant. 914 x 2743 x 2133mm

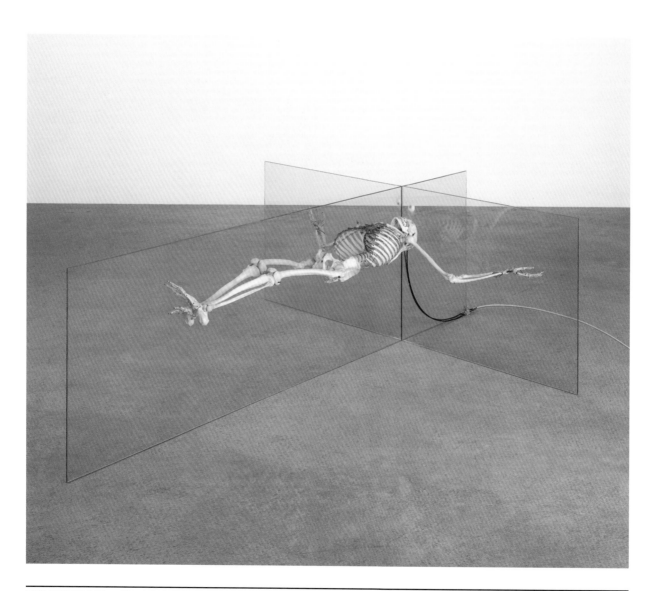

5. Identification of human remains: forensic radiology

Summary The identification of human remains is of paramount importance in medico-legal investigations. The comparison of antemortem and postmortem radiographic records is one of the main techniques used to achieve a positive identification. The purpose of this paper is to present a comprehensive review of the use of roentgenography in forensic medicine, with special emphasis on the nature of the radiographic markers often utilized for identification. Clinical radiologists should be aware of the importance of storing radiographs over prolonged periods of time and of efficient record keeping methods to enable prompt retrieval of X-ray films in mass disaster situations. Furthermore, because of their skills in radiographic evaluation, the radiologist's expertise might prove invaluable in forensic consultations.

T. Kahana, J. Hiss

The identification of human remains is one of the most essential aspects of forensic medicine. Beyond the humanitarian considerations of such a task, identification is essential for the completion and certification of official documents such as death certificates, probates of wills and disbursements of benefits and insurance.[1] Scientific identification of human remains might be accomplished by fingerprint, dental, anthropological, genetic or radiological examinations.[2] There may be variations in the state of preservation of human remains due to factors such as normal chemical processes affecting the cadaver, the mechanism of death or animal scavenging. The skeleton usually survives both natural and unnatural processes and therefore can nearly always be examined radiographically. Similarly, radiographs obtained for clinical purposes always include skeletal features. Therefore, it is commonly possible to obtain antemortem and postmortem radiographs for identification.

The use of radiographs in routine and mass disaster identification has long been in effect and its application in necroidentification is effective, swift and relatively easy. Antemortem and postmortem radiographic comparison is a common procedure in the identification of unknown human remains in forensic facilities throughout the world.[3]

We present here a review of the use of radiography for identification purposes and its versatility within forensic medicine.

Radiological identification was first reported in 1926 by Culbert and Law,[4] who stated that, by comparing the morphology of sinuses and mastoid air cells in antemortem and postmortem radiographs, they could establish positive identification. The reliability of identifications based on the comparison of cranial and postcranial radiographs is well established.[5, 6] Forensic investigators and radiologists concur that 'many parts of the human skeleton can serve as bony prints for the identification of human remains, and in certain respects bones have an uniqueness similar to that of fingerprints.'[7]

Today, radiographs are a common diagnostic tool, widely used in dental practices, hospitals and health services throughout the world. Storage facilities exist in most health institutions to keep radiographs over long periods of time. Computerized record keeping, available in most hospitals, expedites the retrieval of individual X-ray films, making radiographic comparison one of the most

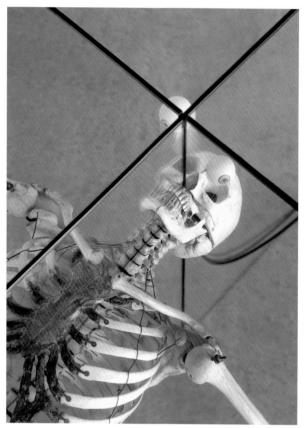

Fig. 5.2 – Death is Irrelevant. (detail) 914 x 2743 x 2133mm

identification value: on the one hand the feature has to be unique to the individual and on the other hand it has to remain stable over time despite ongoing life processes.[10]

Radiographic identification techniques

Radiographic identification can be accomplished when there is a lead as to the possible identity of the victim, usually this is the result of comparing an anthropological profile (gender, age, stature and ethnic affinity) with police or military missing persons reports.

The correct radiographic identification of the deceased depends greatly on the similarity of the antemortem and postmortem radiographic films. Positioning and exposure of the radiographs for comparison is important, since the forensic expert ideally strives to duplicate as closely as possible the antemortem angulation, beam centring and depiction.[9] Computerized simulation using a CT scanner has been proposed for reproduction of antemortem X-ray images. [6] This method can accurately reproduce the focus –object distance, object–film distance, brightness and contrast of the image, although most modern forensic facilities in the world do not yet own such sophisticated equipment. Radiation exposure time can be judged by trial and error. For instance, skeletonized remains should receive approximately one-half of the standard exposures.[9]

common techniques used by forensic anthropologists in order to establish positive identification of unknown remains.[7,8] In fact, it has been reported that some 72% of the identifications in modern forensic science are obtained by comparing antemortem and postmortem radiographs.[2]

Although all regions of the body have been reported to be of use in positive identification, radiographs of the skull, dental, chest and abdominal areas are the most frequently used.[2] This is probably because the individuality and uniqueness of the features in these areas have been tested in the past. Positive radiographic identification is accomplished by meticulous comparison of the details present in the radiographs. However, there is no minimum number of points of comparison that must be present to determine identity. Usually one to four unique concordant features and no discrepancies are considered enough evidence for positive identification.[9]

Morphological features depicted on radiographs must comply with two requirements in order to be of forensic

Fig. 5.3 – The facial and cranial skeleton is unique to every person. If antemortem radiographs can be obtained for the person likely to be the victim, matching on the frontal sinus pattern can provide absolute identification.

The effect of the radiographic conditions on the reliability of the identification has been tested in a number of investigations.[2] The results show that considerable variance in projection and film quality do not preclude the correct identification. Furthermore, the correlation between radiographs of the same bone taken under different radiographic conditions was considerably higher ($r = 0.60-0.90$) than the correlation between the radiographs of different bones taken under the same conditions ($r = 0.0-0.40$).[10]

Use of cranial radiographs in positive identification

Radiographs of the head are an important source of antemortem information. They provide an objective record of anatomical structures, as well as evidence of pathological conditions, previous trauma and surgery. Specifically, cranial and facial structures visible in the various types of extraoral radiographs commonly used today, may provide numerous features for comparison with appropriate postmortem X-rays of these same structures. The most frequent bone markers compared in cranial roentgenograms include gross anatomic structures such as maxillary and frontal sinuses,[4, 7, 11] normal anatomic variations,[12, 13] and dental restorations, [2, 14] as well as trabecular architecture.[15]

The individual variations of size and configuration of the frontal and sphenoid sinuses, as well as the mastoid air cells, were first noted by Schuller in 1921 and their uniqueness was tested in ensuing years.[16] The reliability of comparing antemortem and postmortem radiographic depictions of the frontal sinus was tested by Kullman et al[17] based on a double blind test, where three independent observers successfully matched 99 pairs of cranial radiographs.

Radiographically apparent vascular grooves in the inner table and diploe of the skull, which represent arterial and venous channels, can also be used for forensic purposes. In a retrospective study conducted by Messmer and Fierro in 1986 [12] it was observed that the vascular groove patterns undergo little significant changes with growth and development, except for minimal symmetrical increases in size reflecting modest growth in the cranium during life. Although deepening of the middle meningeal artery and venous plexus into the inner table, common in the elderly, has been proposed for estimating age in older individuals, the vascular groove patterns remain constant throughout life and can be used as a marker for positive identification.[13]

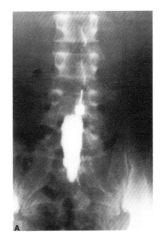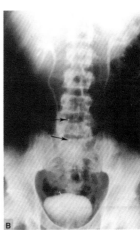

Fig. 5.4 – Left: Radiograph during myelography. Right: Antemortem: residual contrast medium following myelography, seen during intravenous phielography.

Similarly, the ectocranial suture pattern, which begins to fuse in the fourth decade of life, has also been proposed as a highly individual and reliable marker for positive identification.

The teeth are the most durable of the human tissues, and the materials used in dental restoration are also extremely resistant to destruction by chemical and physical elements. The innumerable combinations of missing teeth, carious lesions, restorations and prostheses involving the 100 surfaces of the deciduous dentition and 160 of the adult dentition, along with anatomical variations of teeth and jaws, form the basis for dental identification.[14]

Panoramic radiographs, which enable visualization of most structures of the jaws and related areas on singles film and have a high reliability factor, have been advocated for mass screening, such as screening of military personnel. In fact, since 1973, the Israeli Defence Forces have routinely taken panoramic radiographs and dental charting, along with 10-finger dactiloscopic records, as part of the enrolment procedure for their identification database.[14]

Use of postcranial radiographs for positive identification

One of the earliest large studies on individual variations in appendicular bone markers was conducted in 1960 by Greulich. In this investigation, 70 pairs of hand radiographs of same-sexed twins were compared. Structural features of

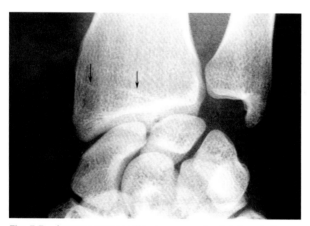

Fig. 5.5 – Antemortem: radiopaque area in distal end of radius, following a green stick fracture.

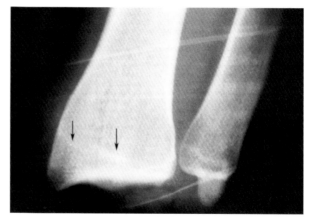

Fig. 5.6 – Postmortem: similar radiopaque area in forearm stump of the cadaver.

the 27 bones of the hand and the distal ends of the radius and ulna were found to be different in all sets of twins. More recently, the morphology of the lateral border of the scapula was examined in a similar test using a larger sample ($n = 200$), and the feature was reported to be a good individualizing trait.

In postcranial radiographs of the axial and appendicular skeleton, the forensic anthropologist often uses normal anatomic variation including the following: vertebral body shape and configuration of the transverse and spinous processes of the vertebrae, the size and shape of the ribs and their relationship to another, the shape and length of the xyphoid process, the trabecular and vascular grooves of the innominate bones and of hands and feet. Similarly, general degenerative changes such as osteophytic lipping and vertebral body crushing, costal cartilage calcifications, disk herniations, bony bridges between vertebrae and bony spiculae on the innominate, evidence of healed trauma and medical intervention are used as individualizing markers.

The forensic reliability of postcranial radiographic features, that is the uniqueness and stability over time (as much as two decades), has been established in several pilot studies.

An illustrative case is the identification of a cadaver found floating in the Colorado River. The body was that of a caucasian male, 20–30-years-old, of medium build and an estimated stature of 175 cm, who had been shot with shotgun, had been stabbed 57 times in the chest, had been beheaded and had had his hands amputated. The head and hands were never recovered.

Based on the preliminary anthropological profile, the County Police suggested a possible match with a missing

individual. The identification procedure was hindered by the lack of crucial postmortem data such as fingerprints or dental information.

The medical records of the missing individual included two X-rays of the upper and lower extremity. On the right hand radiograph a small radiopaque area in the distal end of the radius could be observed, consistent with a thickening of the trabeculae, possibly due to a green stick fracture.

Postmortem radiographs of the right forearm stump of the victim showed a similar radiopaque feature, in the same location and of the same size as the antemortem radiograph (Figs 5.4 & 5.5). Based on the anthropological and radiological data the victim was positively identified.

Radiographic identification in mass disasters

In reviewing the experience from mass disasters, it is apparent that in most countries major emphasis is placed on forensic odontology for identification purposes. In an analysis of ten mass disasters in which British forensic odontologists undertook the identification procedures an average 55% of the cadavers were identified using a variety of dental comparisons. However, in one instance (Thai International Airline Bus crash) only 6.24% of the victims could be identified by dental radiographic comparison. A number of difficulties associated with this method of identification were consistently encountered.

Some of the problems that forensic odontologists have faced for decades include the failure of dental practitioners throughout the world to maintain comprehensive records

The spine consists of a pile of vertebrae, one on top of each other, lying on top of the tail bone. And the tail bone is tilted so there's a wedge between the back of the tail bone, the sacrum, and the lowest, or the fifth lumbar vertebra, and the disc which lies between the two is the most subject to wear. So that does appear to be a design fault, perhaps associated with the upright posture. There's not much you can do about it, but it's a problem.

I think the spine is a fantastic structure. With all the wonders of modern engineering, you could not design a spine artificially with those constraints.

Professor Malcolm Jayson – Rheumatologist

and the prevalence of errors in dental charts, which has been reported to be as high as 45% in a sample of 50 records. Furthermore, there are many individuals who have never received dental treatment, meaning that no antemortem records would be available.

In mass disasters, such as public transportation accidents, terrorist bombings, military actions or the collapse of architectural structures, reliance on more than one identification technique for each cadaver is essential in order to preclude errors.

One of the most difficult tasks in these situations is the identification of individuals who have been completely dismembered as a result of the disaster. For instance, on July 18th 1994 an explosion cuased by a car-bomb, levelled the seven storey building of the Jewish Argentine Mutual Association Centre (AMIA) in Buenos Aires, Argentina, wounding 104 and killing 85 individuals. Following an exhaustive 10-day investigation, conducted by a joint Argentinian and Israeli team, all but seven victims from the missing persons list were identified. The team assumed that these seven individuals were possibly completely dismembered, unrecovered by the rescue teams or missing for reasons unrelated to the AMIA disaster.

A total of 323 body fragments were recovered at the site and catalogued, photographed and X-rayed for identification purposes. Among these remains were the radio-

Fig. 5.7 – Left: Antemortem radiograph of thoracic and lumbar spine showing age related metamorphological features. Right: Radiograph of torso found within the rubble of the 'AIMA' disatster, showing similar charecteristics.

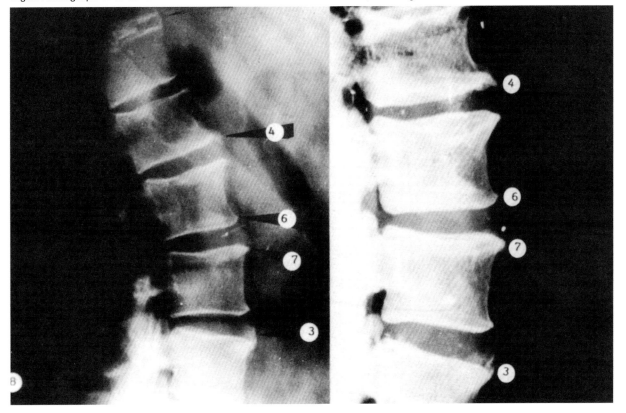

Almost everything that our bodies do is done in a similar way by some other creature, and there are very few ways in which man is unique. Our brain is very highly developed, but everything else about our nervous system, our vision, perception, our learning capacities, all of them can be matched at least by Monkeys, and to a large extent by very much simpler organisms, like an octopus, which has terribly good vision and can learn very efficiently.

Professor Colin Blakemore – Physiologist

graphs of a decomposed, fragmented, female torso. They were compared to antemortem vertebral column radiographs from the missing persons files. One particular set of X-rays of a 71-year-old woman showed good correspondence with the postmortem torso plate. Several radiographic features were present in both the antemortem and the postmortem plates, such as calcification of ligaments and of intervertebral disks, osteophytes and spur formations of the same shape, size and location (Fig.5.6). Based on the radiographic comparison, the torso recovered at the scene was positively identified as belonging to one of the missing persons.

In most mass disasters, 90% of identifications are accomplished either by fingerprint or dental comparison, although in some countries antemortem fingerprints are not available for the majority of the civilian population. In these cases,

Figs. 5.8 – 5.9 – Something Solid Beneath the Surface of Several Things Wise and Wonderful. 2060 x 3760 x 1220mm

identification is accomplished by a combination of the description of personal effects and individualizing medical findings. In June of 1995 the 'Angin Madras', a Korean ship, collided in the South China Sea with the 'Mineral Dampier', a Belgian cargo ship. The 'Mineral Dampier' sank immediately, causing the 27 crew members to drown. The Israeli government sent a marine rescue team to locate and recover the bodies of the sailors in order to bring nine Israeli crew members to burial in Israel.

After four sessions of diving to a depth of 60 metres over a 2-year period, six of the nine Israeli seamen were recovered in various stages of decomposition. The first three bodies were identified by means of fingerprint and dental comparisons. The following two, which were in a more advanced state of decomposition, were identified by dental means only, while the last one was identified by comparing antemortem and postmortem chest radiographs of the sternum.

Similar eversion of the xyphoid process was observed on both the antemortem and postmortem lateral chest plates, positively identifying the remains.

In 18 suicidal terrorist bombings that have occurred in Israel over the last 2 years the identification team has been faced with extremely fragmentary human remains produced by the close proximity of the victims to the epicentre of the explosion. A variety of identification techniques was applied in each case, depending on the availability of antemortem data and of postmortem findings. Similar conditions occur during military actions where identification is complicated by large numbers of unidentified victims, possibly in mass graves, the absence of antemortem medical and dental records and the lack of the means to carry out sophisticated methods of identification.

Conclusion

The use of radiographs for identification of human remains is common in mass disasters as well as in daily forensic practice all over the world.[3] The potential value of comparison between antemortem and postmortem radiographs

Male – Femur
Bone length coefficient
(f x 2.4) + k (cm)*

Female – Femur
Bone length coefficient
(f x 2.3) + k (female)*

Male – Humerus and Radius
coefficient
(h x 1.4) + (t x 1.1) + k (cm)*

Female – Tibia and Radius
coefficient
(t x 2.5 + r x 3.9) + k (cm)*

Fig 5.10 – Living height estimation from skeletal remains.
*Where the constant 'k' to be added to the coefficient
changes with type of bone.

in forensic medicine is nowadays fully appreciated, although more extensive research into the uniqueness and stability of the features used for identification is necessary.

The availability of medical and dental radiographs and the high reliability of the markers depicted on X-rays make this technique extremely useful. In fact, some 72% of forensic cases in which the identity of the deceased is unknown are resolved by means of radiographic comparisons.[2]

Careful record keeping in medical facilities and private practices, retained for as long as it is feasible, is extremely important. In most countries, radiographs pertaining to the inactive files of patients are stored for at least 5 years. In the USA, medical records are usually retained until the statute of limitations for acts of medical malpractice has run. This guideline may require a paediatrician to keep the record for up to 6 years after the age of majority. In Israel, because of the multiplicity of mutilated victims from terrorist attacks and military actions, the National Institute of Forensic Medicine has recommended the extension of the present ministerial instruction of medical record keeping from 5 to 20 years. This measure would require saving the information on magnetic media.

The effectiveness and usefulness of any identification technique greatly depends on the rapidity with which the antemortem data can be obtained. The authors' experience from practising in the US, the UK and Israel has shown that, on average, 10% of the medico-legal cases are unidentified remains. Of these, some 80% are identified by radiographic means. Radiologists should be aware of this alternative use for diagnostic roentgenograms. Because of their training in the evaluation of radiographic studies of normal anatomy, its variants and the effect of pathological conditions or surgical interventions on them, the radiologist's expertise might prove invalluable in consultations of a medico-legal nature.

References

1. Fierro MF. Identification of human remains. In: Spitz WU (ed) Medicolegal investigation of death. 3rd ed. Springfield, Illinois: Charles C Thomas 1993: 71-117
2. Murphy WA, Spruill FG, Gantner GE. Radiographic identification of unknown human remains. J Forensic Sci 1980; 25: 725-735
3. Di Maio DJ, Di Maio VJ. Forensic pathology. New York: Elsevier, 1989: 332-333
4. Culbert WC, Law FM. Identification by comparison of roentgenograms of nasal accessory sinuses and mastoid processes. J Am Med Assoc 1927: 4: 1634-1636
5. Lichtenstein JE, fitzpatrick JJ, Madewell JE. The role of radiology in fatality investigations. American Journal of Radiology 1988; 150; 751-755
6. Riepert T, Rittner C, Ulmcke D, Ogbuihi S, Schweden F. Identification of an unknown corpse by means of computed tomography (CT) of the lumbar spine. J Forensic Sci 1995; 40:126-127
7. Atkins l, Potsaid MS. Roentgenographic identification of human remains. J Am Med Assoc 1978; 240: 2307-2308
8. Birkby WH, Rhine s. Radiographic comparison of the axial skeleton for positive identification. Paper presented at the American Academy of Forensic Sciences, 1983
9. Fischman SL. The use of medical and dental radiographs in identification. Int. Dent. J 1985; 35: 301-306

Figs. 5.11–5.12 – Skullduggery. 2130 x 2130 x 2130mm

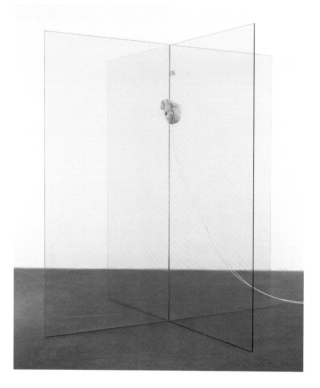

...you're holding the spinal cord in one hand with an instrument while you remove the disc. You remove ligament and bits of soft tissue that are around the spine, and there is the disc, which you then remove with very small little nibblers, curettes, and it comes out looking very much like crab meat, and that's that, then you sew up and go home. It's a much more delicate business than hip work. I mean, with the hip we've got hammers and chisels, whereas inside the spine you've got these very, very fine little instruments.

Mr James Scott – Orthopaedic Surgeon

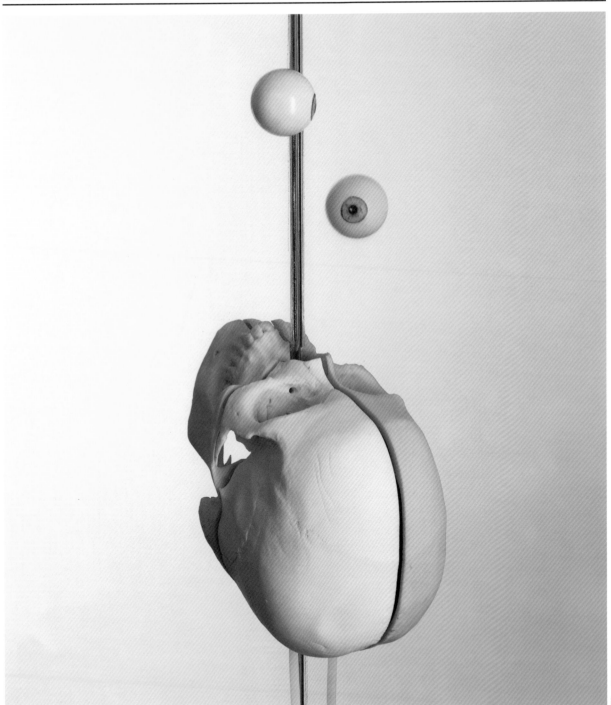

Fig. 5.12

+ .61 0011-8532/90 0.00

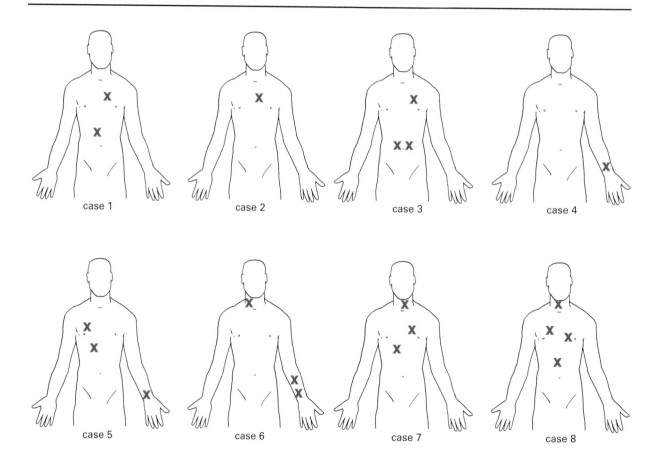

Fig. 6.1 – Schematic presentation of the injury localization
by self-cutting or self-stabbing in each of eight cases of
suicide examined.

6. Eight cases of suicide by self-cutting or self-stabbing

Summary The present article describes eight cases of suicide by self-cutting or self-stabbing. Seven of the deceased had a history of psychiatric problems. In every case, sharp weapon injuries were observed at typical sites of self-inflicted injury. The self-inflicted injuries varied in severity from a single stab wound to multiple cut wounds. In four cases, hesitation marks were found. Among the remaining four cases without hesitation marks, only one had clothing injuries. Based on the scene investigation by the police, it was deduced that each body had been found at or very near the place where the fatal injuries had been sustained. In two cases, toxicological analysis played an important role in discriminating suicide from homicide. In one case, a 52-year-old male stabbed himself fatally after potassium hydroxide ingestion, and in another, a 71-year-old male committed suicide by self-cutting and self-stabbing after drinking an alkaline detergent solution. In five of the eight cases, unusual findings such as a single stab wound, multiple cut injuries, no hesitation mark or presence of clothing injuries were found. In these five cases, the psychiatric history of the deceased contributed to furthering our comprehension of these unusual findings. We believe that thorough toxicological analysis and scene investigations as well as autopsys are essential in discriminating between homicide and suicide. Furthermore, forensic pathologists and forensic physicians at the scene should obtain as much information as possible on the victim's previous characters including previous psychiatric historys in order to elucidate his or her manner or death.

T. Ohshima, T. Kondo

Self-cutting or self-stabbing is an uncommon method of suicide. Bajanowski et al[1] reported that the ratio of homicides to suicides from sharp weapon injury is 5.2. A report by Start et al[2] showed that of 273 deaths from sharp weapon injury, 28 (~10%) were suicides. In every case with fatal sharp weapon injuries, differentiation between suicide and homicide is always required. The classic criteria for discriminating suicide by self-cutting or -stabbing from homicide are generally considered as follows: (1) several (not multiple) injuries are observed on the possible sites of self-infliction; (2) hesitation marks are present; (3) clothing injuries are absent. However, Madea and Schmidt[3] reported suicidal cases with such unusual findings as multiple self-inflicted injuries, a single stab wound, no hesitation mark, or clothing injuries.

In a previous study, we noted that forensic pathologists often encounter autopsy cases involving psychiatric patients, Because the proportion of felonious offences and suicides committed by them is large.[4] It is particularly important to obtain information on the psychiatric history of the victims and/or suspected assailants before or after autopsy. In the present article, eight cases of suicide by self-cutting or self-stabbing are described, and medico-legal aspects of the differentiation between suicide and homicide are discussed, including a psychiatric history of each victim.

During 1991–1995, a total of 261 medico-legal autopsies were performed at the Department of Legal Medicine, Kanazawa University Faculty of Medicine, Japan. Of these, eight were cases of suicide by self-cutting or self-stabbing.

I've seen lots of deaths that have been really horrific, really, really sad, and I felt quite frustrated that here I am committed to a way of life that is very much for the service of the Church, and I don't really have any answers to these profound questions that people are asking me like, 'Why has God let this happen to me?' and 'Why do bad things happen to good people?' It's my faith that I turn to to sustain me to go on asking the questions: 'What is it all about? Why are these things happening to people?' But it isn't God that causes these things to happen, it's a fact of human life that because we have finite existence, because our bodies are basically a machine that runs out, just like a car wears out, then things will happen to us. They aren't made to happen to you, we're not predetermined to develop cancer or a brain tumour, they're just a consequence of human life. But people can't accept that. They want to blame someone who very rarely answers back. And so God's a really good sitting duck, you can really have a good go at him.
Sister Susan McGuiness – Nurse

The autopsy findings, toxicological data, criminal report and clinical records of each victim were thoroughly reviewed. In each case, the victim's character, including the psychiatric history, total number and localization of sharp weapon injuries, clothing injuries, and toxicological data are summarized in Table 6.1 and Figure 6.7.

Case 1

A 19-year-old male college student was found lying dead on the bed in his apartment with a paring knife beside him. There was no evidence that his apartment had been entered by an intruder. At the autopsy, two stab wounds were observed on the left part of the chest and abdomen, both sustained through his clothes. One stab wound to the chest reached the upper lobe of the left lung, and there was dark-red clotted blood (800 g) in both sides of thoracic cavity. The other wound to the abdomen penetrated into the abdominal cavity, which contained dark-red clotted blood (660 g). Through thin layer chromatography (TOXI-LAB®, TOXI-LAB Inc., USA), acetaminophen (paracetamol) (detection limit: 5 μg/ml) and caffeine (detection limit: 0.5 μg/ml), as components of cold remedies he had taken, were qualitatively detected in the urine specimen. Based on our experiences with TOXI-LAB® screening,[5, 6] the concentration of acetaminophen was estimated to be approximately 5μg/ml and caffeine, 0.5μg/ml. TOXI-LAB® analysis revealed neither substances in the blood specimen. Therefore, the blood level of each substance in this case was considered to be at the therapeutic level or less (therapeutic blood level: acetaminophen 2–6 μg/ml, caffeine 2–10 μg/ml). This finding suggests that the suicide was not intended to be drug-induced. Psychiatric history revealed depression to a state found often among Japanese first year students in the first month of college life (May). The Japanese refer to this situation as *Gogatsu-byo*, Japanese for May sickness.

Case 2

A 24-year-old female was found dead at the entrance to her bathroom. A paring knife was discovered in the bathroom, and although her clothes were stained with much blood, they were not damaged. She had been previously hospitalized for a few months with anorexia nervosa, and was still on psychotropic medication. Autopsy revealed a single stab wound to the left part of her chest. Internally, the stab wound had a single wound tract, extending to the right ventricle of the heart. Both sides of the thoracic cavity were found to contain a total of 1140 g dark-red clotted blood. Hesitation marks were absent. TOXI-LAB® analysis of the serum specimen disclosed a faint spot corresponding to amobarbital (detection limit: 1 μg/ml), and the intensity of the spot corresponded to a concentration of approximately 1 μg/ml (the therapeutic level is 1–5 μg/ml based on the experiences of the authors).[5, 6]

By means of a high performance liquid chromatographic system (REMEDi-HS® BIO-RAD Laboratories, USA), bromisovalum was also detected in the serum specimen at the concentration of 3 μg/ml, which was far below its lethal blood level (44–134 μg/ml). There was no urine in the bladder. The detected drugs were consistent with those prescribed by her psychiatrist, and thus toxicological data excluded drug overdose as the cause of death.

Case 3

A 62-year-old female was found dead in her bedroom, with a kitchen knife beside her. The autopsy disclosed a

total of six stab wounds to the left side of her chest and abdomen. Internally, the left thoracic cavity and abdominal cavity contained dark-red blood (325 g and 425 g, respectively). Several superficial stab or cut wounds were also noted on her chest and abdomen. According to her psychiatrist, she had been hospitalized for a few months because of schizophrenia and was discharged 5 days before her death.

Case 4

A 50-year-old male was found lying dead on the bathroom floor of his house; a thin-bladed safety razor was also found in the bathtub. His wife was also found dead at the same time, having hanged herself with a necktie in the living room. The autopsy carried out on the male revealed deep incised wounds on his left wrist that completely severed

the left radial artery and several superficial incised wounds (hesitation marks) that ran parallel to the deep incised wounds. According to the criminal report, the couple had been upset by a crime committed by their son, and this was considered to be the cause of their double suicide.

Case 5

A 65-year-old schizophrenic female (S) and her neighbour (N) were found dead in N's room, with a kitchen knife beside S. The autopsy of S revealed that deep cut wounds on the left wrist had completely severed her left radial artery. Superficial incised wounds (hesitation marks) were also present on her chest, abdomen and left wrist. At the autopsy of N, two stab wounds on the back were observed; these reached the thoracic cavity. According to the medical record on S, she was not under psychiatric treatment. It

Fig. 6.2 – An Unreasonable Fear of Death and Dying. 1: 2130 x 2130 x 1060mm; 2: 2130 x 2130 x 2130mm

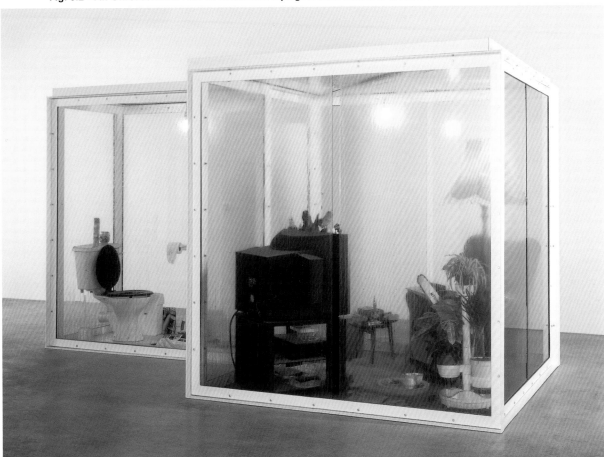

Then we would use analgesic drugs, drugs which diminish the appreciation of pain – classically they're derivatives of opium: morphine or pethidine. Surely, you ask, if the patient is unconscious, he cannot feel pain? But in fact in the midst of being asleep and having a surgeon operating on you, there's a fair amount of reflex activity, because the body resents being attacked, and crudely, a surgical operation is a kind of attack.

If I were to lunge at you with a knife, your body would immediately respond by pumping out adrenaline to defend yourself; you have an in-built flight and fight and fear reaction.

Dr Richard Ellis – Anaesthetist

Fig. 6.3 – Homicide in England and suicide of assailants.

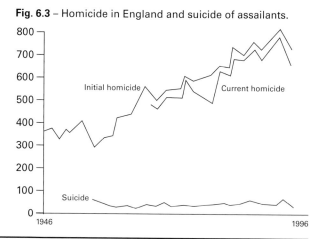

Figs 6.4 and 6.6 – The History of Pain. 960 x 2510 x 2510mm; ball: diameter = 300mm

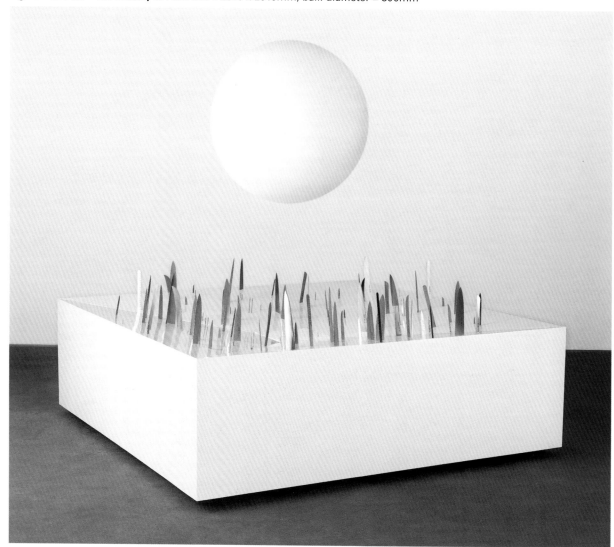

I'm informed of every stabbing that comes in here, because junior staff on duty at night in hospital won't have seen as many as I have, and they may underestimate them. With stabbings, the size of the entry wound can be tiny, and it can have done the most horrendous damage, it can have gone into the heart or a major blood vessel, and it's very easy to underestimate the potential hazard of such a situation, very easy to say, 'We'll put in a few stiches and you can go home', or if it's not bleeding, the patient may insist on going home, or try to, and so on. So they call me –God help them if they don't!

Dr Howard Baderman – Accident & Emergency Consultant

was deduced that the schizophrenic female had cut herself after stabbing her neighbour, and this case was considered a murder followed by a suicide.

Case 6

A 24-year-old female was found dead in a bush, and a thin-bladed safety razor was also discovered a few metres away from her body. Her clothes were not disturbed. At autopsy, multiple, deeply-incised wouonds were found on her neck and left forearm, and her right jugular vein completely severed. Hesitation marks were also observed, on her neck and left forearm. Although she had suffered from schizophrenia in the past, she had not received any psychiatric treatment for this condition.

Case 7

A 52-year-old male with a history of depression was found dead with a knife beside him. A total of four stab wounds were found on his neck, abdomen and left side of his chest. One of the wounds pierced the left lobe of his liver, and his abdominal cavity contained dark-red blood (338 g) with haemocoagula. Hesitation marks were not present. Liquefaction of the oral, pharyngo-laryngeal and upper gastrointestinal tract mucosae was observed, as well as gastric wall perforation. The pH of the gastrointestinal mucosa was strongly alkaline. Based on the autopsy findings and the scene investigation by police personnel, it was considered that the victim had committed suicide by fatally stabbing himself following oral ingestion of potassium hydroxide solution.

Case 8

A 71-year-old male with a history of depression was found dead in his house. A bottle of alkaline detergent solution for lavatory cleaning was also discovered beside him. A deeply incised wound on his neck completely severed the left jugular vein, two stab wounds were found on the left side of his chest and one stab wound on the right. One of the wounds on the left side of his chest reached the left ventricle of his heart, and the wound on the right side extended to the upper lobe of the right lung. There was pinkish blood (916 g) in the left thoracic cavity and dark-red blood (250 g) in the right thoracic cavity. One stab wound extending to the left lobe of the liver was seen on the upper abdominal region, and there was a small amount of dark-red fluid blood in the abdominal cavity. The stomach content (515 g) was dark greenish liquid of high pH. Through toxicological analysis using gas chromatography mass spectrometry, chloroform (one of the components of the alkaline detergent solution) was detected in the stomach contents and the heart blood at the concentrations of 59.7 and 0.3 µg/ml, respectively, but the blood level was below its lethal level (10–160 µg/ml). It was concluded that the male had committed suicide by cutting and stabbing himself after drinking the alkaline detergent solution.

Victim's character

According to the previous reports, suicides by self-cutting or self-stabbing are more prevalent in males than females[2,7]. In the present study, however, there was no difference in sex distribution of the victims. Only in Case 4 was a psychiatric history absent. Start et al[2] reported that a psychiatric history was established in 57% of cases of suicide by self-stabbing. Thus, in Japan, those with a psychiatric history tend more often to choose self-cutting or self-stabbing as a suicidal method.

Localization of self-inflicted injuries

The localization of injuries gives useful clues to forensic pathologists for differentiation between suicide and homicide: whereas in cases of suicide, sharp weapon injuries must be located at anatomically possible sites of self-

infliction, stab and/or cut wounds on the back strongly suggest homicide. Self-inflicted cut wounds are usually found on the neck or wrist.[8] The most frequent site of self-stabbing is the left side of the chest, where the victim believes the heart to be positioned, or in the upper abdomen, where the victim may be reasonably sure that there is nothing in the way, such as a rib, that would prevent entry into a vital organ.[2, 8] Furthermore, there are also several reported cases of suicide in which the fatal stab wounds were seen on the neck or head.[9-11]

In addition, the relationship between the injury localization and the victim's handedness is also important. It is generally considered that no wound is likely to be present on the right arm and/or hand, when the victim is right-handed. However, Fukumoto[12] reported a suicidal case in which, although the victim was right-handed, self-inflicted cut wounds were found on his right palm. In the present study, every subject was right-handed, and no sharp weapon injuries were seen on the right upper extremity, with most of the injuries being located at the frequent sites mentioned above.

Fig. 6.5 – Different types of weapons produce various types of wound on the surface of the skin. Here we see the effect that closed scissors and a craft knife have. Where the weapon is not found at the scene of crime, these marks provide vital clues to the kind of weapon used.

Total number of self-inflicted injuries

Madea and Schmidt[3] encountered a suicidal case with over 60 self-inflicted stab wounds. In the series of examinations by Start et al,[2] the maximum number of self-inflicted injuries was 85 (stab wounds). On the other hand, there are several reported cases of suicide by a single self-stabbing.[13, 14] In such single stabbing cases, it is known that forensic pathologists must very carefully examine whether the stab wound has only one wound tract or more.[13] In the present study, Case 6 was a rare case suicide because multiple self-inflicted injuries were found on the neck and forearm, and Case[2] had a single stab wound with only one wound tract. The total number of injuries is, therefore, a less reliable parameter for the distinction between suicide and homicide.

Hesitation marks

Hesitation marks are superficial sharp weapon injuries which are confined to the epidermal or upper-epidermal layer, and are believed to be the most useful indication in the distinction of suicide from homicide. According to various investigations, including the present one, hesitation marks are observed in most cases of suicide (> 70%) from sharp weapon injury.[2, 7, 15] However, they have been found in homicidal cases as well.[16]

Hesitation marks are usually seen in close proximity to fatal injures. However, Kurihara et al[17] reported a case of suicide by drowning with hesitation marks on the back, and the authors of this paper also observed several hesitation marks on the posterior region of the neck in a case of suicide by jumping from a height after inhalation of thinner.[18]

Clothing injuries

The cut or stab wounds in suicide are usually sustained on sites not covered by clothing, or on sites exposed after the clothing is pulled up. Karlsson et al[7] reported that in four (4.5%) of 89 cases of suicide by sharp weapon injury, the clothing was damaged as well. According to Start et al,[2] self-inflicted injuries were sustained through the clothing in eight (28.6%) of 28 cases. Among the present eight cases, only one reported damage to clothing.

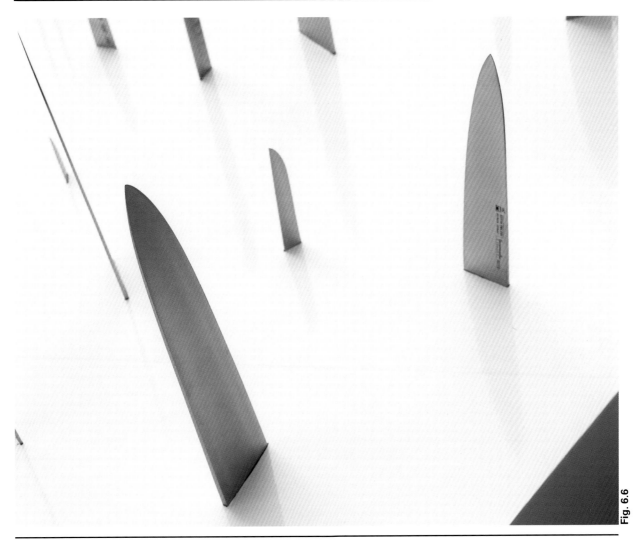

Fig. 6.6

Table 6.1 Psychiatric history, the localization and number of injuries, hesitation marks, clothing injuries and toxicological data in eight suicide cases.

Age	Psychiactric history	Localization of injuries	No. of injuries	Hesitation marks	Clothing injuries	Toxicological data
19	dep	lt chest, abd	2	–	+	*ace (u: 5 µg/ml,*caf (u:0.5 µg/ml)
24	anorexia nervosa	lt chest	1	–	–	*,**amo(s: 1–µg/ml,bro(5:3 µg/ml)
62	schizo	lt chest, abd	>10	+	–	
50	–	lt wrist	>10	+	–	–
65	schizo	lt wrist, rt chest, abd	>10	+	–	–
24	schizo	neck, lft forearm	multiple	+	–	–
52	dep	neck, lft chest, abd	4	–	–	KOH
71	dep	neck, chest, abd	5	–	–	*chl (sc: 59.7µg/ml)

dep: manic state of depressive psychosis, schizo: schizophrenia, abd: abdomen, ace: acetaminophen, caf: caffeine, amo: amobarbital, bro: bromisovalum, KOH: potassium hydroxide chl: chloroform, u: urine, s: serum, sc: stomach contents

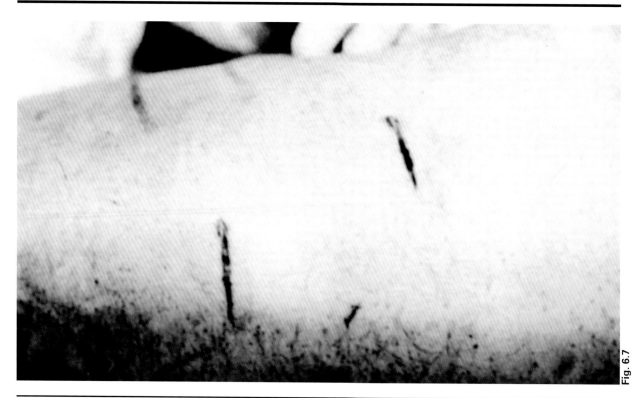

Fig. 6.7

I will give you a specific example in terms of pain. Let us talk about an acute sudden injury. When an injury has occurred it generates a message. The messages are delivered to the spinal cord by the peripheral nerve fibres, coded messages that are saying such and such an injury has occurred in this place: the spinal cord receives that message and passes it on to cells that will transmit that message to the brain. But the fact is, that message doesn't automatically pass, it depends upon what else is going on, so this is a comparison point, not a relay point. And one of the things that may happen at that point is that the brain says, 'I think the general situation is not relevant to feeling pain at the moment, so do not transmit that message.' Now, that decision is being taken right at the very first entry point into the spinal cord, and we call that a 'Gate Control', it is a control of the entry of information.

Professor Patrick Wall – Neurophysiologist

In general, the presence of hesitation marks or absence of clothing injuries seems more reliable than the number of injuries for the determination of suicide. According to the authors' own data, however, there were four cases without hesitation marks, and in one of these cases, damage to the clothing occurred. The reason for these unusual findings might be the presence of a psychiatric history in each case. Furthermore, hesitation marks and damage to the clothing can also be evaluated from the viewpoint of the suicidal motivation. In other words, the absence of hesitation marks or presence of damage to the clothing may show an intense motivation to commit suicide in a victim with a psychiatric history. If this assumption may be accepted, the victim in Case 1 seems to have had the strongest motivation among the eight cases.

Physical activity after self-cutting or self-stabbing

Based on the scene investigation by police staff, each of the present victims was found dead right at or very near the place where the fatal injuries had been sustained. However, the body is not always found where the injuries were sustained. Zimmer et al[19] encountered a case in which a 25-year-old male with a single heart wound was able to run about 100 m. In a case reported by Shiono and Takaesu,[20] a 44-year-old male stabbed himself in the heart with a kitchen knife and died from cardiac tamponade two hours later. Surprisingly, in the interim, he had changed his clothes because they were stained with blood and eaten lunch with his aunt.

Toxicological data

In Cases 7 and 8, judging from the toxicological data, it is conceivable that each victim had unsuccessfully attempted suicide by oral ingestion of poisons (the KOH and the alkaline detergent solution for lavatory cleaning).

Conclusion

Of the eight cases of suicide present herein, five had unusual findings such as a single stab wound, multiple cut injuries, no hesitation mark, or clothing damage. In these five cases, information on the victim's character, such as psychiatric history, contributed much to the determination of suicide as cause of death. Although the classic criteria put heavy emphasis on the autopsy, findings including clothing damage for the differentiation of suicide from homicide, toxicological analysis and scene investigation should be thoroughly performed as well. Moreover, it is always necessary to obtain information on the victim's character, such as a psychiatric history, for better interpretation of unusual autopsy findings.

Further reading

1. Bajanowski T, Varro A, Sepulcher M-A. Tod durch scharfe Gewalt. Kriminologische und kriminalistische Aspekete. Arch Kriminol 1991; 187: 65-74
2. Start RD, Milory CM, Green MA. Suicide by self-stabbing. Forensic Sci Int 1992; 56: 89-94
3. Madea B, Schmidt P. Über ungewöhnliche suizidale Stichverletzungen. Arch Kriminol 1993; 192: 137-148
4. Kondo T, Ohshima T. Retrospective investigation of medico-legal autopsy cases involving mentally handicapped individuals. Jpn J Legal Med 1995; 49: 478-483
5. Nishigame J, Ohshima T, Takayasu T, Kondo T, Lin Z, et al. Forensic toxicological application of TOXI-LAB® screening for biological specimens in autopsy cases and emergency cares. Jpn J Legal Med 1993; 47: 372-379 (in Japanese with English abstract)
6. Takayasu T, Ohshima T, Nishigami J, Kondo T, Nagano T. Screening and determination of methamphetamine and amphetamine in the blood, urine and stomach contents in emergency medical care and autopsy cases. J Clin Forens Med 1995; 2: 25-33
7. Karlsson T, Ormstad K, Rajs J. Patterns in sharp force fatalities – a comprehensive forensic medical study: part 2. Suicidal sharp force injury in the Stockholm area 1972-1984. J Forensic Sci 1998; 44: 448-461
8. Knight B. Forensic Pathology. 2nd edn. London: Edward Arnold, 1996: 231-241
9. Fekete JF, Fox AD. Successful suicide by self-inflicted multiple stab wounds of the skull, abdomen and chest. J Forensic Sci 1980; 25: 634-637
10. Chadly A, Marc B, Paraire F, Durigon M. Suicidal stab wounds of the throat. Med Sci Law 1991; 31: 355-356
11. Hasekura H, Fukushima H, Yonemura I, Ota M. A rare suicidal case of a ten-year-old child stabbing himself in the throat. J Forensic Sci 1985; 30: 1269-1271
12. Fukumoto K. A case of suicidal stabbing with cuts on the right palm. Act Crim Japon 1970; 36: 144-154 (in Japanese with English abstract)
13. West I. Single suicidal stab wounds – a study of three cases. Med Sci Law 1981; 21: 198-201
14. Urban R, Eidam J, Kleemann W, Tröger HD. Isolierter Herzstich ohne Probiersticher-Suicid oder Tötung? Beitr Gericht Med 1989; 47: 273-277
15. Vanezis P, West IE. Tentative injuries in self stabbing. Forensic Sci Int 1983; 21: 65-70
16. Betz P, Tutsch-Bauer E, Eisenmenger W. 'Tentative' injuries in a homicide. Am J Forens Med Pathol 1995; 16: 246-248
17. Kurihara K, Kuroda N, Murai T, Matsuo Y, Yanagida J, Watanabe H. A case of suicide by drowning with hesitation marks on the back. Jpn J Legal Med 1989; 43: 517-521
18. Ohshima T, Takayasu T, Nishigame J, Nagano T. Four medico-legal autopsy cases with the analysis of contribution of drug and poison to the cause of death. Jpn J Toxicol 1994; 7: 155-159 (in Japanese with English abstract)
19. Zimmer G, Miltner E, Mattern R. Zur Handlungsfähigkeit nach Stich-und Schnittverletzung. Arch Kriminol 1994; 194: 95-104
20. Shiono H, Takaesu Y. Suicide by self-inflicted stab wound of the chest. Am J Forens Med Pathol 1986; 7: 72-73

Figs 7.1 and 7.4 – The Way We Were. 2440 x 2740 x 2740mm

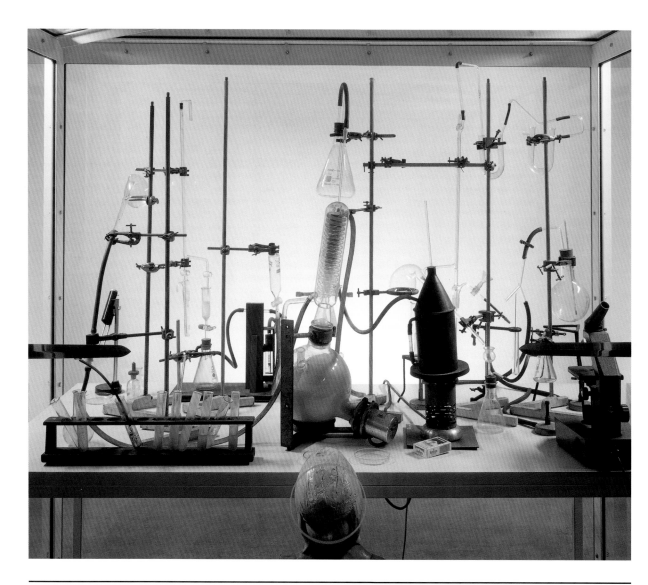

7. Determining the true cause of death in a dermatological disaster

Summary Adverse drug reactions that result in patient death warrant special consideration to determine if the outcome was preventable. We report the results of an investigation into the cause of death of a-63-year old male who was thought to have phenytoin-induced toxic epidermal necrolysis (TEN). Most dermatological reactions from drugs are minor and resolve without sequelae once the drug is discontinued. In some cases, reactions are severe and can be life threatening. The patient arrived at the emergency department with extensive exfolative dermatitis. The differential diagnosis included phenytoin-induced TEN, scalded skin syndrome, and phenytoin hypersensitivity. After he was admitted his clinical status deteriorated and he died 13 days after admission. Autopsy findings were significant for necrotizing dermatitis, necrotizing pneumonia, multiple herpetic ulcerations, multisystem organ failure and blood cultures grew Staphylococcus aureus (TSS toxin positive). Findings that indicate a cause of death other than a drug-induced dermatological reaction are presented as well as an overview of the patient's medical history. The differential diagnosis of drug-induced skin lesions are also discussed.
K. Blaho, K. Merigian, S Winbery

Dermatological reactions to drugs can be common. Most reactions are minor and resolve spontaneously once the drug is discontinued. In some cases, however, the dermatological reactions can be severe and may result in death. Drug-induced skin eruptions include erythema multiforme (EM), Stevens–Johnson syndrome and toxic epidermal necrolysis (TEN). Often thought to be a continuum, these reactions differ in severity, duration and mortality. The exact mechanism of the development of EM is not known but is thought to be an immune mediated response to the drug and/or drug metabolites.[1-4]

EM itself is usually self-limiting and is characterized by iris–like target lesions that often affect the entire skin surface area but rarely involve the mucosa. Mortality associated with EM is rare, and it usually clears within 1 to 3 weeks.[5] Common causes of EM include infection (usually viral) or drug exposure. Some studies have shown that the majority of EM is related to infection with herpes simplex.[6]

A more severe form of EM, Stevens–Johnsons syndrome (SJS), is characterized by rash and mucosal involvement. Skin lesions in SJS often necrose, leading to secondary infection and permanent scarring.[5] SJS is associated with drug exposure or infection. SJS may also manifest with multi system organ involvement. Patients with SJS often appear toxic, are prone to dehydration and are very often hospitalized. Mortality associated with SJS ranges from 5 to 15%.

TEN is potentially the most severe of all drug induced dermatological reactions. Relatively rare in incidence, TEN can have devastating consequences. It is characterized by erythema and bullous lesions that ultimately coalesce, necrose and slough. The lesions resemble second–degree burns. Internal organ involvement is common and can include complications such as sepsis, pneumonia, haemorrhage, renal and heart failure and fluid and electrolyte imbalance.[5] Treatment of TEN is aggressive and is focused on preventing secondary infections and supporting cardiovascular function. Treatment includes tenacious

wound care, anti-biotic administration and fluid and electrolyte replacement.

Past illnesses

The case described is that of a 63-year-old male who died of apparently overwhelming sepsis and multiorgan failure after presenting with an exfoliating dermatitis that was thought to be related to phenytoin therapy. The family of the deceased sought legal action for wrongful death.

The medical history of the patient is described in Table 7.1. Most notably, he had a long history of chronic alcohol abuse. The amount consumed was reported to be a fifth or more of vodka per day. Results from an office visit in 1976 indicated macrocytic anaemia suggestive of alcohol abuse. He had several emergency department (ED) visits where alcohol levels were measured as high as 0.77. Ten years

before his death, the patient was brought to the ED 2 days after falling and hitting his head while intoxicated. He was hospitalized and underwent craniotomy for the evacuation of an intracerebral haematoma in the left temporal parietal area. The patient continued to consume alcohol until the time of his death.

After recovery from the craniotomy, the patient developed a seizure disorder. He was not compliant with drug therapy, which resulted in at least on subsequent ED visit and a hospital admission for seizures. He was treated intermittently with phenytoin and phenobarbital and had several drug levels measured which were all subtherapeutic.

The patient had an intermittent history of skin rashes both related to and unrelated to drug use. Nowhere in his records does it indicate that the patient had any allergies to drugs or other agents. He was referred for follow-up to rule out malignancy because of a rash 8 weeks before his

Table 7.1 – Pertinent medical history of the patient

Year	Where seen	Complaint
1976	Office visit	History (from wife) of alcohol abuse. Low RBC count, low haemoglobin, high MCV.
1977	Office visit	Osteoarthritis of thumb, low RBC, haemoglobin, high MCV, dermatitis, haemorrhoids.
1979	Office visit	Osteoarthritis of thumb, low RBC, haemoglobin, haematocrit, high MCV.
1980	Office visit	Osteoarthritis of thumb, elevated MCV, MCH, decreased RBC, complains of rash.
1981	Office visit	Osteoarthritis of thumb, decreased RBC, haematocrit, increased MCV, MCH.
1983	Office visit	Chest pain with negative ETT. Diagnosis: non-cardiac pain due to emotional stress.
1984	ED visit	Rapid heart beat. Intoxicated (BAL=0.54) Diagnosed with atrial fibrillation.
1985	Hospital admission	Evacuation of intracerebral haematoma acquired when the patient was intoxicated and fell.
1986	ED visit	Intoxicated (BAL=0.77).
1987	ED visit	Coughing. Work-up to rule out pneumonia and COPD.
1987	Office visit	Abnormal EEG.
1988	Office visit	Abnormal EEG.
1989	Office visit	Abnormal EEG.
1991	Office visit	Hyperlipidaemia and thrombocytopenia.
1993	Office visit	Emergency refill of unknown agent.
1993	Hospital admission	Grand mal seizure, BAL=0.38 on admission, treated with phenytoin, lorazepam, diazepam.
1993	Office visit	Exfolative dermatitis and erythroderma. Referred for follow-up to rule out malignancy.
1994	Office visit	Patient complained of seizures, phenytoin and phenobarbitol prescribed.
1994	Office visit	Rash.

Why do doctors hoard knowledge? One reason is because they realize that the amount they know isn't all that massive. There's a feeling that the public is better off not knowing. But people do want to know; after all, their bodies are at the end of the day the one thing that belongs to them. I think it's bad that the medical profession has not taken enough account of the need to get people to know more, to know the limits of medicine, to know the potential of the body and its limits, to know that man is a fallible machine, that disease, you might say, is almost the more natural state of man than health.

Professor Anthony Clare – Psychiatrist

It's the other sort of mind-bending, with drugs, that I think we're exceedingly bad at, and the use of tranquillizers is completely out of control. I'm telling you that drugs such as tranquillizers are acts of brain surgery. You are putting a chemical weapon through the system, not a knife, admittedly, but another form of warfare. And the tranquillizer works by going into the brain and paralysing certain bits of the brain, and having done so, is to a certain extent irreversible. The brain is not just a passive machine. It reacts to drugs or to surgery or to disease by changing, and sometimes it changes irreversibly.

Professor Patrick Wall – Neurophysiologist

Fig. 7.2 – The Void (detail). 2360 x 4710 x 110mm

death. There was no record that the patient completed the follow-up. He also suffered from atrial fibrillation, which was controlled with a calcium channel blocker and digitalis.

The patient presented to a local ED with an extensive exfoliative dermatitis that covered over 80% of his body. He had been stable until 6 days before when a small red papular rash without vesicles, developed covering his chest and arms. There was no drainage of fluid, pruritus or pain. The rash worsened and spread over his entire body. He was seen 2 days previous to his hospitalization at an outpatient clinic for the evaluation of the rash. He was treated with 25 mg of intramuscular diphenhydramine, and given a prescription for 25 mg of oral diphenhydramine. The following day, his skin began to peel and he became ataxic.

Illness prior to mortality

The patient was transferred to a second ED where approximately 80% of his skin was involved with what appeared to be second-degree burns. The lesions were a combination of erythematous and cyanotic skin, much of which had already sloughed. Mucous membrane involvement was minimal and included a small segment of peeling erythematous mucosa on the roof of his mouth. His conjunctivae was mildly erythematous. His vital signs were stable

Table 7.2 – Pertinent microbiological findings during last hospital admission.

Day 1	Blood: gram pos. cocci, Staphylococcus aureus
Day 2	Ocular: gram pos. cocci, Staphylococcus aureus, Gram-negative Bacilli
	Back, right thigh, hand: Staphylococcus aureus
	Thigh: coagulase negative Staphylococcus
Day 3	Blood: no growth
Day 4:	Ankle, thigh: Staphylococcus aureus
	Chest: Staphylococcus aureus, Gram-negative bacilli Arm: Staphylococcus aureus, coagulase
Day 8	Catheter tip, abdomen, arm, leg, no growth
Day 10	Septum: Pseudomonas, Gram-negative baccilli,
	Blood: Staphylococcus aureus, Gram-negative baccilli, coagulase negative Staphylococcus
Day 11	Back, arm: Candida
Post mortem	Blood: Staphylococcus aureus (TSS positive)
	Sputum: Pseudonomas
	Skin: Staphylococcus aureus, Candida

but he was disoriented. He was admitted with possible diagnoses of scalded skin syndrome, drug hypersensitivity reaction, SJA or TEN. A final diagnosis was never made.

Over the course of his 13-day hospital stay the patient developed pneumonia, sepsis syndrome, became hypotensive, difficult to ventilate and had several bouts of ventricular tachycardia. He was treated during this time with antibiotics, anti-inflammatory steroids, pain medications, vasopressors, fluid, electrolyte and nutritional support. His dermatitis continued to exfoliate. Twenty-four hours before his death, the patient was anuric with an elevated creatine. In addition, he remained leukopenic and thrombocytopenic throughout the course of his hospital admission.

Various specialties were consulted for care of this patient including surgery, cardiology, infectious diseases, dermatology, nephrology and psychiatry. Despite therapeutic interventions the patient did poorly. His blood pressure became unstable, he was tachycardiac, had intermittent fever, was difficult to ventilate and ultimately developed acute renal failure. His family was consulted for 'do not resuscitate' orders. He was given comfort measures only, and on the thirteenth hospital day he died.

Autopsy findings included pleural effusion, acites, autolysis of the adrenal gland, glomerulosclerosis, focal interstitial inflammation and haemorrhagic mucosa of the bladder. The GI mucosa had herpetic and candidal lesions. Post mortem pulmonary cultures were postive for *Pseudomonas aerugnosa*. Skin cultures were positive for *Staphylococcus aureus* and *Candida* species. *Staphyloccus aureus* (toxic shock toxin positives) was also found in his blood cultures. Biopsies of the skin showed epidermal necrosis with full thickness involvement of the epidermis with chronic inflammation.

A pathological diagnosis based on the autopsy findings included exfolative necrotizing dermatitis, *Staph aureus* (TSS positive) sepsis, necrotizing pneumonia (Pseudomonas positive), multisystem organ failure, bilateral pleural effusion, and ascites. Phenytoin-induced TEN was not listed as a cause of death by the coroner. However, the family believed that his death could have been prevented had he not received phenytoin to control his seizure disorder.

Discussion

Determining the cause of any severe dermatological reaction can be difficult because there are no standard laboratory tests available.

Table 7.3 – Laboratory values during last hospital admission

Day	Time	Glu (mg/dl)	K (meq/L)	Ca (mg/dl)	Mg (mg/dl)	Co^2 (meq/L)	Creat (mg/dl)	Ua (mg/dl)	Biu (mg/dl)	Alt (u/dl)
1	13:05	149	5.08	8.2	–	21	1.8	6.9	0.7	48
2	08:15	160	4.7	7.2	–	26	1.2	4.1	0.4	47
3	–	–	–	–	–	–	–	–	–	81
4	05:10	–	–	7	–	–	1.1	–	0.4	–
5	05:29	–	–	7.4	–	21.3	1.4	2.3	0.4	–
6	13:20	328	3.77	–	–	–	1.45	1.7	–	48
7	06:10	–	4.01	–	–	23.3	1.3	–	–	49
8	05:03	206	4.34	–	–	20	1.2	2.5	1.7	51
9	22:10	228	3.9	7.2	–	19.6	1.2	–	1.1	–
10	07:20	271	4.08	7.4	1.9	22.1	1.3	2.3	1.5	–
11	04:30	272	3.8	6.7	–	18.7	1.4	–	–	38
12	04:45	303	3.7	–	–	23	2.1	2.6	–	42
13	05:45	329	4.19	5.2	–	24	1.4	2.6	1.7	41

Fig. 7.3 – The Void. 2360 x 4710 x 110mm

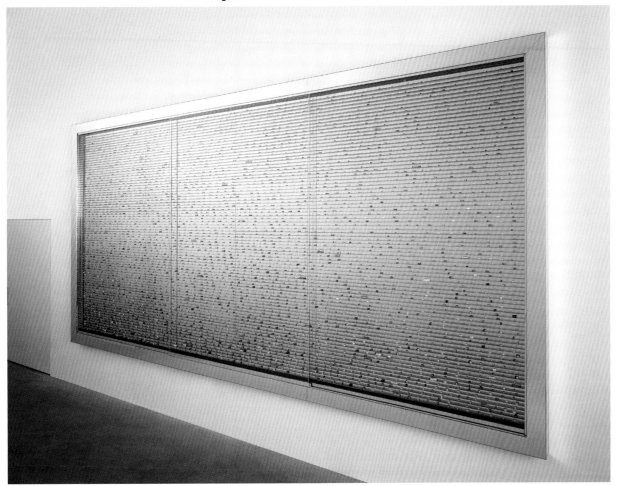

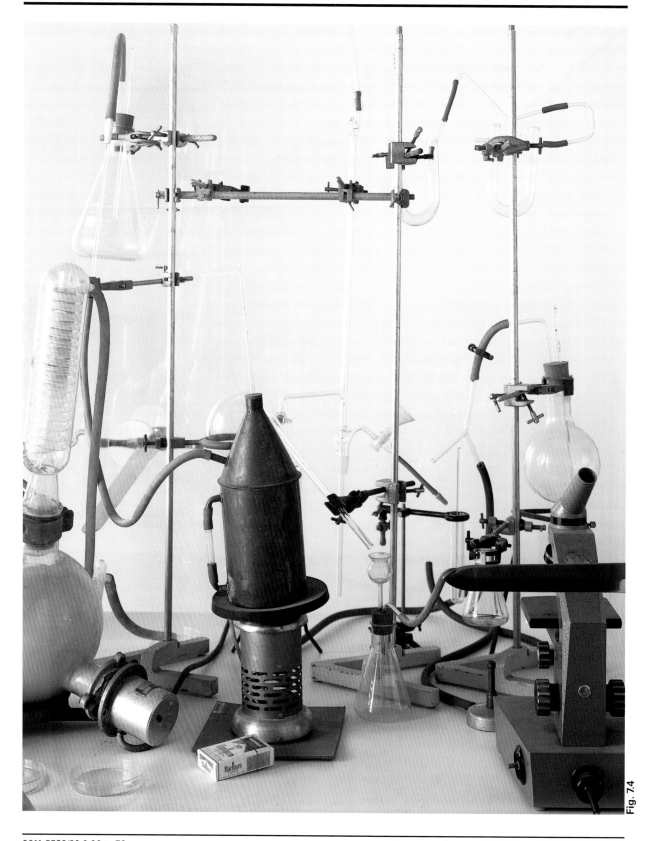

Fig. 7.4

Early in his hospital course, the patient was thought to have erythema multiforme major or SJS. This is described as a more severe form of EM and predominately associated with drug exposure.[5] The most common drugs known to cause SJS are the non-steroidal anti-inflammatory agents, the antiseizure agents and drugs that contain a sulfur moiety. SJS is often associated with prodromal symptoms such as headache, fever, malaise, cough and sore throat that can occur several weeks prior to onset of skin rashes. The rash has target lesions that are symmetric, with inflammatory infiltrates in the dermis. EM usually resolves without significant morbidity and mortality. There is no record that indicates that the patient experienced any of these prodromal symptoms and the nature of his exfolative dermatitis is not consistent with EM.

Toxic epidermal necrolysis (TEN) or Lyell's disease is most commonly related to drug exposure, but can be associated with other medical illnesses or can be idiopathic. TEN is characterized by bullous mucotaneous eruptions that ultimately coalesce. There is loosening of large sheets of epidermis from the underlying layers of the epidermis and dermis leading to a positive Nikolsky's sign. There is extensive mucosal and internal organ involvement. Patients typically lose more than 50% of the body surface area including finger and toe nails and eyebrows. Constitutional signs include high fever, leukocytosis, elevation of transaminases, albuminuria, fluid and electrolyte imbalances, mucosal decompensation of the GI tract and airway. With the loss of the protective skin barrier, colonization and infection with multiple organisms may occur leading to sepsis and septic shock. Histopathologically, there is a split at the dermoepidermal junction.

While the patient had some of the clinical findings of TEN, he had no prodromal symptoms, he did not have a bullous rash, had minimal oral mucosal involvement, and did not have significant elevations in liver enzymes. The patient was given prescriptions for phenytoin and phenobarbital 2 to 3 days before the onset of the rash. He had a long history of poor compliance, whether he took the

Fig. 7.5 – Vial containing a hair sample for forensic analysis. It is shown with a record sheet sealed with wax to prevent tampering. Forensic studies of hair can reveal the presence of certain poisons, such as arsenic.

medications at all or as prescribed is not known. Of interest is an office visit by the patient 8 weeks before his presentation to the ED with a complaint to exfoliative dermatitis and erythroderma. At that time, he was treated with prednisone, hydroxyzine and triamcinolone cream. He was referred for a further work-up to rule out the possibility of a malignancy, but did not complete this. Based on his history of multiple episodes of dermatitis, both with and without drug therapy, it is difficult to say conclusively that the patient died of phenytoin-induced TEN.

Another possible cause of death was phenytoin hypersensitivity syndrome. This is characterized by fever, cutaneous eruption, lymphadenopathy and hepatitis. Other symptoms include interstitial nephritis, anemia, interstitial pulmonary infiltrates, thrombocytopenia, myopathy and diffuse intravascular coagulation. Thought to be an immune mediated reaction, the syndrome begins with fever, malaise and a rash. Diarrhoea, lymphadenopathy and myalgia may also occur early in the syndrome. Eruptions from phenytoin usually resolve spontaneously after the drug is discontinued. The skin manifestations are characterized by a mild, moribilliform or maculopapular rash. Severe dermatological

...it's those sort of illnesses, where things are just left, where early intervention would have helped a great deal. It's ignorance, but it's also a lot of fear, a lot of 'I don't want to bother the doctor', a lot of acceptance of their lot. That's the common denominator amongst people at the bottom of the triangle: they just expect a great deal of ill-health.

The coughs! 'Oh well, I smoke.' But these are rip-roaring chest infections, and examining them, it's clearly an ongoing bronchitis or even a pneumonia. Things like that, and to them it's like it's acceptable in some way: that ill-health is to be put up with.
Dr Susan Lawrence – General Practitioner (Leeds)

Determining the true cause of death in a dermotological disaster

+ .79 0011-8532/90 0.00

Table. 7.4 – History of previous drug exposure in the patient

Previous medications	Medications previous to last admit	Possible causative agent for rash?
Ethanol	Yes	Yes
Aspirin	Unknown	Yes
Piroxican (Clinoril®)	Yes	No
Kenalog Orabase	No	No
Digoxin (Lanoxin®)	Unknown	Yes
Norepinephrine (Levophed®)	No	No
Phenobarbital	Yes	Yes
Cimetidine (Tagamet®)	No	No
Folate	Unknown	Yes
Multi-vitamin supplement	Unknown	Yes
Thiamin	Unknown	No
Ferrous sulphate	Unknown	No
Acetaminiphen (Tylenol®)	No	Yes
Phenytoin (Dilantin®)	Yes	Yes
Hydralazine (Apresoline®)	No	No
Gentamicin (Garamycin®)	No	No
Codeine	No	No
Promethazine (Phenergan®)	No	No
Colace	No	No
Milk of Magnesia	Unknown	No
Bisacodyl (Ducolax®)	Unknown	No
Cefazolin (Kefzol®)	No	No
Heparin	No	Yes
Tobramycin	No	Yes
Chlordiazepoxide (Librium®)	No	No
Haloperidol (Haldolol®)	No	No
Diazepam (Valium®)	No	No
Diphenhydramine (Benedryl®)	Yes	Yes
Carbamazepine (Tegretol®)	Yes	Yes
Ceftazidime (Fortaz®)	No	No
Atenolol (Tenormin®)	No	No
Naloxone (Narcan®)	No	No
Albuterol (Ventolin®)	No	No
Minoxidil (Rogaine®)	Unknown	Yes
Lorazepam (Ativan®)	No	No
Prednisone	No	No
Triamcinolone cream	No	No
Hydroxizine (Atarax®)	No	No
Morphine	No	No
Midazolam (Versed®)	No	No
Oxazepam (Serex®)	No	No
Trimeprazine (Temaril®)	No	No
Vancomycin	No	No
Piperacillin	No	No
Verapamil (Isoptin®)	No	No
Metoclopramide (Reglan®)	No	No
Insulin	No	No
Lidocaine	No	No
Furosemide (Lasix®)	No	No

reactions to phenytoin have also been reported and can evolve from the less severe eruptions. Included in these are EM, SJS and TEN. The more severe reactions such as TEN have been reported to have a high mortality rate; varying from 22 to 34%.

Hepatitis from phenytoin hypersensitivity reaction can cause profound elevations in liver enzymes with serum glutamic oxabacetic transaminase (SGOT), serum glutamic transaminase (SGT) and alkaline phosphatase values in the thousands. The absence of elevated liver transaminases in this patient suggest that he did not have overwhelming phenytoin hypersensitivity.

The lymphadenopathy associated with phenytoin hypersensitivity is also rather distinct. Biopsy reveals diffuse lymphoid hyperplasia with immunoblasts, which is sometimes indistinguishable from malignant lymphoma. The lymph biopsies of this patient revealed some enlargement, but were otherwise unremarkable.

The patient had *Staph aureus* in his blood. *Staph aureus* can cause two toxin-mediated skin reactions: toxic shock syndrome (TSS) and scalded skin syndrome. Scalded skin syndrome (SSS) begins as a sudden onset of generalized erythema producing bullae that slough. On skin biopsy, there is intraepithelial splitting at the striatum granulsosum but no full thickness necrosis such as that seen in TEN. The palms, soles and mucous membranes seem to be spared. Other characteristic signs of SSS are a positive Nikolsky's sign, fever and skin tenderness. As a result of profuse desquamation, the patient looses protein, becomes hypovoloemic and is subject to secondary infections. The patient had several clinical findings that were not consistent with SSS. He had some mucous membrane involvement, desquamation of his soles and palms, and autopsy revealed full thickness dermal necrosis of his skin.

The diagnosis of TSS is made by several criteria. These include a positive culture for the bacteria with TSS toxin, a macular erythematous eruption, fever, desquamation of the palms and soles, and hypotension. Three or more of the following clinical findings must also be present to confirm the diagnosis. These include vomiting, diarrhoea, myalgias with an increase in CPK, mucous membrane hyperaemia, renal impairment as evidenced by an increase in creatine and BUN, hepatic dysfunction measured by an increase in bilirubin SGOT and serum glutamic pyruvic transaminase (SGPT), thrombocytopenia, disorientation and pulmonary oedema. After reviewing the findings to a

Table. 7.5 – Potential causes of death associated with skin rashes

1. Drug-induced toxic epidermal necrolysis
2. Scalded shock syndrome
3. Toxic shock syndrome
4. Stevens–Johnson syndrome
5. Viral exanthematous disease
6. Idiopathic
7. Meningococcoemia
8. Rocky mounted spotted fever
9. Kawasaki's disease
10. Leptospirosis

reasonable degree of medical certainty, the cause of death for this patient was TSS.

Reviewing old records revealed a diffuse history of stomatitis, dermatitis and poison ivy exposure. These skin rashes are not always temporally related to drug therapy and occur throughout the nearly 20 years of old charts that were reviewed. The medical records were not clear if the patient had any specific allergies and there were no documented drug allergies. In fact, his records specifically indicate that he had no known drug allergies. The patient had an extensive history of drug exposure. These drugs are listed in Table 9.4. The most likely agents to produce hyper-sensitivity from this list that correspond with drugs the patient had been treated with in recent history are ethanol, phenytoin and phenobarbital. It would be a great leap of faith to attribute phenytoin exposure as a direct and proximate cause of his sepsis and death. Specifically lacking were eosinophilia and elevations in liver enzymes.

Based on the past medical history of the patient and his premorbid clinical findings, it is difficult to determine the exact cause of death. It is clear that the patient died with multiorgan system failure. The question is whether the preceding rash was responsible for his infection or whether his infection caused the rash. Chronic alcohol abuse could have contributed to a rapid spread of infection and inability to mount an adequate immune response, despite aggressive therapeutic interventions. The presence of *Staph aureus* with a positive TSS in combination with post mortem

findings suggest a cause of death not directly related to a drug reaction or a therapeutic misadventure.

References

1. Shelley W. Herpes simplex virus as a cause of erythema multiforme. JAMA 1967; 201: 153-156
2. Orton P W, Huff J C, Tonnenser M G, Weston W L, Detection of a herpes simplex viral antigen in skin lesions of erythema multiforme. Ann Intern Med 1984; 101: 48-50
3. Nickoloff B J, Griffiths C E M, Barker J. The role of adhesion molecules, chemotactic factors and cytokines in inflammatory and noeplastic skin disease – 1990 Update. J Invest Dermatol 1990; 94: 151-157
4. Friedmann PS, Strackland I, Pirmohamed M, Park K. Investigation of mechanisms in toxic epidermal necrolysis induced by carbamezepine. Arch Dermatol 1994; 130: 598-604
5. Firstch P O, Elias P M. Erythema multiforme and toxic epidermal necrolysis. In: Fitzpatrick T B, Eisen A Z, Wolff K, Freedberg I M, Austen K F (Eds) Dermatology in Internal Medicine. New York: McGraw Hill 1993: 585-600
6. Huff J C, Weston W L. Recurrent erythema multiforme. Medicine 1989; 68: 133-140

Table. 7.6 – Common clinical findings between the patient and those seen in toxic shock syndrome.

Symtoms	Present?
Macular erythematous eruption	Yes
Temperature >38.9°C	Yes
Hypotension	Yes
Vomiting and diarrhoea	Yes
Myalgias with increased CPK	No
Mucous membrane hyperaemia	Yes
Thrombocytopenia	Yes
Disorientation	Yes
Pulmonary oedema	Yes
Conjunctival hyperaemia	Yes
Increased SGOT, SGPT, bilirubin	Yes

Then there's the whole tranquillizer thing, and people asking for sleeping tablets. People find not sleeping tremendously distressing, and if you have the power to help them sleep, sometimes it seems very perverse not to. Ideally, if it's a new problem, you've got to try very hard to find out why they're not sleeping. I mean, they might be having acute worry, marital problems, depressive illness, stress, that sort of thing. But some of them get extremely angry if you don't give them the tablets – the pressure is phenomenal.

Dr Geoffrey Mair – General Practitioner (Suffolk)

Fig. 8.1 – 6 inch metal nail inserted in the scalp. partly concealed by hair, (left) and exposed after postmortem shaving (right).

8. Artefact in forensic medicine: non-missile penetrating injury

Summary Gunshot wounds are well characterized in forensic textbooks and atypical ballistic characteristics feature regularly in forensic literature. Forensic practitioners receive continuing education in recognizing a variety of gunshot wounds. Awareness of a non-missile penetrating injury mimicking a gunshot wound is also relevant to forensic medical examiners or others who are likely to attend a scene of death. In this case, which involved self-stabbing with a metal nail, a homicidal firearm death investigation was instigated because of a misinterpretation by crime scene investigators.
F. Patel

Attention has previously been drawn to artefacts in forensic medicine and forensic practitioners are made aware of artefacts in ballistics such as 'pseudo' powder tattooing, 'pseudo' soot deposition, and 'pseudo' scorching. This knowledge may prevent an over interpretation induced by an inherent high index of clinico-pathological suspicion.

An under awareness of non-missile penetrating injuries simulating a gunshot wound may permit misinterpretation. This artefact is not known to have been reported previously.

Case report

SG was a Caucasian man aged 30 years whose half-naked shirtless body was discovered beneath the balcony of his first floor flat. Although a medical practitioner attended the scene to confirm that life was extinct, it is not known what preliminary medico-legal opinions were expressed. A homicidal firearm death investigation was instigated by the police authority who had the body removed to public mortuary.

Medical history

The deceased had been admitted to a psychiatric hospital some years previous following therapeutic surgical intervention for self-inflicted wounds to his chest. The reason he gave for the attempt to kill himself was that he had sinned against the 'Holy Spirit'. It is not known what implement was used. He was diagnosed as schizophrenic, suffering from religious delusions. He had no further psychotic symptoms and after 20 months his medication was stopped. He remained well but was unable to resume work as an electrician. He was regularly reviewed because of the risk of relapse and it was noted that in the last 6 months he was experiencing further religious thoughts.

Postmortem examination

He had an irregular precordial injury 1.75 x 1.25 inches, transecting an old left lateral thoracotomy scar and incorporating adjacent circular necrotic wounds 0.375 inches and 0.5 inches in diameter. It was clear that the precordial wound was infected and could not be an acute injury. The surrounding skin was gangrenous and blackened. There were satellite superficial 'tentative' abrasions.

There were distinct 6 inch deep double wound tracks from the precordium into the 4th inter-costal space penetrating the left pleural cavity and the pericardial sac. The lung and the heart were not pierced. There were subacute inflammatory changes with empyema thoracis and purulent pericarditis. Microbiological investigation was not done.

A 6 inch dirty metal nail was present *in situ* within the scalp above the right ear. The nailhead was in front of the earlobe and angled backwards. The nail protruded 1.5 inches through a circular skin defect 0.5 inches at its lower end and 0.375 inches at the tip. Local dissection of the scalp injury demonstrated a 3 inch long infected track of the nail inserted in the extracranial subcutaneous plane.

There was also a perforating injury to his right hand which showed a circular defect 0.25 inches on the dorsum and 0.375 inches in the palm. The hand wounds were consistent with a nail similar to that inflicting the scalp injury.

The remainder of the autopsy showed confluent full-thickness small lacerations on the scalp concealed by head hair and various contemporaneous small abrasions consistent with a fall from a moderate height. There were displaced fractures of the skull with extensive overlying subcutaneous contusion and acute subdural haematoma. The cause of death was attributed to the cranio-cerebral trauma.

A subsequent police enquiry at the scene resulted in the recovery of another 6 inch nail on the bed in his flat. The residence of the deceased was found secure and there was no firearm or ammunition in the vicinity.

Inquest verdict

It would seem that after having self-inflicted a non-lethal injury by self-stabbing with an unsterile metal nail, the wound naturally became severely infected as no effort was made to seek medical attention. He probably became febrile and an acute toxic confusional state might explain his fall over the balcony although there is a possibility that the fall could have been as a result of his mental illness. He had

> I tell patients that they've got cancer every day of my working life. I like to think I don't get hard about it, I try to treat every situation individually and be thoughtful about what I say. I think some patients' deaths I've found quite tough, but I don't lose sleep over it – I'm pretty hard in that way.
> **Dr Nick Thatcher – Oncologist**

not been seen by anybody for some time but a neighbour had heard screams and chanting coming from the flat 5 days before. The significance of inserting the nail in the scalp could be interpreted as being symbolic of a 'crown of thorns' and in the hand as representing 'crucifixion'.

An open verdict was recorded since the manner of death cannot be deemed suicide without strict proof of suicidal intent at the time.

Discussion

Gunshot wound characteristics are described in specialist forensic textbooks and the atypical or unusual gunshot wounds feature regularly in forensic literature. It is important that forensic medical examiners (police surgeons) and other doctors who are expected or requested to express preliminary opinions at a scene of death, are aware of non-missile penetrating injuries mimicking a gunshot wound.

In the case reported, there was a suspicion of homicidal firearm death initially because of a misinterpretation at the scene. The non-missile penetrating precordial wound with

Fig. 8.2 – Non-missile penetrating injury resembling bullet wound on the hand, (left) dorsal view after postmortem cleaning and (right) probed palmar view.

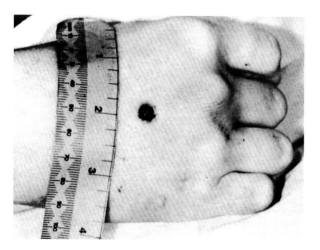

blackened gangrenous skin surround and satellite 'tentative' abrasions, which simulated powder tattooing and soot residue of a close range firearm discharge, was misinterpreted by the crime scene investigators as a gunshot wound. A purple–black appearance of subcutaneous haemorrhage in an injury from a bullet missile may appear to be soot on cursory examination and more commonly the edges of dried-out gunshot wounds indeed take on a black appearance. The perforating injury to his hand with a resemblance to a bullet wound from a small calibre gun appears to have confounded the issue. No firearm or spent ammunition were found at the scene.

Self-inflicted missile injury with a metal nail from a nailgun directed between the eyes in a parasuicide case and into the thigh accidentally have been reported. Non-missile penetrating injury with a sewing needle, which accidentally punctured the heart and caused lethal cardiac tamponade, has been reported and others reviewed.

A careful preliminary assessment of all cases of sudden death and correct diagnosis of criminal activity which saves police time and will further ensure good clinical practice in forensic medicine.

Fig. 8.3 – Non-missile penetrating precorordial injury with blackened gangrenous skin and satelitte 'tentative' marks mistaken as a close range gunshot wound with tatooing.

References

1. Patel F. Artefact in forensic medicine: childhood iatrogenic oral injury. Police Surgeon 1992; 41: 8-9
2. Patel F. Artefact in forensic medicine: fetal congenital abnormality. Am J Forensic Med Pathol 1993; 14: 212-214
3. Patel F. Minerva (Mongolian spot). BMJ 1993; 307: 948
4. Patel F. Artefact in forensic medicine: postmortem rodent activity. J Forensic Sci JFSCA 1994; 39: 257-260
5. DiMaio VJM. An introduction to the classification of gunshot firearms, ballistics, and forensic techniques. New York: Elsevier Scientific Publishing Co, 1985; 4: 52-98
6. Zaki SA, Hanzlick R. Gunshot wound with asphalt related pseudo-soot, pseudo-tattooing, and pseudo-scorching. J Forensic Sci JFSCA 1987; 32: 1136-1140
7. Patel F. Suicide notes and suicidal intent. Police Surgeon 1993; 44: 24
8. Donoghue ER, Kalelkar MB, Richmond JM, Teas SS. Atypical gunshot wounds of entrance: an empirical study. J Forensic Sci JFSCA 1984; 29: 379-388
9. Stone IC, Petty CS. Interpretation of unusual wounds caused by firearms. J Forensic Sci JFSCA 1991; 36: 736-740
10. Peterson BL. External beveling of cranial gunshot entrance wounds. J Forensic Sci JFSCA 1991; 36: 1592-1595
12. Schwarzchild M. Images in clinical medicine. Nail in the brain. N Eng J Med 1993; 328: 620
13. Avision GG, Irwin A, Khaweri FA. Minerva (nail in the thigh) BMJ 1994; 309: 212
14. Shiona H, Akane A, Tanabe K-I, Matusubara K. Cardiac tamponade caused by a stab wound with a sewing needle left in a kimono. Am J Forensic Med Pathol 1993; 14: 155-157

From the Cradle to the Grave

Death Certificates

When a patient dies the morbid anatomy technician is responsible for dealing with a number of certificates that relate to the death; the most important being that which deals with the cremation, as there are a number of forms required.

Form 1 An application by the relatives of the deceased for a cremation.

Form 2 Is signed by the registered doctor who has recently treated the patient and submitted the Death Certificate.

Form 3 Signed by another practising doctor but with no history of treating the deceased or working with the deceased's doctor.

Form 4 Nominated by an independent medical referee who is not satisfied with the statements made by the doctor and requests an independent autopsy.

Form 5 The coroner's report after the autopsy/inquest.

Form 6 Authority to cremate the deceased issued by the medical referee after autopsy is complete.

Form 7 Certificate of cremation.

In a normal situation, a doctor will have treated his/her patient within the last two weeks of his/her life. When the patient dies, the doctor issues a certificate to the next of kin that states the cause of death. This certificate enables disposal of the body.

When a case is referred to a Coroner, various other procedures outlined in other chapters come into operation.

When the body must be taken out of the country for burial, a certificate needs to be issued stating that the corpse if free of communicable diseases.

No specific form is available for such purpose. Common practice suggests that the morbid anatomy technician obtains a certificate from the pathologist who carried out the autopsy.

Fig. i – From the Cradle to the Grave. 2130 x 3050 x 2440mm

9. Cardiotoxic mechanisms and interrelationships of cocaine

Summary The underlying mechanisms of myocardial infarction as a result of cocaine abuse appear to be multifactorial. The various cardiotoxic mechanisms and interrelationships of cocaine are fully reviewed, and a chart has been reconstructed to give the reader a clearer understanding of them. Moreover, an unusual case of a 29-year-old male cocaine abuser is presented because it illustrates many of the reported cardiotoxic effects, all of which are present in the same individual.
F. T. Zugibe, M. Breithaupt, J. Costello

The mechanisms of cocaine cardiotoxicity appear to be multifactorial. Myocardial infarction,[1-19] cardiomyopathy, arrhythmias (ventricular fibrillation, QT prolongation, asystole, atrial fibrillation, etc.), myocarditis, and aortic rupture are the major cardiovascular complications associated with cocaine abuse. At autopsy, the coronary arteries may appear totally normal, or severely occluded as a result of intimal hyperplasia, atherosclerosis, thrombosis or a combination of these. It may be of interest to note that in the case of thrombotic occlusion, no association appears to exist with plaque rupture or heamorrhage as is the case in non-cocaine-related coronary artery thrombosis. The myocardial fibres may appear unremarkable, some may be exhibiting areas of contraction band necrosis suggesting coronary artery spasm[6] or show myocardial infarction in various stages. Focal areas of non-specific myocarditis, hypertrophic cardiomyopathy, patchy myocardial fibrosis, aortic rupture or a combination of these may be present. The purpose of this paper is to collate the various mechanisms and interrelationships of cocaine toxicity and to present an unusual case of a 29-year-old male cocaine abuser with recurrent myocardial infarction that illustrates many of the reported mechanisms in one individual.

Clinical findings
First heart attack
A 29-year-old white male was admitted with severe mid-sternal chest pain and suffered a cardiac arrest in the emergency department, with successful resuscitation. His creatinphosphokinase (CPK) was 12 440 IU/L, CPKMB fraction 458 IU/L and lacticydehydrogenase (LDH) 1850 IU/L. His ECG showed acute anteroseptal, anterior and

Fig. 9.2 – Large area of myocardial fibrosis on anterior septum. Also note the high takeoff of the right coronary ostia located 1.8 cm above the sinotubular junction (black and white arrows). There is a recent transmural infarction with haemorrhage (white arrows).

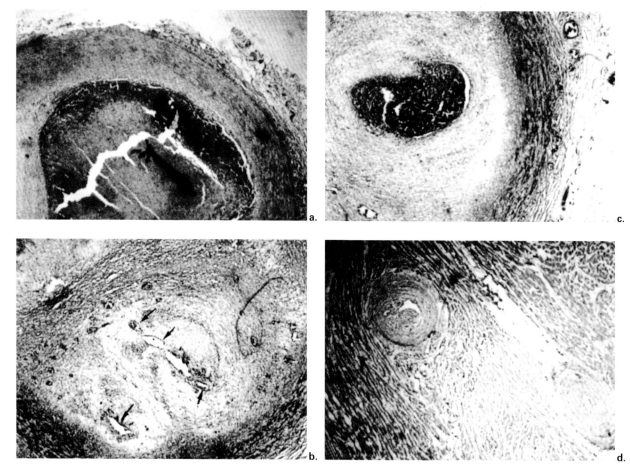

Fig. 9.3 – a: Thrombosis of the distal LM, H&E x250. b: Complete obstruction of the proximal LAD by intimal hyperplasia. Note the multiple foci of recanalization , Trichrome x250. c: Thrombosis of the distal LM at the junction of the LM and the LAD, Trichrome x250. d: Marked intimal hyperplasia of intramural vessels, H&E x250.

anterolateral myocardial infarction and a prolonged QT_c of 0.47. The Capoten protocol with tissue plasminogen activator (TPA) infusion was initiated, and subsequent cathetherization reported severely depressed left ventricular function with marked anterolateral akinesis, single vessel disease with minor lesions in the left anterior descending coronary artery and no occlusions. On the first day of admission, his cholesterol and triglycerides were 245 mg/dl and 345 mg/dl respectively, and on the fifth day they were 162 mg/dl and 196 mg/dl. No drug screen was performed. He was discharged after 1 week.

Second heart attack (2.5 months post-discharge)
He was readmitted with chest pain and radiation into both arms. His CPK was 700 IU/L, CPKMB fraction 38.7 IU/L and LDH 367 IU/L. An ECG showed anterolateral infarction, right bundle branch block, a right axis deviation, a junctional rhythm and a prolonged QT_c of 0.5.

Perhaps you fancied a girl momentarily on the train. An hour later you may have remembered the incident, although a week later you might not. But that would certainly have given you a tweak, changed your heart rate, your endocrine system will have changed. And those changes are never momentary, they always have a long-lasting tail to them. If you admit that memory is a property of the brain, then obviously the brain has to be changing with the environment. In one sense that's an absolute platitude – you learn by changing your brain.

Professor Patrick Wall – Neurophysiologist

A patient was told that there was nothing more that could be done, but there was a treatment that was very much in the early stages that would give unpleasant side effects and may not do any good and would make him feel fairly rotten.

Straight away that person said, 'Yes, I'll try it.' My feeling was, 'No, don't try it, go home, enjoy yourself for the last two or three months if you can, see all your friends, whatever...'
Sister Mandy Smith – Nurse

His cholesterol was 175 mg/dl and triglycerides 172 mg/dl. A drug screen was positive for cocaine and benzoylecgonine. He was discharged after 5 days and on the following day he underwent Cardiolite perfusion imaging, which revealed extensive anterolateral and apical infarction.

Third heart attack (3 days post second discharge)
He felt nervous, took a bath and collapsed. Resuscitation efforts were unsuccessful and he was pronounced dead in the emergency department. He had benzoylecgonine concentrations of 49 mg/l in his blood and 10.5 mg/l in his urine.

Autopsy findings
Macroscopic
The body was 70 inches in height and weighed 170 pounds. There was moderate cardiomegaly with a heart weight of 480 g. A large anterior wall aneurysmal dilation (wall thickness 0.4 cm) measuring 11 cm x 8 cm was striking. An endomyocardial scar extended from the atrioventricular region to the apical area and a large endomyocardial thrombosis permeated the full myocardial thickness in the apical region. The septal wall was thinned to 1.2 cm and showed marked fibrosis, marked hyperaemic margination and a yellowish coloration. The right ventricle was moderately dilated and there was a high takeoff of the right coronary ostia above the sino-tubular junction. Bisection at the junction of the left main coronary artery (LM) and left anterior descending coronary artery (LAD) revealed a complete obstruction of the distal LM by thrombus and a complete fibrous obstruction of the proximal LAD. Both lungs were oedematous and markedly congested and weighed 760 g on the left and 600 g on the right. The liver weighed 2080 g and showed moderate congestion. The kidneys each weighed 210 g, were moderately congested and the surfaces were smooth without evidence of nodularity. The abdominal, thoracic and ascending segments of the aorta showed mild atherosclerosis.

Microscopic
An occlusive platelet thrombus was present in the distal LM that overlayed an essentially normal intima with minimal intimal hyperplasia. Marked intimal hyperplasia of the proximal LAD was present with multiple small areas of recanalized vessels containing erythrocytes. The intimal hyperplasia was concentric and essentially composed of collagen fibres, smooth muscle fibres, and some elastin fibres. Both concentric intimal hyperplasia and an overlying thrombus were present at the junction of the LM and LAD. The intima of the middle portion of the LAD revealed a tiny focal area containing cholesterol clefts. Many intramural vessels with moderate to severe intimal hyperplasia were present. Large areas of coagulation necrosis, advanced removal of necrotic myocytes, highly vascularized granulation tissue, increased eosinophilia and myofibrosis were present. Contraction band necrosis was also noted.

Discussion
In order to reconstruct the cardiotoxic mechanisms involved in this case, one must be familiar with the reported cardiovascular effects of cocaine. The cardiovascular effects of cocaine are multifactorial. Our case is of particular interest because it illustrates many of the reported cardiovascular effects of cocaine cardiotoxicity in one individual, including intimal hyperplasia consisting of smooth muscle, collagen and elastin thrombosis on a relatively normal intima, on an area of non-atherosclerotic intimal hyperplasia and on an area of atherosclerosis; myocardial infarction in various stages, including increased eosinophilia, coagulation necrosis, advanced removal of necrotic myocytes, areas of vascularized granulation tissue and myofibrosis; foci of contraction band necrosis; and QT_c prolong-ation on his ECG.

One of the major effects of cocaine is its ability to block the reuptake of catecholamines in presynaptic peripheral and central nerves, causing a marked rise in norepinephrine noradrenaline production that results in an increase in blood pressure, an increase in heart rate, a decrease in coronary blood flow, a decrease in the diastolic interval, and a decrease in the myocardial oxygen supply. In a large

On a physical level, death in an A & E department or a resuscitation area is often very traumatic. People end up here area because something tragic and unexpected has happened. Say they've been involved in a road traffic accident, then because of the circumstances of the death, the person may be very smashed up and may not look very nice; they may be burnt, or mutilated, or whatever, and you may need to do some quite invasive procedures, i.e. a central venous line into the chest, or intubating them, putting a tube down into the lungs, where you may actually sever a capillary – and there will be plenty of blood around. You try to maintain their dignity by keeping their anatomy covered up, but keeping them covered up isn't the priority; the priority is to get their heart beating again and to get them breathing.

Sister Susan McGuiness – Nurse

number of cases, the consequences of this prolonged increase in catecholamines results in greater myocardial oxygen demands frequently causing prolonged vasoconstriction which, in turn, results in hypoperfusion, thereby causing ischaemia, which may precipitate ventricular fibrillation, and/or myocardial infarction, and/or death.[1] Cocaine-induced vasoconstriction has been confirmed by coronary angiography. In the majority of cases, there appears to be no evidence of cardiovascular disease, but contraction band necrosis is frequently seen.[6] Contraction band necrosis was also prominent in our case. The aetiology of the contraction band necrosis has been attributed to myocardial injury caused by the markedly increased levels of catecholamines or to decreased perfusion through the coronary arteries resulting from brief vasospastic episodes of occlusion followed by vasodilation and reperfusion. Cocaine also appears to raise the calcium level, which exerts a direct effect on calcium influx into blood vessels and myocytes causing myocyte injury or necrosis, and/or contraction band necrosis[7] and/or a dilated cardiomyophathy, or myofibrosis. Other mechanisms of cocaine-induced cardiomyopathy have been reported. The focal myocardial fibrosis present in our case may represent healed contraction band necrosis as suggested by Tazelaar at al. It is of interest to note that the majority of the cases of cocaine-induced myocardial infarction are found in young males in their 20s and 30s. In cases where underlying obstructive coronary artery disease is present, the use of cocaine may prove lethal by virtue of increasing the double product and demand for increased oxygen.[5, 6] The effects of the prolonged increase in catecholamines may also promote or accelerate atheroge-nesis[12, 18] hypertension, and or aortic rupture. Cocaine may promote atherogenesis by virtue of Bernoulli's theorem, where fluid in motion possesses energy by virtue of its velocity and pressure, and a decrease in static pressure induces a 'suction' effect that facilitates changes leading to the formation of an athero-

sclerotic plaque. The increased cardiac output increases the velocity pressure with a reduction in static pressure that may accelerate the development of atherosclerosis.

In our case, and in a significant number of cases, coronary thromboses are present with and without under-lying vascular disease.[10, 18] In this regard, cocaine may enhance the response of platelets to arachidonic acid leading to thromboxane production and platelet aggregation, either as a direct effect or as a consequence of cocaine-induced coronary spasm, thereby causing thrombosis in essentially normal vessels (as well as those with underlying vascular disease) myocardial infarction, and/or death. It has been proposed that arterial thrombi can also be caused by the procoagulant effect of cocaine mediated through the depletion of protein C and antithrombin III. A significant number of reported cardiovascular deaths that are associated with cocaine abuse are due to acute myocardial infarction caused by coronary occlusive disease owing to non-atherosclerotic, intimal hyperplasia, which consists of smooth muscle with or without collagen or elastin, and with or without overlying thrombosis. The completely obstructive intimal hyperplasia of the proximal LAD and the markedly narrowed intramural vessels owing to intimal hyperplasia, which in our case consisted primarily of smooth muscle admixed with collagen and elastin, was consistent with reported cases that are believed to be caused by prolonged vasoconstriction and/or by smooth-muscle growth-factor stimulation relating to the platelet response to the arachidonic acid sequence, or may be due to endothelial disruption or injury.[18] Platelet-derived growth factor (PDGF) has also been reported to induce intimal proliferative lesions. Norepinephrine is also known to induce intimal proliferative lesions and it also acts directly on myocytes, causing myocardial dysfunction and platelet aggregation, which impairs the action potential generation implicated in the induction of myocyte necrosis and produces an associated inflammatory component. The

Fig. 9.4 – A Way of Seeing. 2440 x 3960 x 3050mm

...we have sorted out the liver and the kidney, and the heart and the lungs, we will have despatched the offal – that's the human body in comparison with the brain. The way in which mind and matter integrate and create is the fundamental mystery of life. The brain is the only organ that truly comm-ands all. I mean, to watch the workings of the kidney is a miracle of nature, but the brain is in a different order. And unravelling the brain is going to take – I was going to say a lifetime – an eternity, I suspect, and we're only beginning.

Professor Anthony Clare – Psychiatrist

platelet aggregation may also result in thrombosis in the areas of intimal hyperplasia or in areas of atheromatosis, causing ischaemia, infarction and death. It may be of interest that the coronary angiography performed following the first admission in our case revealed no obstructive lesions, yet autopsy showed severe concentric intimal hyperplasia of the LM and the LAD. Karch[7] indicates that there may be a problem in diagnosis if a concentric intimal

I mean, in one sense all of nature's flawed, if you want to use the notion of flaw meaning anything that has a defect or a potential to disease. If you're someone who gets depressed by defect, don't go into medicine. Go on to the wards and you begin to wonder how do people normally function? You see every system with disturbances. But defect is the very essence of medicine; medicine is about defect. That's why doctors become either rather cynical or hypochondriacal.

Professor Anthony Clare – Psychiatrist

obstruction is present because it is likely to be overlooked. There may be a failure in detecting the presence of concentric intimal hyperplasia in cocaine users who suffer myocardial infarction, because the hyperplasia involves the whole length of the coronary arteries.

It is also common knowledge in cardiology that the interpretation of coronary arteriograms is primarily subjective, that severity of arteriograms are frequently underestimated by angiographers when compared to autopsy findings, that contrast arteriograms are two-dimensional representations of three-dimensional structures, and that in the presence of severe proximal lesions, the contrast does not always fill the distal segment adequately for proper evaluation. Cocaine's ability to block the reuptake of catecholamines in presynaptic peripheral and central nerves is also responsible for the production of serious dysarrhythmias by virtue of the resultant myocardial ischaemia caused by prolonged vasoconstriction, and by its effect in causing an increase in intracellular calcium.[16] It is also important to consider the anaesthetic effect (membrane stabilizing effect) of cocaine owing to the blockade of sodium channels, causing a reduction in sodium transport and, consequently, promoting dysrhythmias. Local anaesthetic effects can lead to prolongation of the QT_c and QRS intervals, which may promote arrhythmogenesis and death, much like that of quinidine and other first level antiarrhythmic agents.[7,14] The ECGs in our case showed prolonged QT_c intervals of 0.47 on the first hospital admission and 0.50 on the second admission. Moreover, the frequency of premature ventricular contractions increased when cocaine was used as a local anaesthetic for laryngoscopy.

In addition, the high takeoff of the right coronary ostia could cause ischaemia from hypoperfusion, even if now other pathology is present, since the sinuses of Valsalva permit maximal opportunity for diastolic filling. Any hypoperfusion resulting from the presence of a high takeoff of the right coronary artery would be of particular importance in this case, because it would have added to the ischaemia caused by the coronary artery narrowing.

Fig. 9.5 – Light micrograph of human heart muscle (myocardium) from the right ventricle following myocardial infarction, the death of a section of heart muscle resulting from an obstruction in a coronary artery. The fragmented fibres stain more deeply than normal muscle. If the patient survives the heart attack, the repair begins, heralded by an invasion of polymorphs (white blood cells).

Fig. 9.6 – Necrosis and fibrosis following myocardial infarction. Light micrograph of human heart muscle (myocardium) from the left ventricle following myocardial infarction. Infarcted and fragmented muscle fibres occupy the right of the image, giving way to a necrotic mass of digested muscle which is undergoing the process of fibrous repair. This process takes place in surviving patients.

...most of our modern understanding of how nerves work, which is fundamental to our whole knowledge of the brain and nervous system, how drugs act on nerves, how anaesthetics work, all of that came out of work on – wait for it – the nerve of the squid. Hodgkin and Huxley, who won a Nobel prize for that work, were interested in how nerves work in their own bodies. They chose something that was big, easy to keep alive in a dish, and easy to manipulate, so they chose the giant nerve fibre of the squid, which is about a millimetre or more in diameter,

a huge thing, but the principles they found applied to us.

A very large proportion of our practical work was done on whole, anaesthetized, de-cerebrate animals. In my opinion that contact with living tissue was not only educationally valuable in that it gave one an insight as to how the whole body works, which you can never get in the same way from a textbook, but it was also crucially important for people whose next contact with living tissue would be with people.

Professor Colin Blakemore – Physiologist

Conclusion

A careful review and reconstruction of the reported cases completely supports the hypothesis that the mechanisms of cardiotoxicity are multifactorial. In addition, an unusual case of cocaine toxicity in a 29-year-old male cocaine abuser illustrates the existence of many of these mechanisms in one individual. The finding of a high takeoff of the right coronary ostia in this case would have further accelerated the development of ischemia.

References

1. Amin M, Gabelman G, Buttrick P. Cocaine-induced myocardial infarction. Postgrad Med 1991; 90: 50-55
2. Coleman DL, Ross TF Naughton JL. Myocardial ischemia and infarction related to recreational cocaine use. West J Med 1982; 136: 444-446
3. Cregler LL, Mark, H. Medical complications of cocaine abuse. N Engl J Med 1986; 315: 1495-1499
4. Cregler LL, Mark, H. Relation of acute myocardial infarction to cocaine abuse. Am J Cardiol 1985; 56: 794
5. Howeard RE, Hueter DC, Davis GJ. Acute myocardial infarction following cocaine abuse in a young woman with normal coronary arteries. JAMA 1985; 254: 95-96
6. Isner JM, Chokshi SK. Cocaine-induced myocardial infarction: clinical observations and pathogenetic considerations. NIDA Research-Monograph. 1991; 108: 121-130
7. Karch SC, Billingham ME. The pathology and etiology of cocaine-induced heart disease. Arch Path Lab Med 1988; 112: 225-230
8. Kossowsky WA Lyon AF. Cocaine and acute myocardial infarction: a probable connection.

9. Lange RA, Cigarroa RJ, Yancy CW Jr et al. Cocaine-induced coronary artery vasoconstriction. N Engl J Med 1989; 321(23): 1557-1562
10. Minor RL Jr, Scott BD, Brown DD, Winniford MD. Cocaine-induced myocardial infarction in patients with normal coronary arteries. Ann Int Med 1991; 115: 797-806
11. Mittleman RE, Wetli CV. Death caused by recreational cocaine use: an update. JAMA 1984; 252: 1889-1893
12. Mittleman RE, Wetli CV. Cocaine and sudden 'natural death'. J For Sci 1987; 32: 11-19
13. Pasternack PF, Colvin SB, Baumann FG. Cocaine-induced angina pectoris and acute myocardial infarction in patients younger than 40 years. Am J Cardiol 1985; 55: 847-848
14. Rezkall SH, Hale S, Kloner RA. Cocaine-induced heart diseases, Am H J 1990; 120: 1403-1408
15. Rod JL, Zucker RP. Myocardial infarction shortly after cocaine inhalation. Am J Cardiol 1987; 59: 62
16. Russell EH, Hueter DC, Davis GJ. Acute myocardial infarction following cocaine abuse in a young woman with normal coronary arteries. JAMA 1985; 254: 95-96
17. Schachne JS, Roberts BH, Thompson PD. Coronary artery spasm and myocardial infarction associated with cocaine use. N Engl J Med 1984; 310: 1665-1666
18. Simpson RW, Edwards WD. Pathogenesis of cocaine-induced ischemic heart disease. Arch Path Lab Med 1986; 110: 479-484
19. Smith HW III, Liberman HA, Brody SL, Batty LL, Donohue BC, Morris DC. Acute myocardial infarction temporally related to cocaine use: clinical angiographic and pathophysiologic observations. Ann Int Med 1987; 107: 13-18

Fig. 10.1 – A Way of Seeing (detail). 2440 x 3960 x 3050mm

10. Revealing Reality Within a Body of Imaginary Things
George Poste

When I shall be dead, the principles of which I am composed will still perform their part in the universe and will be equally useful in the grand fabric, as when they composed this individual creature.
David Hume (1773), Essays: Literal, Political and Moral, Oxford University Press (1963)

Science draws its inspiration from often vague and tentative but wider cultural shifts and transmutes them into highly focused, vigorous, clear language and into powerful images and metaphors.
Ian Marshall and Danah Zohar, Who's Afraid of Schrödinger's Cat, William Morrow, New York (1997)

Without the instruments and accumulated knowledge of the natural and sciences – physics, chemistry and biology – humans are trapped in a cognitive prison. They are like intelligent fish born in a deep, shadowed pool.
E.O. Wilson, Consilience: The Unity of Knowledge. Alfred A Knopf, New York (1998)

A paradox is not a conflict within reality. It is a conflict between reality and your feeling of what reality should be like.
Richard Feynman, Nobel Laureate in Physics (1958)

A thing... is full of threats and promises. Glass 'threatens' to break on impact; sugar 'promises' to dissolve in our tea. We credit objects or substances with a whole range of powers, propensities and tendencies to do certain things, or react in certain ways, upon the realization of certain conditions.
Helen Steward, Dormitive Virtues Times Literary Supplement 19 May 2000

The title chosen by Hirst for this exhibition, *Theories, Models, Methods, Approaches, Assumptions, Results and Findings*, captures the paradigmatic framework for modern science in formulating testable hypotheses to explain and codify natural phenomenon and to analyse and interpret data obtained from experimental observation, whether at the level of the visible or the invisible. The essence of the contemporary scientific method is that all phenomena – physical, chemical and biological – can be laid bare to reveal the elegance of the underlying principles of design, and how these principles are employed in nature to generate limitless complexity, extravagant diversity and, most important, to maintain the inherent plasticity required to generate new forms by the relentless imposition of change, mutation and transformation.

'Complexity', the Reverend William Paley observed in the eighteenth century, 'is a property of things, one as notable as their shape and mass.' It was a shrewd, and very modern observation. Complexity now seems more complex than ever. Hirst's selection of ping pong balls and an air blower in a contoured cabinet to convey simultaneously the reductionist simplicity of the individual elements and the complexity of the multi-component system as the universal template on which all order and disorder are shaped reflects an incisive conceptual comprehension, combined with masterful understatement and tutorial clarity. This work provides a visual metaphor of the efforts

+ .97 0011-8532/90 0.00

of science to define the mechanistic topography of the natural world.

This work captures in a straightforward manner the five cardinal elements of our current understanding of unifying themes in natural phenomena: 1) that the range of interactions and outcomes that can occur between interacting particles (atoms, molecules, cells, organs, people, cultures, ecosystems, galaxies) when a perturbing force is applied is limitless; 2) that the evolving 'pattern' of order produced by any particular combination of inter-actants and perturbants will reach a point at which the assembled system becomes self-organising and will impose inescapable fate(s) on the interacting elements; 3) that the boundary between the seemingly random, chaotic behaviour of the interactants and their transition into ordered structures is fluid, fleeting, fragile and under constant siege, poised to tip in either direction with the slightest change of the environmental conditions (in this exhibit the velocity and direction of the air jet, the number of people in the gallery affecting the vibration of the floor and shifts in temperature and humidity are but a few of the relevant variables); 4) that knowledge of the precise position and properties of all of the interacting particles will allow their fates to be simulated and predicted with a high level of precision; and 5) that the scientific desire for absolute precision and predictability stated in the preceding sentence will never be attainable since the vagaries of quantum mechanics will impose a final frustration in which Schrödinger's infamous cat will purr contentedly in recognition of the fact that the very act of observation will alter the system being observed so that it will never be exactly as it seems.

The parts of the holistic system change through their participation in the system. The Explicate Order of Newtonian physics gives way to the shadowy realm of the Implicate Order. The more we try to pin it down the more it eludes us. The uncertainty principle trumps all! Indeterminancy, non-linearity, superposition, non-locality, relational holism, acausality, chaos, catastrophe theory and cats that are simultaneously alive and dead have become the talismans of the new physics.

The fall of a sandcastle on the English coast changes the nature of the Great Pyramid.

J.McT.E. McTaggart (1921)

In his minimalist conceptualization of the dynamics of the order:disorder continuum, Hirst sustains a thematic fidelity, albeit using a very different format, with earlier, more explicit, and more easily sensed, presentations of the frailty of living systems in the face of the ubiquitous risks of decline, decay and death. The rotting and diseased flesh, electrocuted flies and torn butterflies presented in Hirst's art are but manifestations of the order:disorder continuum. This new piece provides an unambiguous illustration of how quickly seemingly stable structures can dissipate rapidly into disorder and entropic collapse to generate new patterns and assemblies that will be subject to yet more transitions and a never-ending series of cyclical shifts between chaotic disorder and reconfiguration into new assemblies. Darwin lives! This work could (and should) be taken into any school classroom to illustrate the order: disorder continuum as the single defining characteristic of the natural universe and the driving force behind its inherent metastability and the blind, uncaring evolutionary forces that act on every component in the universe from the simplest basic building blocks (atoms and molecules) to the most complex systems (global ecological networks and galactic expansion and contraction). The chain between cause and effect can be subtle and sinister. A butterfly flaps its wings in Africa and generates a hurricane in Florida; converting British cattle into carnivores made them mad and the silent prions from the brains of these altered beasts now threaten man; and the electronic tentacles of the worldwide web forge unprecedented patterns of human connectivity in cyberspace with what unknown outcomes to follow?

All is order, all is disorder. Much may be understood, but something will always remain elusive, ready to create the next vectors of surprise, elation or dread.

The constant flirtation between order and disorder is also portrayed in several other pieces in the current exhibition. *The History of Pain* exposes a floating beach ball of pristine white innocence to the omnipresent threat of Sabatier blades of honed, ablative savagery. The thicket of threat will cut or kill at any moment with only the uncertain lifeline of an air jet to offer protection against danger and sudden demise. But mere chance alone does not determine the risk. If every aspect of the trajectory of the ball, and the physics of vortices and eddies of air currents existing around the blades were known, then the risk to the ball, and the probabilities as to which knives might injure, could be predicted and interventions made to

accelerate or prevent damaging collision. Once again, Hirst provides a powerful representation of the primary purpose of the scientific method to identify, control and alter natural phenomena by the acquisition of reliable knowledge, while also providing a more straightforward allegorical representation that life's a bitch and that there are a lot of different things out there to hurt you, to get you killed.

Hirst's engagement with complexity and combinatorial diversity is also manifest in his well known spin- and spot -paintings. New versions of the latter appear in this exhibition. Hirst has often stated that he is overwhelmed by the infinite possibilities of painting. In Hirst's grids of dots the colours are never used twice but to his apparent chagrin: 'No matter how I feel as an artist, the paintings end up looking happy. We are used to picking out chords of the same colour and balancing them with the chords of other colours to create meaning but with a never-repeat-a-colour-system this can't happen. So in every painting there is a subliminal sense of unease.' (Interview with Martin Gayford, *Modern Painters*, 1998.)

He that has eyes to see and ears to hear may convince himself that no mortal can keep a secret. If his lips are silent, he chatters with his fingertips; betrayal oozes out of him at every pore.
Sigmund Freud (1905)

Without history, without art, with a memory that begins with each morning's wakings and ends with the night's sleep, they are able to achieve a numbness far more comforting to the spirit than the always dangerous and sometimes fatal exploration of self and world which was the aim of our old culture, now discarded.
Gore Vidal, Two Sisters (1964)

All information can be expressed digitally. All information can be transported in digital form. All information can be stored in digital form.
Andrew Grove, Chief Executive, Intel Corp, What Can Be Done, Will Be Done. Forbes ASAP (1996)

We have reached the epoch of the nanosecond. That is our condition, a culmination of millennia of evolution of human societies, technologies and habits of minds.
James Gleick, Faster. The Acceleration of Just About Everything, Pantheon Books, New York (1999)

Man is so perfectible and corruptible that he can become a madman through sheer intellect.
George Christophe Lichtenberg (1778)

Death, particularly if violent, traumatic or painful, commands centre stage in Hirst's iconography and collage. But several new dimensions of his exploration of this theme are evident in the current exhibition.

In two related works, *Skullduggery* and *Death is Irrelevant*, Hirst's intellectual forays into medicine are harnessed to invoke the latest concepts from the vanguard of the neuro-sciences and computing.

By adorning a skull and a supine skeleton with *faux* eyes suspended, cartoon-like, outside the spatial constraints of the skull and rendered resistant to the fermented decay of the grave that strips all other flesh, Hirst emphasises the importance of the eyes as a dominant sensory conduit in life but conveys the future prospect of the eye as an engineered, manipulatable portal in the new world of cognitive neuroscience and the pending union of miniaturised mechanical sensors with the natural senses.

When a viewed image floods our brain, a formidable cascade of information transfer, processing and storage occurs. The visual image of the external world first enters the eye encoded in the photonic quanta of light waves that strike the retina at the back of the eye. The retina converts this optical signal into a series of chemical signals which, in turn, are transmuted into an electrical signal that travels down the optic nerve to different regions of the brain for processing and to elicit the instant reaction that is followed by eventual conversion into stored memory.

As modern neuroscience probes these remarkable events, the question emerges as to how far these processes, when fully dissected into their molecular chemistries, could be reproduced in the brain artificially without the original image ever being seen by the recipient. Of the difficult signals used to link the eye and the cognitive centres of the brain, the electrical signals pulsing down the fibres of the optic nerve are the simplest to monitor and can be converted reliably into a digitised form. If the 'digital signature' of any image can be captured, the question arises as to whether implanting this digitised signature into a brain that had never seen the original image would evoke the same response that the original viewer had experienced? If so, could a historical digital archive of an individual's visual experiences, and the accompanying repertoire of evoked emotions and

memories, be transferred to another individual? If so, the eye becomes an information portal that transcends the grave, heralding the dawn of extropian man. Stored mental information could be transferable between individuals in-life, and to others after-life. Hirst's disembodied, extropian eyes define the future digital vehicle for the transfer of visual and cognitive experiences that transcend death, eclipse time, and obliterate individuality.

Should we fear this novel cognitive frontier or pursue it with intense desire? Is Hirst making an optimistic statement about the technological capacities that now appear on the near-horizon or is he offering an alarm call to the prospect of inevitable abuse whenever technology creates powerful tools that have the conflicting duality of both beneficent and malignant applications? In these two works, Hirst captures brilliantly the unprecedented power of modern technology and the likely future prospect of miniaturised computational devices (silicon) implanted in our bodies (carbon) to general carbon-silicon hybrids as the first electronic-organic progenitors of cyborgian evolution.

Science and technology multiply around us. To an increasing extent they dictate the language in which we speak and think. Either we use those languages, or we remain mute.
J.G. Ballard (1974)

Speed is the form of ecstasy the technical revolution has bestowed on man. He is caught in a fragment of time cut off from both the past and the future; he is wrenched from the continuity of time, he is outside time.
Milan Kundera, Slowness, Harper Collins, New York (1966)

The art world is a very prissy little thing over in the corner, while the major cultural forces are being determined by technoscience. The whole way we imagine ourselves is being redefined, and the art world is still talking about garden politics or whatever, without taking on big corporate biotechnical advance.
Natalie Jermijenko, New York Times Magazine, 11 June 2000.

In highlighting the capabilities of science to alter human cognitive capacities, including the radical prospect of up- and down-loading visual images and other sensory inputs, Hirst strikes a thematic continuity with earlier works that emphasise the readiness of many in western society to strike a Faustian bargain for the purpose of instant gratification and access to the comforts offered by each generation of new technologies. One need not look far to sense the scale of the bargain that has been struck: happiness, addictive euphoria and geriatric libido, all made possible by modern synthetic chemistry; the rise of the 'virtual' experience as the escape from the challenge of 'the real' brought to you in your home courtesy of broad band-width telecommunications; the insidious onward march of corporate techno-globalism and its commercial imperatives of global branding and cultural homogenisation; the erosion of critical faculties washed away by the tidal wave of banal, dumbed-down entertainment, media triviali-sation and the preoccupation with celebrity; the legitimi-sation of self-indulgence; and the accelerating retreat from responsibility and accountability for one's own actions.

For many in the arts community, the obligate and growing dependency of society on the fruits of tech-nology, and the concentration of ideological and economic power in the hands of those who define and control *terra technologica*, are highly threatening. The perceived threat from science, and the accompanying knee-jerk opposition to its progress, are manifest primarily in the privileged salons of the chattering classes who espouse fashionable anti-technology slogans, advocate the adoption of 'alter-native' lifestyles and mindlessly mouth new age mantras while hypocritically indulging in the benefits of modern medicine, telecommunications and the myriad other phys-ical comforts bestowed on *Homo economicus* in the more affluent cohorts of western society.

Hirst does not succumb to trite over-simplification about the complex relationships between society and new technologies. His forthrightness, manifest both in his art and in his opinions, neither praises nor condemns the role of technology in shaping the human condition. But he observes with a critical and searing eye. He offers the viewer the opportunity to discern features and relationships that might have gone unnoticed if these subjects were presented in a less explicit manner or in a more muted collage.

The vitrine remains a central element in this new collection of Hirst's art. As in the past, he exploits this medium with consummate skill to demarcate spaces, to delineate boundaries and to highlight relationships within each piece to lure the viewer's attention, while simultan-eously imposing a subtle physical barrier which the viewer is not allowed to transcend.

The mirrored wall between the two cadavers in *Adam and Eve (Banished from the Garden)* conveys not just the physical separation imposed by death but also epitomises the emotional distancing that is now tragically more the norm than the exception in longstanding relationships, endured and maintained for all the wrong reasons.

In *A Way of Seeing,* the enclosure of the doctor within the vitrine makes his act of judging the clinical fates of the individuals whose specimens adorn his desk a distant and alien process. This provides a perfect metaphor for the remoteness and dismissive arrogance of many within the medical profession towards their patients. The high priesthood of secular medicine has replaced the church as the source of salvation. The physician priest, clothed in the identifiable robes of the new technological religion, sits at an altar adorned with the expensive totems of modern medicine. Medicine takes high ritual to a fine art, to be choreographed carefully to induce maximum respect from a vulgar public who must be kept ignorant about the scientific gospels and accept without comment or dissent the wisdom of decisions made about their own care.

The cheap trinkets of seaside holidays lie scattered in the outer compartment of the vitrine, symbolising disdain for the plebeian pleasures of holidays or other trivial distractions from the demands of 'high science'. The misplaced paternalism and patronising attitudes of far too many physicians towards their patients is laid bare. The 'Trust me I'm a Doctor' syndrome, incubated from the outset of medical school education, can all too quickly become a dangerous camouflage for clinical incompetence. The cynical arrogance of those in the medical profession whose only refuge lies in some long distant qualification, now long rendered irrelevant by the pace of change in medical knowledge, is also captured by Hirst by the subtle insertion into this exhibit of a flagrant violation of current rules about laboratory safety which ban smoking and eating. Surely, such rules 'do not apply TO ME?' – the quintessential pompous professional is alive and well, and too many patients are paying the price.

In assessing the full range of Hirst's depiction of scientific and medical themes over the past decade it is difficult to discern whether he applauds or deplores the way medical technologies are evolving. Does he oscillate between the two poles or is he neutral about the socio-cultural implications, seeing medicine merely as a rich vein of visual material to be mined by his artistic innovation?

No one who has talked with Damien would deny his intellectual curiosity about the technical foundations of the modern life sciences and their practical applications in pharmacy, medicine, surgery and forensic analysis. His personal library shelves bear witness to his scholarship. Medical texts are now a routine element of his studio décor, often to be brandished before the next unsuspecting visitor to expose them to images, typically highly graphic, just discovered by Damien as new grist for his aesthetic mill.

Experiment is the sole source of truth.
Henri Poincare (1887)

We take our cue from science, at once the source of our material achievements and the model of cumulative, self-perpetuating enquiry, which guarantees its continuation precisely by its willingness to submit every advance to the risk of supersession.
Christopher Lasch, The True and Only Heaven: Progress and Its Critics, Norton, New York (1991)

Dreams of the far future destiny of man, the old dream of Man as God were dragging up from its shallow and unquiet grave. The very experiences of the dissecting room and the pathological laboratory were breeding a conviction that the stifling of all deep-set repugnances was the first essential for progress.
C.S. Lewis, That Hideous Strength, Macmillan, London (1976)

The condition of the modern man, with his mobility and his displaced knowledge, is never to be able to share a sense of belonging. He will always be an outsider; His return to nature will always be partial, touristic and semi-detached.
Jonathan Bate, The Song of the Earth, Macmillan, London (2000)

In addressing the big issues of the intrinsic frailty and vulnerability of life, the constant presence of death and disability and the role of ingenious technologies in blunting the ravages of disease, Hirst appears to respect the enormity of the technical challenges and the accomplishments made. His fascination with the underlying principles of biological design and function is consistent with the technological

imperative to dissect to identify the root cause of disease in order to design new ways to palliate, cure and, ideally, prevent illness and to delay the infirmities of old age. *Stripteaser, Trinity…* and *The Void* each provide a collage of stages in the evolution of medical knowledge. Comparative anatomy, physiology and pathology – the study of form, function and disease in animals – has been a fertile source of research knowledge to better inform human medicine. This theme is reflected in *Something Solid Beneath the Surface of Several Things Wise and Wonderful.* The delicate skeletal structures in this exhibit illustrate the exquisite economy of biological design. The same bony structures can be identified in the diverse skeletons but each are adapted by evolution to accommodate the selection pressures of evolutionary time.

But even in these works, and certainly in the other pieces discussed below, one senses that Hirst entertains a far more complex interpretation and seeks to convey on occasions a more sinister montage of fear, morbid fascination, nihilism and futility in the representation of the human body and its clinical encounters.

The obstetrical dyad of *Love Lost* and *Lost Love* combine sardonic humour with the contentment of contemplated parenthood and a subliminal theme of sex and violence. The bondage innuendo of the female patient strapped to the stirruped chair, the marriage ring removed from the obstetrical digit when probing a third party and the clever selection of the piscine battalions produce a complex iconography that juxtaposes the celebration of delicate new life created with the brute physical forces of sex and its consequences.

Fish have long been used as symbols of life and fertility because of their fecundity and the vast numbers of gametes which they spread casually on the waters. In psychoanalytic theory the fish is a symbol for the penis. Other attributions in history place fish as the strange creatures of the deep that were the first to leave the water for land to begin the evolutionary journey that culminated in the human form. Less attractive representations of fish as artistic metaphors of reproduction are seen in Ulrike Rosenbach's graphic performance art tableaux, in which her associate Heinz Cibulka holds up a gutted fish to his penis as a surrogate vagina. The volatile chemical, trimethylamine, produced in human vaginal secretions, is the principal chemical essence of decaying fish and fishy vaginas have long featured in the lexicon of sexual innuendo in the schoolyard and laddish culture.

At a more elevated level of interpretation, the aquatic environment provides a compelling metaphor for the protective cocoon of the amniotic sac in which the unborn foetus floats, while the darting movements of the fish portray the increasingly confident mobility of the sentient foetus. In *Love Lost,* the fish selected have bright attractive forms, conveying residual affection towards a precious legacy from one no longer present. In contrast, in *Lost Love,* the larger, dark fish cast a threatening air to portray the gestational product as the unwanted, rejected, brooding incubus from a historical liaison no longer cherished. The unattractiveness of the dark fish also embodies the unspoken fear of every parent that their progeny will not be blond or blue-eyed as desired or, horror of horrors, be deformed and exposed to societal rejection and discrimination as savage as any racial apartheid.

The portrayal in *Love Lost* and *Lost Love* of the extremes of the reproductive process succeeds in conveying the serenity and anticipated joy of expectant parenthood with the unstated recognition of the pain of the birth to come and the readily denied prospect that other pregnancies will be unwanted or will end in the teratology of deformity and shattered lives. On balance, these works stake an optimistic claim, reinforced by the calm of the muted blue-white hues of the water suffused by life-giving nutrients and oxygen.

No comparable optimistic claim can be made for two other pieces in the exhibition, *An Unreasonable Fear of Death and Dying* and *From the Cradle to the Grave.* These depict the inescapable degradation, squalor and futility that beset the lives of so many in old age. The all encompassing physical and mental decay that Edmund Burke called the 'silent touches of time,' are revealed with typical Hirstian starkness. Although the perils and pain of the deteriorating body have long been a signature element in Hirst's work, these pieces are the first to explicitly represent the vagaries of life lived to old age.

The parts of the stones where a liquid sap blended with the early substances were changed into flesh, the solid part that nothing could soften transformed to bone. What had been veins in the rock kept that same form and name… Thus we were a hardy race made for toil; all that we are gives evidence of our origin.
Ovid Metamorphosis

Death takes us piecemeal, not at a gulp.
Seneca

These men lie in wait for their own blood, they set a trap
for their own lives.
Proverbs 1:18

In *An Unreasonable Fear of Death and Dying,* a chainsaw
penetrates the cushion of the most used chair in the house,
targeting the atrophic genitals of the occupant that would
have lain flattened as lifeless folds of tissue on the delap-
idated fabric. No more stark symbol of the violence of final
excision could be offered: savage castration and buggery
as reward for a life wasted and rendered inconsequential
at its end.

The shabby furniture in *An Unreasonable Fear of Death
and Dying* dates from a different era. The scattered debris
of kitsch trinkets attests to the owner's foreshortened hori-
zons and the accumulated grunge reflects the economic
marginality that confronts so many in old age. Confined by
a vicious cycle of poverty, apathy, isolation and fetid decay,
they retreat from any interaction with the external world
and the outside world ignores them. In Hirst's skilful collage,
the *memento mori* of the squalid room are rendered even
more grotesque by the dominating presence of the latest
high-definition television and the displayed image of CNN
as the only window to the outside world. 'We've done our
bit for grandpa by buying him the latest TV': so reads the
confessional of the modern family in absolving itself from
any need to visit their aged forebears let alone involve them
in life outside of the electronic box or their physical cell.

It was a 'sort of duty' to get inside places as filthy as the
Brooker's boarding house. It was best not to stay too long.
The smell was an immoral act; it spoke of a collapse of all
decent domestic values.
George Orwell, The Road to Wigan Pier, Victor Golancz,
London (1937)

The excremental soiling of the adjacent vitrined lavatorial
space in *An Unreasonable Fear of Death and Dying* chronicles
the travails of geriatric incontinence and the abandonment
of personal hygiene by the increasingly forgetful, or overtly
addled, aged mind. The survival of libido is a stronger
instinct than intellect and the nominal titillation of soft porn
magazines retains its attraction in Hirst's geriatric cage.

The only element of this striking assemblage that the
viewer cannot experience is the characteristic odour of the
slow decay that would pervade such quarters and the
tactile slime of the accumulated microscopic films of dirt,
dust and shed skin cells, deposited as a thickening patina
on every surface of this hovel. The inescapable smell, and
the physical smectic depositions, bear witness to neglect,
apathy and the extinction of purpose. Hirst captures these
ephemeral elements with dramatic incisiveness by his use
of a blood film to contaminate and colonise every surface
of the living area. This overt film cannot be ignored by the
viewer and provides a brilliant surrogate for the wafted
olfactory scents and accumulated microscopic flotsam.
These are ignored blissfully by the occupant but form an
increasingly suffocating barrier that banishes others from
any desire to visit. In this dank, dismal room the blood is
cast as an effluvial film, exuded as life nears its futile end
with nothing accomplished and with no meaningful
memories to transcend pending death as a legacy to those
who live on. Do such lives ever have any fear, or even
registry, of death and dying?

The intellect of man is forced to choose.
Perfection of the life, or of the work,
And if it take the second must refuse
A heavenly mansion, raging in the dark.
When all that story's finished, what's the news?
In luck or out, the toil has left its mark:
That old perplexity an empty purse,
Or the day's vanity, the night's remorse.
W.B Yeats, The Choice (1954)

Rather than expressing a new classless society in a fresh
way as everyone imagines it does because of the hype –
the argument goes – in fact the (YBA) art expresses middle
class contempt for the working classes.
Matthew Collings, Dimocracy, Modern Painters (2000)

A similar range of sentiments, encompassing the empti-
ness, futility, frustration and isolation of so many geriatric
lives, is also captured by Hirst in *From the Cradle to the
Grave.* The dichotomy of life at work and at home is defined
by the guillotine wall of the vitrine that separates these
two, separate, almost schizoid, existences. The compart-
ments of the vitrine demarcate the structured behaviours
adopted in the two environments and the numbing bore-

Revealing Reality Within a Body of Imaginary Things

+ .103 0011-8532/90 0.00

dom and routines of life in each. These two compartments abut to a third vitrinic space that lies beyond, empty save only for a walking stick to blunt the infirmities of old age.

Other telling social observations are captured by Hirst in this piece. The superior status of life at work versus the home is reflected in the broken and chipped Formica of the home furniture. The surrender to the social pretensions of the workplace are conveyed by the presence of the quality broadsheet newspaper on the work desk while escape to the home environment allows the crap of the tabloid press to be enjoyed with no apology and no risk of oversight by prying eyes. The toys scattered on the home carpet link the generations, from *Star Wars* robots to the cyber-heroine, Lara Croft, reflecting an eternity of residence in this unchanging space and the transition from parent to grandparent. Ageing is also conveyed by the presbyopic reading glasses and the transition to toothlessness. No bite, no purpose and just a walking stick awaits as a reward for a lifetime of work and sacrifice.

The three sources from which our suffering comes: the superior power of nature, the feebleness of our own bodies and the inadequacies of the regulations which adjust the mutual relationships of human beings in the family, the state and society.
Sigmund Freud, Civilization and its Discontents (1895)

In mourning, it is the world which has become poor and empty; in melancholia it is the ego itself.
Sigmund Freud, Mourning and Melancholia (1902)

The challenge of the new century will be how to create suitable amusement and a suitably powerful psychopharmacology to entertain the masses, and to control the unemployed and the unemployable.
Jacques Servan-Schreiber (1968)

Some lose conviction in mid-arc of play, their skin turns numb, they dress and will depart:
The perfect body lingering on goodbyes, cannot find strength now for another start.
Dealers move in; and murmuring advertise drugs from each doorway with a business frown.
Thom Gunn, Boss Cupid, Farrar, Straus and Giroux, New York (1999)

The progressive relegation of existence to futility and insignificance is neither instant nor preordained. The descent occurs in the company of many travelling companions: neglect, abandonment, apathy, timidity, hostility, resentment, denial, nihilism and, ultimately, the final paralysis of inaction, and then death. More and more individuals in modern society seem unable to summon the strength to resist these forces. Perhaps it is this disturbing social reality that lies at the heart of Hirst's longstanding attention to the role of chemical substances, natural and synthetic, in muting the shrill voices of the psychological (and psychiatric) demons that dash expectations, frustrate aspirations, injure pride, deflate egos, numb the mind and amplify the trauma of unrequited or unreturned love and, in so doing, catalyse the destructive desires of individuals to engage in denial, indulgence, victimhood, depressive withdrawal and progressive channeling into ever narrower, ever darker, mental corridors from which they will not return. The void awaits; a dark sucking space that swallows self-esteem, shatters loving relationships and suffocates all desires. Hirst's *The Void* defines the savage irony of pharmaceutical salvation from these lurking fates for the price of the inevitable encounter with the future void imposed by spurned and muted realities.

Hirst's fascination with pharmacology, pharmacy and pharmaceutical products, particularly those with psychotropic qualities, has been a sustained theme in his art, a frequent companion in his personal affairs, and the marketing theme for his foray into a tangential career as the owner of the London restaurant, *Pharmacy*. Hirst derives an obvious, perhaps even obsessional, satisfaction from the endless geometric forms and colours of the thousands of pills, tablets and capsules that constitute the modern pharmacopoeia. The demands of pharmaceutical competition place a high premium on the commercial capture of distinctive tablet geometries and colours, using the devices of painting to promote global branding, ensure instant recognition and to forge the loyalty of doctors and patients. Specific shapes and hues provide the signature flags for the manufacturing companies in their quest to capture *terra infirmatica* in comparable fashion to the flags of earlier privateers and mercenary regiments that conquered lands rather than diseases.

The assembly of a catalogue of pharmaceutical dosage forms has its most obvious analogies in philately and trainspotting, with each new variant to be documented assid-

uously for a narrow *cognoscenti*. It is easy, however, to overlook the exquisite attention to technical detail required to construct the 8000 *faux* pharmaceutical dosage forms presented in *The Void*. Each pill is an exact configurational duplicate of a marketed pharmaceutical product. The construction of each variant in this exhibit requires the construction of a precision-engineered punch at considerable cost, together with legal assurances to national regulatory authorities that a punch designed for this artistic purpose will not find its way into the hands of those engaged in the less well-regulated domains of illicit supply of more exotic chemical excursions.

As more hours of our days are spent in synthetic environments, life itself is turned into a commodity. Someone makes it for us; we buy it from them we become the consumers of our own lives.
Mark Slouka, War of the Worlds: Cyberspace and the High-Tech Assault on Reality, Basic Books, New York (1995)

People believe in medicine, but don't believe in art, without questioning either.
Damien Hirst, cited in After Shock, Calvin Tomkins, The New Yorker, 20 September 1999

Pharmaceuticals have assumed the status of essential succour in our lives. Our dependence is now complete. As the innovations of pharmaceutical R&D unveil ever more wondrous agents to combat our maladies, reconfigure our lifestyles and expand our longevity, we return again to a hunter-gatherer lifestyle in which the sustaining basics of nuts and berries are replaced by the new staples of therapeutic organic heterocycles, proteins and genes as the new age survival rations. Pharmaceuticals become routine fodder in obligate daily doses. Hirst's *The Last Supper* provides both a prescient recognition and a parody of these trends in pharmaceutical subjugation. This work provides thirteen panels in which common foods have become proprietary brands, marketed under the instantly recognisable labels of the global pharmaceutical companies. The *humor noire* is reinforced by the implied eclipse of natural foods by engineered products produced by the future wonderments of chemistry and genetic manipulation. Hirst's choice of thirteen panels also provides an allegorical statement about the risk of future betrayal by unchecked scientific progress, whether manifest in the form of unsafe drugs or in the

future usurpment of the pleasures of eating and drinking by neuromimetric pharmacology.

In portraying the therapeutic cornucopia created by modern pharmaceutical research in *The Void*, and the parallel progress in medicine and surgery portrayed in *Striptease* and *Trinity…*, Hirst offers no guide to the viewer on the relevance of these items to any particular disease. The viewer must either speculate, or match their personal encounters with the medicines and instruments displayed. Hirst's imagery attests to the pervasiveness of our pharmacological dependence but, as in his previous works, he reserves particular commentary for the unique realms of addiction, pain and violence. In these inter-related and overlapping psychological territories there are no distinctions based on gender, race or age. Pharmacology rules, OK!

The success of modern pharmaceuticals in the therapeutic ablation of anxiety, aggression and the amnesia of ageing shares a chemical unity with the illicit pharmacology of street drugs used to induce psychoexpansive, hallucinogenic and sensory overloads or sexual frenzy. Drugs, legal and illegal, now define, and constantly reconfigure, the psychological reference points in navigating life for an enormous, and rapidly growing, segment of the population. Several distinct domains can be mapped in this landscape of psychotropic dependency, each related to perceived pain: the avoidance of physical pain (analgesia and anaesthesia); the denial or blunting of mental pain (anxiolytics, anti-depressants); the addictive escape and detachment from the perceived overwhelming challenges of reality (narcotics, hallucinogens, drug-induced suicide); the desire to escape from the torment of psychotic visions (anti-schizophrenic agents); and the ultimate control of psychotic violence in those who inflict painful death on others without remorse or guilt (anti-psychotic agents for the imprisoned and injectable poisons for the execution of convicted killers).

Physical pain is the most common source of human suffering and has a complex taxonomy. It can be acute or chronic, real or imagined, local or systemic, trivial or threatening, fleeting or fatal, episodic or continuous. In its most extreme form it is dire, unendurable and apparently without end, rendering the sufferer willing to relinquish any future, including life itself, for relief from their agony. The historical quest for prayers, potions and pharmaceuticals to blunt and redress invasive physical pain reflects the prominence of pain in human affairs. Shamanic medicine,

modern synthetic chemistry and the latest stereo-taxic neurosurgical robotics that ablate the brain pathways controlling pain perception each share a common goal to limit the savage assaults of pain and its imposed distortions.

Hirst's *Looking Forward to the Total and Absolute Suppression of Pain* captures with clarity and humour the intrusiveness and irritation of unwanted mental stimuli by luring the viewer into a vitrine that becomes increasingly claustrophobic as the intensity of the cacophony of noise and visual assault from repetitive video clips of advertisements for painkillers escalate to a threshold that evokes the desire for instant relief. Causation and relief are merged in ironic commercial union. Listen, watch, engage and interact and you will encounter pain but, oh thou participative sinner fear not, the road to the kingdom of therapeutic salvation lies straight ahead in the temple of pharmaceutical analgesia.

The iconography presented in this work also highlights the invasiveness of electronic media into every aspect of the modern environment: the numbing *musak* of the elevator, shopping mall and workplace; the barrage of electronic banners and embedded cookies that track your mouse clicks and your peccadillos in the new 24/7/365 world of the internet with its access to anything, anywhere, anytime; and the ubiquitous electronic eyes, some seen but most unseen, that likely now observe you in more ways than you might imagine, need or desire. Jeremy Bentham's panopticon awaits!

Indulgent pleasure, often carried to excess or to extremes, is a familiar, and probably vital, human trait. Anthropologists and neurobiologists consider that the stimulation of brain circuitry for pleasure has played a crucial role in human evolution by favouring behaviours which facilitate the sexual and social bonding needed to build family and communal relationships as well as to propagate more forceful forms of pleasure such as conquest, domination and the exercise of power.

Contemporary neurobiology envisages that the brain contains a set of 'reward centres' whose state of stimulation (or lack of) has a profound impact on the psychology (and psychopathology) of every individual. The ease with which the reward machinery in the brain can be triggered to produce a sense of pleasure appears to vary enormously between individuals, including the likely prospect of genetic predispositions to under- or overstimulation. The former would predispose an individual to anxiety, depression, panic, shyness, social phobias and

to various levels of introverted withdrawal. In contrast, individuals with reward centres that demand hyperstimulation to provoke pleasure would be predisposed to addictive excess.

The cigarette is probably the perfect symbol for our fucked-up times. Sex, death, glamour, squalor, law suits, big business. Third world exploitation; take your pick and suck it in.
Anon, Ciggie Stardust, Esquire February 2000

The addictive properties of tobacco and Hirst's characterisation of smoking's sublime appeal as a form of 'slow suicide' have been a routine feature in his work and commentaries. Overflowing ashtrays feature in several pieces in the current exhibition, presented as either a symbol of the rational rejection of risk in the case of the doctor in *A Way of Seeing* or in *From The Cradle To The Grave*, as a subliminal desire for accelerated death as an exit from the numbing boredom of an existence devoid of meaningful content.

How far from home can a mind go, and still be a mind?
Wendell Berry, Life is a Miracle, An Essay Against Modern Superstition Counterpoint, Washington (2000)

Chemical dependency and addiction on a far greater scale than nicotine are inherent in Hirst's constant focus on the seductions of the pharmacy as the panacea for human ills and easy disengagement from confronting the perplexing demands of life. Addiction becomes simultaneously a way out, and a way in; an entry into a new realm and into a new community where the perceived slings and arrows of earlier misfortunes can no longer harm. Social rejection can be ignored because it no longer matters. The brain goes where it has never gone before, even though it will now never be as it was before. The progressive scrambling of cognition, cogency and coherent thought, the dyskinesias, seizures, nasal erosions, needlestick pus and necrotising vasculitis matter little as the spiralling descent to oblivion, overload, overdose and out-of-here in a body bag evolves as the predictable trajectory of addiction. Pustulated street addicts smeared with their own vomit and excrement share cultural communion with celebrity addicts; their union forged by the common memetic bonds of doped neural circuits, faded euphorias, lost memories of

hypersensation, the sacrifice of careers, families and friends and the final expulsion of rational judgement as the frenzied excesses of junkied nihilism obliterate everything.

There's no such thing as innocence. Innocence touched with guilt is as good a deal as you can get.
Mike Hammer in Mickey Spillane's, Kiss Me, Deadly (1955)

Here is a place of disaffection
Time before and time after
In a dim light.
T.S. Eliot, Burnt Norton. Four quartets (1944).

But the nihilism, degradation and destructiveness of chemical addiction pale in comparison with the expression and the projection of these same traits into the behaviour of the criminally psychotic. The actions of those who desire to kill, torture, degrade, butcher or cannibalise their victims have never enjoyed a greater audience than today. The public appetite for information on serial killers and the details of the perversities and horrors propagated on their hapless victims is insatiable, fed by a media competing for market share in the extremism stakes by purchasing ever more graphic content.

The seeming *cri de coeur* of the statement 'Stop Me B4 I Kill Again' smeared in lipstick (or is it blood?) in *Figures in a Landscape* embodies the polar emotions exhibited by many serial killers. For some, the statement is a genuine alarm call arising from some fleeting residual normalcy in which they want others to terminate their criminal actions. For other killers in this extreme class, it is an arrogant, cynical and mocking declaration of their own perceived superiority and their ability to outwit the police and forensic detection. It is an essential prop in the planned theatre of their actions; a declarative statement of the pleasure of toying with the authorities and a clear sign that they will kill again.

Hirst offers us no clue as to motive of the psychotic author of the message in his collage of death and implied corporal dismemberment. The extravagance of the act implied and the messy, crazed process of disassembling the victim(s) stand in stark contrast to the almost obsessional, fastidious neatness of the final packaging of the presumed body parts and the careful deodorisation with sachets of Haze concentrated fragrance gel and 'Super-fresh Neutradol'. This preoccupation with precision in disposal is often a characteristic of crimes of such overwhelming hideousness. Hirst documents the forensic domain with a keen eye. The size and weight of each plastic bag is to be matched and checked carefully to avoid premature rupture or the risk of leakage and tell-tale seepage that might reveal their morbid contents. How many piles of nondescript, black, double-ply, double-wrapped garbage sacks are there in the world on any given day? How many would reveal secrets about lives extinguished or about the myriad other illicit desires, fetishes or unsuspected practices performed routinely in the homes of the seemingly respectable? Hey neighbour, can you help me to take my rubbish bags down to the kerb for collection?

In many aspects of his categorisation and portrayal of technology and its implications, Hirst displays an obvious awareness of state-of-the-art developments in science. Yet, curiously, in his representations of clinical medicine, as opposed to science, he exhibits an apparent reluctance to project the new face of medicine being imposed by the analytical power of molecular biology and genetics in dissecting our bodies at the level of the invisible. This contrasts with the historical focus of medicine on the macroscopic domain of the whole body and its organs. It is as if Hirst hankers for an earlier, nostalgic era of a simpler medicine uncomplicated by sophisticated science. The anatomic models presented here, and in his earlier works, would not be out of place in a university teaching hospital from the 1950s. The exaggerated physical scale of the revealed anatomy in the 20ft high bronze, *Hymn,* with its abstracted form and candy colourations reinforces the simplification of the human form. Organs with no detail beyond shape, the smooth contours and the simple, bright colours. No complexities, everything fits and everything seems right! Why complicate matters! In deriving *Hymn* directly from a children's educational toy from Humbrols Young Scientist series it is as if Hirst seeks to rid himself, and us, of the burden of comprehending the enormous structural complexity, visible and invisible, that he reveals when he lays bare what lies beneath the skin in dissected reality. *Hymn* has no pretensions. Jonathan Jones writing in the Spring 2000 issue of *UNTITLED* offers a comparison : '(It) is a great big toy… Hirst's object has the uncanny sharpness of everything he does…no artful ambiguity. It suggests that art itself is a toy and its function is to enable us to play, with ideas, forms, self-knowledge. If art can give us as much pleasure and insight into the human condition as his son gets from his toys, implies Hirst, we will be happier, healthier.'

The interpretation that Hirst has 'arrested' his portrayal of medicine somewhere in the mid-1950s conveys a subliminal desire for technical simplicity that resonates with the perceived serenity of this decade. Nations were rebuilding after the devastation of war and the brash radicalism and political activism of the 1960s had yet to be unleashed. Penicillin and other wonder drugs promised a new era of healthcare. People trusted their doctors, and even politicians, to do the right thing. Medicine was in confident mood, poised to do great things for mankind. Then it all began to disintegrate. The slick expediency of politicians undermined faith in government and institutions. Corporatism and profitability defined the new priorities for healthcare; greedy doctors and growing revelations about malpractice eroded confidence in professional competency and compassion. The final vestige of credibility for the physician as an authoritative, all-knowing, figure is now in the process of being stripped away as the rapid expansion of medical knowledge renders far too many physicians ignorant and ill-prepared to practise modern medicine.

The iconography of the genetic age, epitomised by the double helix of DNA and the four letters, ATC and G of the universal genetic code, has no place in the Hirstian collage. Similarly, the elegant three-dimensional shapes of chemical molecules resolved at the atomic level that are the technological bedrock on which modern drug design is now built have yet to find their place in Hirsh's cabinet of technical curiosities.

The more hopeless the disease, the more splendid is the devotion and unselfish the charity of those who strive to alleviate it.
St Bonaventure (1221-74)

The apparent reluctance to depict the more modern face of medicine is perhaps also manifest subliminally by Hirst in *The Way We Were*. The primitive laboratory equipment, the dated furniture, the old-fashioned heater and the emotive donation box of the 'crippled' child with a leg brace, soliciting funds for the yet-to-be-won war against polio capture the innocent optimism and expectancy of the 1950s. The research effort to defeat polio, an infection from a long-forgotten era for most, was a galvanising force for public generosity and remarkable social unity. The chosen metaphor of a 'war' against polio was acceptable to a society not yet healed from the scars of a world war. The

silent, invisible attacker must be killed before it takes another victim. The war is victorious, science wins, medicine triumphs and a new generation is spared from the infectious scourge. Where, and what, are the medical enemies of today that would elicit a comparable national emotional outpouring in celebrating the creation of a vaccine or a new medicine of the kind that occurred when a polio vaccine was discovered? Rather, 'I've got a disease so where's my new drug' is today's churlish claim and, 'if it's not available, who's to blame?' A charity donation box on display today would be seen as an open invitation for burglary. Better that we spend those remaining few pounds/dollars on the lottery and the statistical improbabilities of personal wealth rather than support medical research. Where are the common causes that will unify us? Where are the compelling political visions to build a better world? All that exists today is just me; me, me, me and fuck you! The swords inserted in the vitrine of *The Way We Were* are a sharp metaphor for the death of an era and the loss of shared values.

For the writer, perhaps the most intriguing piece in the exhibition is *Concentrating on a Self-Portrait as a Pharmacist*. A first – a portrait. Better yet, a self-portrait. The image and brushwork have a Baconian dimension with homage paid to Hirst's openly declared respect for Bacon. The portrait projects obvious pangs of reticence and is presented purposely as work in progress to deny critics any final judgement about technique. Hirst has declared frequently his enthusiasm for drawing and portraiture. In his own words: 'I wanted to be the best drawer in my class'.

First come hints, then fragments of systems, then defective systems, then, complete and harmonious systems.
Thomas Babington Macaulay (1835)

...go to Nature rejecting nothing, selecting nothing, and scorning nothing.
John Ruskin cited in Ruskin and the Dawn of the Modern, edited by Dinah Birch, Clarendon Press, Oxford (1999)

When I curated the exhibition 'Freeze' in 1988 everybody said to me, 'Now you've got to decide whether you are an artist or a curator, and I said why? There was no reason. Now people ask me 'What are you going to do now – pop videos, films or are you going to be an artist? I can't see the difference. I just do the whole thing. It's all art to me.
Damien Hirst, I Want to Spend the Rest of My Life

0011-8532/90 0.00 + .108 *Revealing Reality Within a Body of Imaginary Things*

Everywhere, With Everyone, One to One, Always, Forever, Now. Booth-Clibborn Editions, London (1998)

The bold innovations in collage that have characterized Hirst's work from the outset of his artistic career have brought him deserved international acclaim, widespread public recognition and admission to the pantheon of the artists judged most influential in shaping the vector of contemporary art in recent years. His work evokes polarized reactions. For some, the only conscious register is shock. Others seek to portray him as an opportunistic journeyman who delegates the preparation of much of his work to others, arguing that he is a mere technician rather than an artist. His many supporters proffer vocal condemnation of such critics and enthuse about the richness of his themes and the uniqueness of the assembled collages.

The current exhibition introduces new content and format, while retaining strong thematic and aesthetic ties with his earlier works. These new works powerfully reinforce the over-arching theme that is at the core of Hirst's art in highlighting the complex and precarious relationships between the technological quest to limit human suffering and the seemingly limitless capacity of humans for hubristic destruction.

He portrays a savage dystopic world that can be tamed only by the fortitude of human courage and by the innovative intellect. He defines with incisive clarity the juxtaposition of polar opposites in human affairs: hope and despair; health and disease; life and death; violence and passivity; order and disorder. In offering allegorical representations of these opposing forces he always brings us back to our inescapable union with the technological imperative and its permeation into every aspect of our lives.

The analytical rigour of the scientific method and the pursuit of a fundamental understanding of the universal organising principles that define the foundations of all structure and form in the universe are seen by Hirst as a source of inspiration and celebration. However, the metastability intrinsic to the order:disorder continuum dictates that Hirst must also reveal the constant vulnerability of the established order and the role of technological progress as a harbinger of new disruptions and dislocations. Some of the consequences of the radical changes catalyzed by technological advance will be predictable, others will not. Those found incapable of navigating the dark and swift tides created by these quantum shifts in technical knowledge will pay a heavy price for their ignorance, whether as individuals, communities or as nations.

The perspective offered here makes no pretence to assess Hirst's work in the broader context of art history, or even the short evolutionary history of YBA art. This essay has its origins in a friendship that began with a meeting with Damien as part of his inexhaustible appetite for information about the latest research vistas in genetics, medicine and computing. In his quest to better comprehend the direction and implications of contemporary science to enrich the allegorical power of his work, Hirst is probably unique in the artistic community. For him there are no false cultural barriers to constrain the boundaries of his curiosity. He is not trapped by the timidity that paralyses most in the art world from engagement with the exhilarating, yet scary, pace of change being wrought by the technological *accelerando*. In seeking to convey the social, cultural, ethical and philosophical implications of these turbulent events to a broader audience through his artistic interpretations, Hirst merits inclusion with those artists throughout history who have sensed the enormity of the social disruptions imposed by successive waves of technological revolution, starting with the Renaissance and the Enlightenment as the engines for the Industrial Revolution, to be followed by the post-Darwinian era and the accelerating demise of religion at the hands of rational science, and then onward to the atomic age and now to the threshold of a future world that will be shaped by the new technological titans of genetics and computing.

Irrespective of the surprises that science will encounter in its future exploration of *terra incognita*, and the attendant artistic representations that will evolve in parallel, these scientific and artistic excursions will be linked across space and time by the constancy of the experimental method and human ingenuity. Or, as Hirst might define it, the continuity between past, present and future will be based on *Theories, Models, Methods, Approaches, Assumptions, Results and Findings*.

Figs. 10.2 – Victim of asphyxia by hanging. Note the parchment-like ligature abrasion mark of the neck caused by the folded bed sheet used as the weapon.

Appearances are a glimpse of the obscure.
Anaxagoras of Clazomenae (c. 500 – 428 BC)

There is no excellent beauty that hath not some strangeness in the proportion.
Francis Bacon (1605)

Of the terrible doubt of appearances, of the uncertainty after all – that we may be deluded ...
Walt Whitman, Leaves of Grass (1855)

The 1990s witnessed the rapid ascendancy of a new art movement in London. Opinions remain divided as to whether this art represents a coherent and distinctive shift in the evolution of contemporary art or whether YBA is merely a convenient tagline, imposed retrospectively, to forge a tenuous bond between disparate artists who have little in common beyond their age and their rapid rise to fame. Theoretical and taxonomic ambiguities notwithstanding, few would dispute the impact of the art promoted in London in the last ten years. It catalysed a new momentum in art and altered irrevocably the relationship between art and the mass media. In so doing, it reshaped the aesthetic and economic forces operating in the professional art world. Perhaps most striking of all it expanded dramatically the importance accorded to the public persona of the artist and the impact of the art on the public at large.

To be certain in matters of taste is to be certain in matters of morality: ethics and aesthetics are one.
Roger Scruton, Art and Imagination (1974)

The intent is to make high culture difficult, to surround beauty with a wall of erudition. The hidden purpose is twofold: to protect art against popular entertainment and to create a new barrier, a new obstacle to membership ... Everything out there, in the world of naïve and unthinking people is kitsch.
Roger Scruton, An Intelligent Persons Guide to Modern Culture (1999)

Art must reintroduce emotions long banished as being in some way embarrassing; ... so that the gallery is reserved for one of its least remembered functions, a focus for amazement..
Damien Hirst, cited in Charles Hall, A Sign of Life, Institute of Contemporary Arts, London, 1991

Plato condemned art for distorting reality and corrupting character. ...Aristotle countered that art's pleasures derive from mimetic truth, that we take pleasure in recognizing images of things that would horrify us in real life.
Richard Shusterman, Let's Entertain: Life's Guilty Pleasures, Walker Art Center, Minneapolis (2000)

The purposeful blurring of the barriers between art, the media and popular culture has been the principal defining element of the new art being made in the last decade. The combination of skilful courting of the media, shrewd commercial positioning by gallerists and patrons, the tabloid appeal of the more controversial content of these works and the behavioural excesses of many of its leading practitioners catapulted art beyond the narrow domain of the professional art world into the burgeoning global reach of television, journalism, pop music and mass consumerism.

In orchestrating a purposeful union with multimedia and popular culture it was perhaps inevitable that the greatest public recognition should be accorded to those artists whose work embraced the themes that the media had identified as the drivers of their own future commercial success: the cultivation of in-yer-face attitudes; laddism and 'yoof' culture; profanity and confrontation; sex, violence and death; drugs, degradation, humiliation and exhibitionism; anti-intellectual posturing, ubiquitous trivialisation and the rise of the idiot celebrity; hamburgers and instant everything; all to be played out against a backdrop of grunge, urban shabbiness, infrastructure decay and junk culture.

Many commentators deplored these trends, seeing them as evidence of the inexorable progression of cultural aphasia and the corrosive effects of cultural relativism in which anything becomes acceptable because no moral or other distinction need be made. The Canutian railings of the critics against the tide of popular culture, and their bemoaning of the dumbing down of society for its preoccupation with instant gratification and its finger always poised on the fast forward button, serve little purpose beyond a vituperative personal catharsis for those destined to be displaced and left behind.

The new art filled a void. By its prescient recognition of the need for art to define a new liminality to reflect the shift from a rural to an urban pastoral, and from an artistic elite to mass culture, it took the bold actions needed to assert its relevance. It created a new, accessible art with a harder edge; art that was cool, insolent, ambiguous and diverse, entertaining and humorous, tolerant, chaotic, unabashedly urban and better suited to the times. It also forced a seemingly wilful confrontation with the reactionary bastions of the cultural elite of the world of high art. The shock tactics of its practitioners in flouting proprieties were designed to create distance from what had gone before; to reject the arcane cultural codification of the professional art world with its incestuous sycophancy and snobbish exclusivity. Unalterable truths, ironclad laws and the established canon were to be cast aside to make room for performances of all kinds. Take us or leave us; no analysis necessary. It is now a truism that anything can be art. But the way in which something becomes art and the way in which it either fails or succeeds is still worthy of consideration.

The purposeful dissociation of art from the traditional reference points within the high art community of the Academy, the premier auction houses and the refined white geometries of the upmarket galleries was reinforced from the outset by the selection of radically different venues for the display of these new artistic energies. Beginning with *Freeze, Modern Medicine* and other early warehouse exhibitions, the epicentre for this group of artists shifted to the factory-gallery. Abandoned industrial buildings and disused retail spaces became the preferred venues for display, a trend whose current apogee is seen in Herzog and de Meuron's transformation of London's Bankside power station into the Tate Modern.

Despite the apparent distancing from the traditional coterie of the art institutions, academics, public funding bodies and leading galleries, the YBA cohort of the 1990s and their patrons were careful never to stray too far from the embrace of the professional art world. This evolution of art would provide a classic case study in any modern business school curriculum as a masterful exemplar of success created by the canny identification, articulation, execution and dissemination of new content. Stated in bizspeak : 'we have witnessed the emergence of a powerful franchise (YBA), supported by powerful brands (Hirst, Hume, Whiteread, Emin, Turk, Bulloch, Lucas, Ofili, McQueen), that has achieved unprecedented public recognition (mass media, Saatchi, New Labour), allowing targeted expansion into new growth markets (low art for a mass media plus reproduction rights) while retaining its traditional customer base (the art establishment)'. Everyone wins! Corporatism triumphs and heady new altitudes are scaled in the fiscal terrain of commercial art.

At work, over all, is an apparent fever of curatorial urges to usurp the independent prerogatives of artists, critics and ordinary viewers, reducing art to glorified illustration, criticism to ineffectual demurral, and viewership to studenthood.
Peter Schjeldahl, The New Yorker, 29 May 2000

There's nothing English about Damien Hirst's dead meat. Not even the most ingenious of art chroniclers has found the words to confer on these highly successful artists, – a national identity that any of them would recognise as integral to their work. Their world is thoroughly international. If anything, they are alienated from the confines of what 'Britishness' might mean.
Hugo Young, Identity Parade, Tate (Spring 2000)

Mutual self-preservation demands that the professional art world must still be courted. New works must be assimilated at regular intervals into the traditional temples of high culture to be anointed with the imprimatur of establishment approval. The lengths to which the quest for claimed relevance and rationalisation will be carried to sustain this symbiotic union is conveyed in the hyperbolic curatorial commentary of Andrea Rose, Head of Visual Arts at the British Council, in her Foreword to the Exhibition *Dimensions Variable : New Works for the British Council Collection,* held in London in 1997 : 'There is …a recognition in this setting that the art of young British artists has its antecedents in other art… Stubbs and Wallinger; Hogarth and Hirst; Gainsborough and Gary Hume; who is to say that the rising stars of the British art world should not take their place alongside names that have long been synonymous with English art, and all that 'Englishness' entails.'

When you think about the older artists going around in their suits, being in biennials and giving the same interviews all the time about their concerns and being a bit gratingly half-intellectual you feel refreshed by this frankly abject juvenile style, even if it's only for a moment.
Matthew Collings, Blimey! From Bohemia to Britpop, The London Art World from Francis Bacon to Damien Hirst. 21 Publishing, Cambridge (1997)

The art would be quite as dreadful as the philistines said it was – obscene, trivial, soiled with bodily fluids and exhibiting a fuck-you attitude – but this time deliberately so: it would use the philistine's energy and power in the mass media against them
Julian Stallabrass, High art lite: British art in the 1990s, Verso, London (1999)

So art becomes a world of appearances and a sequence of news, a matter of what 'everybody' or 'nobody' talks, thinks, cares about. It is inherently satirical. It makes all art activity seem contingent, superficial and involuntary.
Tom Lubbock, Modern Painters, Summer (1997)

Hirst and his cohorts steer happily between the sublime and the ridiculous, earning equally appropriate academic beard-stroking and tabloid frenzy. It's a matter not of 'high and low', but of inside and outside.
Peter Schjeldahl, Those Nasty Brits, The New Yorker (1999)

In any era, art must validate its relevance. Hirst himself defines precisely the changed aesthetic and the new metrics imposed on art in an era of mass consumerism: 'Art has got to be able to stand up to everything else and if it can't it, doesn't work. That's why it has to be multi-layered, because if you have an idea of an audience then it has to communicate with everybody' (interview with Andrew Wilson, *Art Monthly,* June 1994, #177, p.8).

Without deliberate action to engage a broader public, art in the 1990s would not have survived as a vibrant cultural enterprise. Instead, it would have suffered the atrophy and decline that overtook numerous long established bulwarks of intellectual life and academic scholarship in the 1990s, as society came to see them as outmoded, irrelevant or as targets for overt ridicule. Only by asserting its relevance could contemporary art hope to prosper in competition with the ever-faster, ever-shorter cycles of fad and fashion imposed by the mass media and the internet as the new economic engines of mass consumerism, global iconomania and the rise of global art empyrean.

Yet in exhibiting the adaptive plasticity needed to build public interest, art spawned new dangers. Novel content that enjoys widespread public acclaim can all too quickly become a straitjacket that confines the artist to banal repetition to meet market demand for instant consumer recognition. Content is placed at risk of being little more than a logo. The personality of the artist becomes the brand. The public behaviour of the artist, from the profound to the inane, is documented by the media to reinforce the union with the art. The trinity of content, presentation and the artist's public persona are skilfully choreographed to sustain media attention as the key element in the calculus of commercial success and the maintenance of celebrity.

The work of Damien Hirst, perhaps more than any other artist of the last decade, best reflects these trends and events that have shaped this group of artists as the nation's aesthetic pace-setters.

Changes in contemporary art can no longer be described simply as progress, but are founded on the domestication of the marginal, the dangerous and the alienated.
Julian Stallabrass, High art lite: British Art in the 1990s, Verso

He (Hirst) has a kind of terrible curiosity to find how living things work, by taking them to pieces.
Brian Sewell, An Alphabet of Villains, Bloomsbury, (1995)

Each time he (Hirst) showed a new work it was as if some art-world Jack the Ripper had perpetrated one more outrageous crime. The public's reaction was the same admixture of horror and frank admiration that it reserves for the acts of the most elusive criminal.
Richard Shone, Some Went Mad, Some Ran Away, Serpentine Gallery, (1994)

I just want to find out about rotting.
Damien Hirst, Interview with Will Self, Modern Painters (1994)

Hirst's eclectic prodigality has created visually stunning assemblages from ready-made elements and diverse organic materials. The Hirstian iconography is immediately identifiable: the precision-engineered vitrines; the cabinets of modern curiosities; the regimented displays of surgical instruments, medical devices, anatomic simulacra and animatronic mimics; unlovely flesh the signature subject of these artists – is presented in extravagant diversity: whole, suspended, dissected, flayed, sectioned, formaldehyde-fixed or in rotting decay; entombed cadavers and carcasses; animate, living organisms destined for death to convey the frailty and transience of biological life in constant flirtation with entropic decline and destruction; the stark hygiene of the clinical domain juxtaposed to the squalor and ugliness of ageing and pathological distortion; chemistry as the simultaneous purveyor of addiction and of therapeutic salvation; the grand trinity of pharmacology, pharmacy and pharmacognosy; the allure of addiction; the I-am-a camera realism; the limitless combinatorial patterns of colours generated as spin and spot paintings; and each work accompanied by slick, lengthy titles coined, by Hirst's own admission, with the intent to as much to inform as to confuse the viewer.

Hirst's work over the past decade strikes a balance between obvious thematic continuity and the unhesitant pursuit of new vectors in both content and image. Intensity, irony and, one suspects on occasions, mockery, are consistent elements of Hirst's work. This is manifest in the confrontation of unresolved opposites and the omnipresent risk of widely divergent fates. The big continuities of life are presented in an optimum format for a media-revolutionised world. Sin, struggle and suffering in a fallen world are contrasted with the exuberance of life in the face of destructive forces and the watching and waiting for death.

The scientific and the forensic domains are harnessed in a common framework to reflect the cyclical patterns of life, decay and death and to chronicle the ingenious agenda of modern science to attenuate, frustrate and, ultimately, escape from the burden of disease and to delay terminal decline. Hirst exposes us to the weight of a world of confusing and conflicting secrets: simultaneously elegant but threatening; the predictable poised to transform at any moment into the stochastic; and the seeming stability of 'order' in a knife-edge balance with chaos.

The tensions generated by claimed scientific truths and technological progress in a world increasingly bereft of the historical comforts of place, family, community and the veneration of age are revealed. The *accelerando* of advanced technology offers a seductive siren song of limitless comforts and a protection from the uncaring vagaries of nature, all available for the mere price of uncritical acceptance of modern technology and its corporate sponsors. Progress and comfort are offers that cannot be refused (and, if you order now, operators are standing by to bring you the additional benefits of aesthetic and cognitive ablation, delivered direct to your home by multiplexed digital streaming with additional personal support services available at your local pharmacy, courtesy of organic chemistry, that will quickly blunt any rude mental intrusions and unsettling images about the state of things that might otherwise be evoked by reflective thought).

The inventory of pharmaceuticals assembled in polychromatic regiments of diverse geometries, and the meticulous rows of surgical instruments, convey the efforts of medicine to blunt the invasions of disease. But, these therapeutic capabilities are presented less as an illustration of the accomplishments of science in solving technical challenges than as a forceful reminder of the comfortable amnesia which health imparts. We subjugate our unspoken fears of future pain or surgical assault, while never ceasing to be fascinated with these unsettling themes when presented in the abstract or when happening to others. We deny our macabre fascination, perhaps even fetish for some, with the prospect of surrender to clinical exploration and to interrogation by instruments designed to probe every orifice and cavity in our bodies.

Revealing Reality Within a Body of Imaginary Things

+ .113 0011-8532/90 0.00

The tools of science and medicine and the dissected revelation of human and animal form embody the Enlightenment ideal of scientific investigation for the betterment of the human condition. Yet, when placed in collision with a Hobbesian vision of an increasingly nasty and brutish society, which rejoices in ignorance and violence and seeks the cultural anaesthesia of sex, drugs, and Jerry Springer, the case for any higher purpose in science and in advancing human welfare assumes a tragi-comic dimension. At the same time, the power of modern science in shaping society continues to expand at unprecedented speed. Hirst captures the intrinsic duality of science as a beneficent instrument for improving human comfort and as a nihilist force for the subjugation of individual autonomy via the homogenisation of the mass consumer society, the chemical manipulation of mind and mood and proliferating electronic capabilities to monitor and control human behaviour.

The final element that defines the public response to Hirst's work lies in indulgent voyeurism. Hirst, and his well publicised peers, have provided the media with a rich lode for mining the sensational. Rotting cow heads, fornicating bovines, electrocuted flies, body fluids, elephant dung, impregnated condoms, soiled sheets and mannequins with disproportionate and displaced genitalia are the stuff of journalistic dreams. Everyone, from high culture to low life, has an opinion about today's contemporary art and its practitioners. No one is neutral. Divisive and explosive passions abound – essential grist for the mill of hard commercialism of the media who must seek out what sells to a society already overdosed on prurient sex, the bizarre and all forms of extremism. Vociferous condemnation of these artworks by reactionary politicians, theologians and sundry hacks serves only to pique the public interest and to expand the paying audience. Art becomes but one more channel to surf for voyeuristic gratification by those who would otherwise deny their fascination with the unspoken and the unspeakable.

The ontologies of Hirst's work resist any easy delineation. The psychic topographies and sensual cartography are complex, fluid and often confusing. The boundaries between the vulgar and the grotesque, and between the metaphorical and the literal, are blurred and reconfigure endlessly. Considerations of the relationship between the fractured components of the dissected entities and their original holistic forms may start out as an unemotional,

detached evaluation but quickly gives way to fear, fascination and the unease evoked by the pathological, the perverse and the psychotic. These emotions, in turn, quickly mutate into the hardened psychological protections of insensitivity and indifference to suffering as our collective shield against scary fates and destinies yet to be encountered.

They fuck you up,
your Mom and Dad.
They may not mean to,
But they do.
Phillip Larkin, This Be The Verse

Where are you going, young artist? Are you any use? You're always flying around in jets and being in international group shows and staying in hotels. What do you care what anything means?
Matthew Collings, Blimey! From Bohemia to Britpop. The London Art world from Francis Bacon to Damien Hirst, 21 Publishing, Cambridge, (1997)

I can't wait to get into a position to make really bad art and get away with it. At the moment if I did certain things people would look at it, consider it and then say 'Fuck Off' But after a while you can get away with things.
(Damien Hirst, Interview with Liam Gillick, Gambler 1990)

And it must be said that he (Hirst) has achieved that ambition.
Julian Stallabrass, High art lite. British art in the 1990s, Verso, London, (1999)

With Hirst the process comes to a conclusion as both art work and self disappear into pure image, pure celebrity, as the time approaches when people will have forgotten how Hirst became famous in the first place. It was, after all, in terms of newspaper copy or trends in clothes or pop songs, a very long time ago.
Julian Stallabrass, High art lite. British art in the 1990s, Verso, London (1999)

I avoided seeing Hirst's new one million pound artwork (Hymn) for so long. And there really is an astonishing vulgarity to the figure that stands above at the Saatchi Gallery. When I read the denunciatory reviews, when people told me the Thing was repellent my heart sank. Then there was the little matter of Hirst's having to pay off the toy's

designer and manufacturer. So this is goodbye, I thought.
No more Damien – not as a serious Artist. He's turned
into the senile Salvador Dali about forty years too soon.
Jonathan Hughes, UNTITLED, Spring 2000

The presentation of a collection of new works by an internationally recognised artist is, by definition, a major event. The anticipated enthusiasms, the shallow, sycophantic praise offered by all at the opening night, followed by the snide caustic slanders at dinner the same night when out of earshot, and the pending reviews all serve to tighten the artist's viscera, quicken the pulse, lower the threshold of irritability and deepen the tension of final preparation. Paranoiac fear that the bar code of public acclaim will reveal an outmoded product gnaws constantly, despite all brash denials to the contrary. Performance matters on the night. There is no tachyphylaxis or easy release from emotional overload for the artist and the accompanying exaggerated expectations and fears.

Game over, no repeat, you're fucked, oblivion time, tired, drraagging, you're toast!, telephone 0898 – FEAR. The new lexicon of failure adjusts to tabloid trivialization and internet time. Generation d, picture-in-picture, code division multiplexing, projection into the tetherless telecosm, the rise of e.cology and the electronic road to virtual anything emphasise the centrality of speed, time, timeliness and transience as the new forces of public acceptance and corporate appeal. Success is only as good as your last success. From sublime art to sub-atomic physics the same unswerving principle applies: show me what you've done for me lately. Hunt, bait and denigrate are now the norms for modern journalism in their frenzied pursuit to offer another sacrifice from the ranks of the successful to feed the unsatiated public appetite for the demise of the famous. The cruel metronome of the clock of fame is always poised to move on and to dispense with another transient celebrity.

When does YBA become OAP (old artists posturing)? A decade is an eternity in a modern world where radical change is now the technological and cultural norm. Where are the new challengers? What will be seen as the next iteration of innovation in technique or content?

Oh, courageous artist: do you have the armour, the fortitude and the analgesic threshold to withstand these forces? Or must you invoke the proven dictum, if you can't convince them, at least confuse them! And who really cares?

Dr George Poste, CBE, FRS, is Chief Executive Officer of Health Technology Networks in Scottsdale, Arizona. His association with Damien Hirst began while he was Chief Science and Technology Officer at SmithKline Beecham, the Anglo-American Healthcare Corporation. He is a Fellow of the Royal Society, a Fellow of the Academy of Medical Sciences and a Fellow of the Royal College of Pathologists. He serves on the Boards of Directors of several leading biotechnology companies in America and on a variety of Committees for the UK and US Governments, including the UK Human Genetics Advisory Commission and is Chairman of the US Department of Defense Science Board on Bioterrorism. (gposte@healthtechnetwork.com)

Revealing Reality Within a Body of Imaginary Things

+ .115 0011-8532/90 0.00

Naja Naja Kaouthia (No. 0064)

Household gloss
on canvas.

2463 x 2514mm

Venoms

Naja Naja Sputatrix (No. 0070)

Household gloss
on canvas.
2336 x 2946mm

Naja Hannah (No. 0045)

Household gloss
on canvas.
2336 x 1727mm

Household gloss
on canvas.
1524 x 2743mm

Naja Nivea (No. 0074)

Naja Flava (No. 0041)

Household gloss
on canvas.
686 x 533mm

Household gloss
on canvas.
635 x 685mm

Naja Naja Atra (No. 0062)

Naja Haje (No. 0044)

Household gloss
on canvas.
1524 x 1320mm

Naja Nigricollis Crawshawii (No. 0071)

Household gloss
on canvas.
1930 x 1828mm

Naja Nigricollis Pallida (No. 0073)

Household gloss
on canvas.
1574 x 863mm

Household gloss
on canvas.
1930 x 2946mm

Naja Melanoleuca (No. 0047)

Household gloss
on canvas.
457 x 1879mm

Naja Mocambique Mocambique (No. 0050)

Household gloss
on canvas.
1498 x 1549mm

Naja Nigricollis Nigricollis (No. 0072)

Household gloss
on canvas.
2514 x 3733mm

Notechis Ater Humphreysi (No. 0075)

Naja Naja (No. 0060)

Household gloss
on canvas.
482 x 533mm

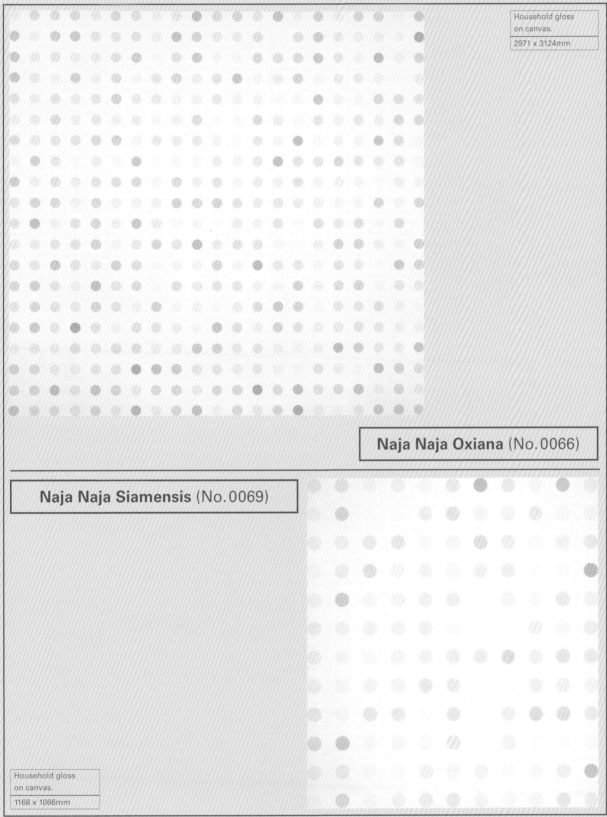

Household gloss
on canvas.

2971 x 3124mm

Naja Naja Oxiana (No. 0066)

Naja Naja Siamensis (No. 0069)

Household gloss
on canvas.

1168 x 1066mm

Fig. 11.1 – The Way We Were. 2440 x 2740 x 2740mm

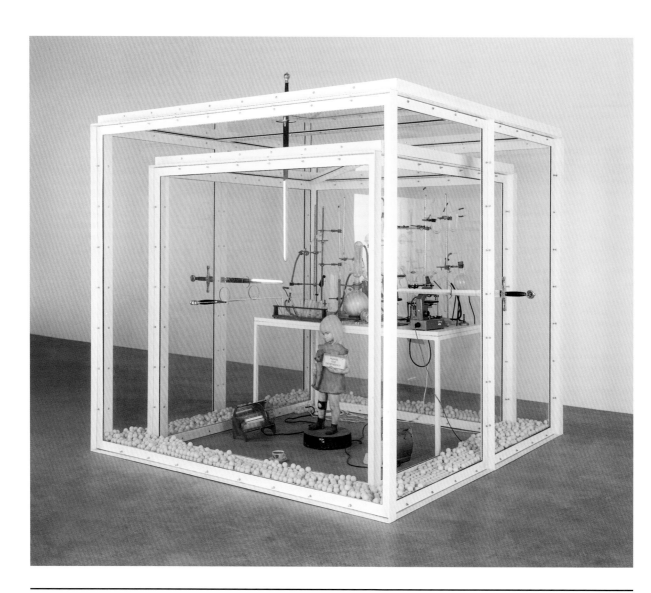

11. The pattern of homicidal slash/chop injuries

Summary Homicides as a result of slash/chop injuries are not commonly reported in forensic literature. A 10-year retrospective study from 1987 to 1996 was performed on the pattern of homicidal slash/chop injuries in University Hospital, Kuala Lumpur. A total of 37 cases was analysed. The ages ranged from 17 to 85 years. The victims consisted of Indonesian (37.8%), Chinese (24.3%) and Malay (8.1%) ethnic groups; 2.7% of the cases were not identified. Most of the cases were due to intentional violence (n=27), while the rest consisted of domestic violence (n=2), robbery (n=2), psychiatric homicide (n=1), accident (n=2) and unclassified (n=3). In the intentional violence group, the majority of the victims (n=16) had more than five wounds. In contrast, the victims in other categories had less than five wounds each, with the exception of a single case in the psychiatric-homicide group. In homicide victims with a single wound, the most common site of injury was the neck. In those with multiple wounds, the common sites were the head and neck. Sixteen cases showed defence injuries, all of them belonging to the intentional-violence group. The reasons for the high incidence of homicidal slash/chop wounds are discussed, as well as the difficulties associated with interpretation of such wounds.

B-B Ong

Homicide by sharp penetrating injuries is common in Malaysia, as in most parts of the world. However, unlike other places, most of the cases encountered here are not due to stab wounds. Slightly more than half of these cases are directly or partially attributed to slash/chop wounds.

There is a paucity of literature regarding sharp-force injuries of this nature. Most major textbooks on forensic pathology give either brief or no details on wounds of this nature. Most studies on sharp-force fatalities also do not discuss these injuries in detail. The following study attempts to examine the pattern of homicidal slash/chop injuries with their associated features in postmortem cases performed at the University Hospital Kuala Lumpur during a 10-year period (1987–1996) and discusses problems that may arise in wounds of this particular nature.

Material and methods

The study covers a 10-year period from 1987 to 1996. All homicidal cases directly or partially attributed to slash/chop wounds were analysed. Cases were identified manually from the 'cause of death' column written in the Autopsy Register Book. A total of 38 cases were identified. Thirty seven of the postmortem reports were extracted and analysed (one was not available).

For the purpose of this study, slash/chop wounds were defined as an incised wound that was inflicted by impact of a weapon with a sharp cutting-edge forcefully onto the body. Only wounds that exhibited underlying cuts to internal organs or bones were classified as slash/chop wounds. Incised wound of a slicing nature (like cut throat) have been excluded from this study.

The cases were analysed together with their associated features, under different categories of nature of killing for the purpose of this study. The nature of killing was inferred from the history available in the postmortem report. The categorization of the groups was arbitrarily given as follows:

- Intentional violence – refers to killing with intent either in contract murder or in gang warfare

- Domestic violence – is determined as homicide as a result of disputes or jealousy within the family, friends or household
- Accident – is defined as non-intentional or accidental killing as derived from the history
- Psychiatric homicide – indicates those deaths caused by person suffering from a mental illness
- Robbery – refers to homicide during the act of robbery
- Unknown cause – when the history is either not available or clear.

Demographic characteristics

There was a total of 37 cases, comprising 32 males and 5 females. The ages ranged from 17 to 85 years, with most (14 cases) in the 21–30 years age group. The majority of the victims were from Indonesian ($n = 14$) and Chinese ethnic groups ($n = 10$), while the rest consisted of Malay ($n = 3$), Indian ($n = 9$) and unknown ethnic groups ($n = 1$).

Nature of killing

A large majority of the cases were due to intentional killing ($n = 27$). Two cases each were as a result of domestic quarrels and robbery. One homicide case was classified as killing by a person suffering from psychiatric illness.

Fig. 11.2 – Pie chart showing the distribution of study population according to nature of killing.

- ☐ planned: 27
- ☐ domestic: 2
- ☐ robbery: 2
- ▨ accident: 2
- ☐ psychiatric: 1
- ■ unknown: 3

Table 11.1 – Victim distribution according to age and sex.

Age	Males	Females
10–20	2	0
21–30	12	2
31–40	5	1
41–50	6	0
51–60	1	1
> 60	3	1
Unknown	3	0

There were two cases of alleged accident. In one of the cases, a woman who was alleged to be an innocent bystander was hacked on her back during a gang fight involving two different parties. In the other case, two butchers were quarrelling brandishing their meat cleavers. One of them was alleged to have swung his meat cleaver carelessly resulting in the infliction of the fatal wound to the other person's neck. Three cases cannot be categorized owing to lack of information in the autopsy reports.

Of the five cases involving women, two were due to intentional violence, one was alleged to be unintentional or accidental, one victim was killed by her mentally ill grandson and in the other the nature of killing was unknown. The remaining victims were all male.

The number of wounds inflicted

The number of slash/chop wounds inflicted was divided arbitrarily into categories involving a single wound, from two to five wounds and more than five wounds.

In the intentional violence group, the majority of the cases (16/27) had more than five slash/chop wounds. Five victims were killed as a result of a single slash/chop wound while the rest received from two to five slash/chop wounds. The only other case involving more than five wounds was in the psychiatric homicide category.

Consistent with the claims of accidental killing, the two cases described above had a single slash/chop wound each.

Site of the body inflicted with the slash/chop wounds

There were nine cases of homicide involving a single slash/chop wound. The neck appeared to be the most

common site (five cases) followed by the head (two cases) and trunk (two cases). Except for a single case where the wound was sited on the abdomen (trunk), the slash/chop wound in the other cases had cut the underlying bone.

In the seven cases involving more than one slash/chop wound, the injuries were limited to only one site on the body; these sites divided into the head or neck, trunk and limbs. Four of these cases involved either the head or the neck, a single case involved the trunk and in two cases the wounds were limited to the limb regions, one involving the upper limbs only. In these latter two cases, one victim had both his forearms amputated at the elbow level, while the other had both his legs slashed from the back at the knee level.

The rest of the victims ($n = 21$) had more than one region of the body showing slash/chop wounds. The head and neck appeared to be more involved when compared to the other regions. In most cases, these wounds were inflicted randomly, resulting in the wounds being orientated in various directions on the body.

Associated injuries

Five victims, all of them from the intentional violence group, had other significant associated injuries. One showed signs of manual strangulation. The other four had stab wounds. The dimensions of the stab wounds in these latter cases were substantial, suggesting that similar weapons used to inflict the slash/chop wounds were probably used to inflict the stab wounds.

Defence injuries

There were sixteen cases involving defence injuries, fourteen from the intentional violence group. Most of the defence injuries ($n = 13$) were of the 'block' type, i.e. using the forearms or arms to block the slash/chop blows ('passive

Fig. 11.3 – Victims of various categories of nature of killing with number of wounds inflicted.

wounds'), and not the 'grip' variety ('active wounds'), i.e. attempting to grip the weapons with hands. Eleven of the cases involving defence injuries belonged to the category of more than five slash/chop wounds.

Brief description of the slash/chop wounds

In all the cases where detailed descriptions of the slash/chop wounds were available, the edges of the wounds were sharp. Some of the wounds had a rim of abrasion at their margin. In a few of the cases, the wound continued at either one or both ends as a linear abrasion or superficial incised wound (not penetrating the skin). In wounds where there were superimposed slashes, the ends of the wounds were jagged.

Most underlying muscles and organs were also sharply cut. The wound may be shelving in different directions

I was not prepared for the onslaught. I had my expectations of what the job was when I was a clinical student, I thought I knew what was going to happen, but I didn't quite realize the ferocity of such responsibility. I mean, everything really comes on to your shoulders in a big way, like instead of making decisions in a theoretical context in front of the consultant, '...Well, we could perform a laparotomy...'. Suddenly it's you that's doing it, and it makes things

totally different, it sharpens up your wits and your instincts no end. Immediately you become a lot more astute, not because you become cleverer but because you have to put what few bits of knowledge you've got into some sort of semblance of a rational decision. I hated it at first because it was so foreign to me, but now I quite enjoy it; especially when you get it right, it gives you a nice feeling afterwards.
Dr Richard Warner – Houseman

Table 11.2 – Cases of single slash/chop homicide with details of injury and circumstances of incident

Sex	Age	Site	Internal injuries	Weapon used	Additional information
M	63	Horizontally on left face towards front of neck	Cut left mandible, submandibular gland and associated muscles and blood vessels	Meat cleaver	
F	63	Vertically on outer back of chest	Cut head of left humerus, posterior ribs and lungs	Curved semi-lunar knife	Was a passer by in a gang fight
M	42	Horizontally on left neck	Cut all soft tissues, blood vessels and muscles on left side up to the third cervical vertebra including the left transverse process	Meat cleaver	Result of an altercation between two butchers – alleged to be an accident
F	26	Horizontally across front of right base of neck to left upper chest	Cut strap muscles, left carotid artery and jugular vein, trachea and anterior aspect of vertebral body	Not known	Signs of manual strangulation also present
M	22	Horizontally across front of abdomen	Cut transverse colon. Retroperitoneal structures spared	Not known	
M	26	Horizontally on left face towards back of upper neck	Cut left maxilla bone, ramus of mandible, base of skull involving floor of posterior cranial fossa, meninges and left occipital lobe of the brain	Not known	
M	43	Horizontally on left upper neck	Cut left sternomastoid, submandibular gland and facial artery	Not known	Also had head injuries owing to blunt trauma

depending on the angle at which the blade of knife impacted upon the body.

The underlying bone showed some variations in the wound pattern. In a couple of cases, notching of underlying bone was described, probably as a result of weapon withdrawal. Most of the underlying bones were simply 'cut', indicating a clean fracture. Depending on the angle of impact, pieces of the bones were 'shaved' or sliced off. Several incisions at the same site on the bone may be seen, particularly if superimposed slashes were made. In some cases involving the skull, the ends of the incision continued as radiating linear fractures. In a few other cases, the outer table of the skull showed a clean cut, but the inner table showed linear fracture, with bone chips directed inwards.

Discussion

There are several reasons for the high incidence of homicidal slash/chop wounds in this region of the world. First, there is the easy availability of such weapons in the market, mainly for use as a recreational or household tool. For example, a gardening knife, known locally as the 'parang',

...we've developed the technology to go through the mouth to the base of the brain. You see, the base of the brain is just lying there on a piece of bone: if you put your finger in your mouth and feel the back of your throat, there's a piece of bone there – if you touch it, it may make you feel sick. That piece of bone is the topmost vertebra of your neck, and going a little further up, that is the bone at the base of the skull. And on the other side of that is the brainstem, where those vital centres I was telling you about are. So rather than lift it up and get at it from behind, we can now do that going from the front.

Mr Alan Crockard – Neurosurgeon

Table 10.3 – Site of the body involved in cases with multiple slash/chop wounds.

Site	Number of cases
Head	18
Neck	15
Trunk	12
Upper/lower limbs	2

is used widely for gardening and clearing scrubs. Not surprisingly, it is a common weapon used in such homicides in this region. The more sophisticated criminals use home made swords, which come in various shapes and sizes, often designed to be as lethal as possible.

Although the strict laws against guns in Malaysia have been successful in reducing gun-related killing, they are also one of the prime reasons of the widespread use of swords or machetes in criminal activities, as perpetrators turn to other means of violence.

Fig. 11.4 – Multiple 'block' type of defence injuries. Note the slash wound on the chest.

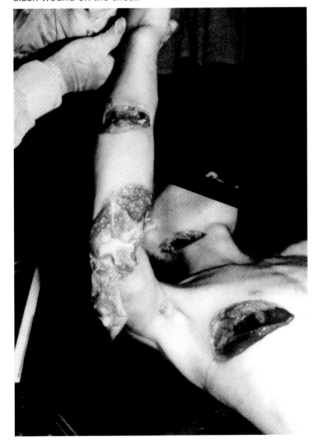

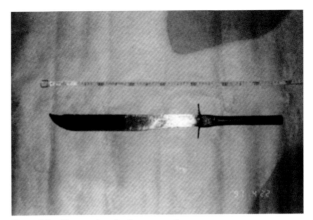

Fig. 11.5 – Example of a homemade weapon.

In recent years, there has been a huge influx of Indonesian migrant workers. They have brought their own traditional weapon to Malaysia, a sickle-shaped knife used in defence. It also serves as a useful homicide weapon and, indeed, a large number of homicides in this series involved Indonesians, most of them in the intentional killing category.

Most of the cases involving locals were from the intentional violence group, usually as a result of rivalry amongst gang members (Triads). As a result, there were a high percentage of males involved, as gangs usually comprise men.

The majority of the cases with more than five slash/chop wounds were involved in intentional homicides. One of the reasons may be the determination on the part of assailants to make sure that the victims are dead. The victims may also try to defend themselves and this action will result in the infliction of further blows. This was borne out by the fact that in this study more than half (14/27) of the cases within the intentional homicide group involved defence injuries. In addition, the multiple wounds could be due to a frenzied attack. The victim may also have been attacked by a number of persons simultaneously, especially in gang warfare. This could also explain why the distribution and orientation of the wounds on the body were both random and scattered.

The neck and head seem to be the site of predilection, in contrast to stab injuries, where the trunk, especially the precordium, is the most common site. Both the head and neck are traditionally known to be vital areas and this could be the one of the reasons why the assailants choose them. The slash/chop wound is also regarded as 'superficial' in nature when compared to the stab wound, and

If you talk about the function of pain, there are certainly people, the present Pope for example, who would speak of noble suffering and of suffering which reminds you of your mortality and your salvation and so on. He is assigning a function to pain, he is being a neurophysiologist in a way.

Professor Patrick Wall – Neurophysiologist

since the heart is located deep in the chest, this is not the preferred site. The mode of the attack in a slash injury is a swinging action, usually in a vertical or oblique plane downwards, and the head and neck being on top of the body are the obvious targets.

In most cases of multiple slash/chop wounds, the positioning of injuries was widespread. The orientation of the wounds was also random. This is not surprising, as the victim might be mobile during the attack or there might be several assailants inflicting the injuries at almost the same time.

Most of the associated injuries were stab wounds. From the weapons' dimensions given in autopsy reports, it appeared that large knives were used, and may well have been the same weapons used to inflict the slash/chop wounds. Most of the weapons recovered by the police had sharp tips that could be easily used for stabbing.

Eleven out of sixteen victims with defence wounds had five or more slash/chop wounds. Most probably, the victim, in trying to defend themselves, had caused further infliction by the assailant or assailants. Our study also found that most of the defence wounds were of the 'block' type. Owing to the swinging or swiping motion of the knife, it would be easier for the victim to block or parry the blow rather than to grip the weapon.

Fig. 11.6 – Slash/chop wounds on the neck. Note the superficial incised wounds on the right margin of the wound, caused by superimposed slashes on the gaping wound.

The rest of the cases ($n = 21$) revealed no defence injuries. This included all cases involving single slash/chop wounds. This would imply that in most of these cases, the victim was taken by surprise.

It is very difficult to suggest the type of weapon used to inflict these injuries. More often than not, no weapons were found in the vicinity or were not recorded in the autopsy report. Hence, the type of weapons could not be compared with the injuries presented. However, it is reasonable to deduce that it would be very difficult to correlate the type of weapon with the wound taking into consideration the chopping/slashing nature of the injuries.

The wounds could be of any depth or length even using the same weapon. The shape of the wound depends upon the force used, angle of penetration, orientation of wound on the body, which part of the blade made contact with the body, the curvature of the blade and the curvature or various parts of the body. The process of withdrawal of the blade may also influence the final shape of the wound. Occasionally, the slash wound appeared to have a tailing superficial incision at one or both ends, suggesting the weapon was longer than the wound as this superficial incision was caused by either the curvature of the blade or the body away from the point of impact. It is also very difficult to ascertain how many weapons (knives) were used in cases of multiple wounds. The multiplicity and random orientation of the wounds suggest more than one weapon, but given the numerous variables involved, it is very difficult to draw any firm conclusions. Hence, prosecution of the assailants in multiple slash/chop-wound homicides is fraught with difficulties, as it is very difficult to ascertain who was responsible for the inflicting the fatal blow.

Similar to stab wounds, there may be difficulty in distinguishing the mode of death in cases involving a single slash wound and especially to ascertain whether it was intentional or accidental. However, in an accidental injury, it would be reasonable to expect that only the tip or distal end of the weapon is able to inflict injury rather than its whole length, especially when the intention was to brandish the weapon. The force of the slash/chop may also help in distinguishing whether it is intentional or accidental.

Again, it is unlikely to be accidental if the force used appears to be great (e.g. cutting or fracturing underlying bone).

Occasionally, there may be a rim of abrasion along the margins of the incised wound. Spitz suggested it could be due to the width of the blade, but in our experience, it could be due to the dull edge or the rough rusty sides of the blade which abraded the skin as it penetrated into the body.

Conclusion

More than one-half of the homicide cases which presented in University Hospital, Kuala Lumpur from 1987 to 1996 consisted of slash/chop injuries. Most of these cases belonged to the intentional violence group. Reasons for the high incidence include culture, the easy availability of such weapons, the strict control of firearms and a high influx of migrant workers, especially in the last few years. Correlation of the slash/chop wounds with the weapon is poor. Hence, the prosecution of these cases is difficult, especially in cases involving multiple slash/chop wounds.

References

1. Milroy CM, Ranson DL. Homicide trends in the State of Victoria, Australia. Am J Forens Med Pathol 1997; 18: 285-289
2. Tardiff K, Gross EM. Homicide in New York City. Bull NY Acad Med 1986; 26: 299-303
3. Scott KWM. Homicide patterns in the West Midlands. Med Sci Law 1990; 30: 234-238
4. Knight B. The pathology of wounds. In: Forensic Pathology, 2nd edn. London: Arnold, 1996; 151
5. Di Maio DJ, Di Maio VJM. Wounds due to pointed and sharp, edged weapons. In: Forensic Pathology. New York: Elsevier, 1989; 204-206
6. Watson AA. Stabbing and other incisional wounds. In: Mason JK (ed.) The pathology of trauma, 2nd edn. London: Edward Arnold, 1993; 104
7. Cameron JM. Wounds and trauma. In: Camps FE (ed.) Gradwohl's legal medicine, 3rd edn. Bristol: John Wright & Sons Ltd 1976; 270
8. Spitz WU. Sharp force injury. In: WU Spitz (ed.) Medicolegal investigation of death, 3rd edn. Springfield: Charles C. Thomas, 1993; 290
9. Polson CJ, Gee DJ. Injuries: general features. In: Polson CJ, Gee DJ, Knight B (eds) The essentials of forensic medicine. 3rd edn. Oxford: Pergamon Press 1985; 112-122
10. Mant AK. Wounds and their interpretation. In: Mant AK (ed.) Taylor's principles and practice of medical jurisprudence, 13th edn. Edinburgh: Churchill Livingstone 1984; 237-239
11. Ormstad K, Karlsson T, Enkler L, Law B, Rajs J. Patterns in sharp force fatalities – a comprehensive forensic medical study. J Forens Sci 1986; 31: 529-542
12. Karlsson T. Homicidal and suicidal sharp force fatalities in Stockholm, Sweden. Orientation of entrance would in stabs gives information in classification. Forens Sci Int 1998; 93: 21-32
13. Moar JJ. Homicidal penetrating incised wounds of the thorax. A Afr Med J 1984; 65: 385-389
14. Katici U, Ozkok MS, Orsal M. An autopsy evaluation of defence wounds in 195 homicidal deaths due to stabbing. J Forens Sci Soc 1993; 34:237-240
15. Chao TC. Homicides and suspected homicides in Singapore. Med Sci Law 1993; 13: 98-102
16. Firearms (Increased Penalties) Act 1971 (Act 37)
17. Hunt AC, Cowling RJ. Murder by stabbing. Forens Sci Int 1991; 52: 107-112
19. Murray LA, Green MA. Hilts and knives: a survey of ten years of fatal stabbings. Med Sci Law 1987; 27: 182-184
20. Knight B. The dynamics of stab wounds. Forens Sci Int 1975; 6: 249-255
21. Green MA. Stab wound dynamics – a recording technique for use in medico-legal investigations.

They are very anxious that you are doing the operation. If not, they want to know who will cut them up. The working class is the contrary. If you say, 'I am going to do the operation', they often look at you with suspicion, almost horror, because they see a rather plump, middle-aged man – it's not their dream surgeon; they want somebody who is gowned and masked and comes from heaven and does the operation and disappears. Many people would look at me and say, 'I'm not going to let that chap cut me up. He's just an ordinary man. I want God to do this!'
Mr Ellis Douek – Ear, Nose & Throat Specialist

DUCK LIVER®

Each capsule contains
10 mg Phenoxybenzamine Hydrochloride BP

30 capsules

Omelette

injectievloeistof
1 ampul met
injectievloeistof bevat:
750 anti-Xa eenheden
danaparoid

10 ampullen à 0,6ml
Voor subcutane of
intraveneuze toediening
Voor het gebruik de ingesloten
gebruiksaanwijzing lezen
In het donker bewaren
bij 2 tot 30 C

U.R.
ROG 51006

Oxtail®
Oral Solution
morphine Sulphate

10 mg/5 ml

Each 5ml contains Morphine
Sulphate BP 10mg

100ml

Damien
Hirst

ig. A.1 – The Last Supper 1525 x 9800 x 53mm

Product Category Quick-Reference Guide

his index cross-references each brand y prescribing category. Entries in both he Product Information and Diagnostic Product Information sections are ncluded, but only if fully described.

he categories employed in this index ave been determined in co-operation with the products' manufacturers, or if ecessary, by the publishers alone. A uide to the heading and subheadings ppears here.

Vaccine adverse event reporting system

Health care providers and manufacturers are required by law (42 USC 300aa-25) to report reactions to vaccines listed in the Vaccine Injury Table. Reports for reactions to other vaccines are voluntary except when required as a condition of immunization grant awards.

The form appears opposite and may be photocopied for submission.

DIRECTIONS FOR COMPLETING FORM
(Additional pages may be attached if extra space is needed)

GENERAL

* Use separate form for each patient. Complete the form to the best of your abilities. Items 3, 4, 7, 10, 11 and 13 are considered essential and should be completed whenever possible. Parents/Guardians may need to consult the facility where the vaccine was administered for some of the information (such as manufacturer, lot number or laboratory data.)

* Refer to the Vaccine Injury Table (VIT) for events mandated for reporting by law. Reporting for other serious events felt to be related but not on the VIT is encouraged.

* Health-care providers other than the vaccine administrator (VA) treating a patient for a suspected adverse event should notify the VA and provide the information about the adverse event to allow the VA to complete the form to meet the VA's legal responsibility.

* These data will be used to increase understanding of adverse events following a vaccination and will become part of CDC Privacy Act System 09-20-0136, "Epidemiologic Studies and Surveillance of Disease Problems". Information identifying the person who received the vaccine or that person's legal representative will not be made available to the public, but may be made available to the vaccinee or legal representative.

* Postage will be paid by addressee. Forms may be photocopied (must be front and back on same sheet).

SPECIFIC INSTRUCTIONS

Form completed by: To be used by parents/guardians, vaccine manufacturers/distributors, vaccine administrators, and/or the person completing the form on behalf of the patient or the health professional who administered the vaccine.

Item 9: Check "YES" if the patient's health condition is the same as it was prior to the vaccine.
Item 12: Include "negative" or "normal" results of any relevant tests performed as well as any abnormal findings.
Item 13: List ONLY those vaccines given on the day listed in Item 10.
Item 17: List any prescription or non-prescription medications the patient was taking when the vaccine(s) was given.
Item 18: List any short term illnesses the patient had on the date the vaccine(s) was given (i.e., cold, flu, ear infection).

VACCINE ADVERSE EVENT REPORTING SYSTEM
24 Hour Toll-free information line 1-800-0376-3478
P.O. Box 2389, Rockville MD 20849-1500
PATIENT IDENTITY KEPT CONFIDENTIAL

HIRST

Patient Name:	Vaccine administered by (Name):	Form completed by (Name):
Last First M.I.	Responsible physician	Relation to Patient Vaccine Provider Patient/Parent
Address	Facility Name/Address	Address Manufacturer other
City State Zip	City State Zip	City State Zip
Telephone No. ()	Telephone No. ()	Telephone No. ()

1.State	2. County where administered	3. Date of Birth dd / mm / yy	4. Patient age	5. Sex M F	6. Date form completed

7. Describe adverse event(s) (symptoms, signs, time course) and treatment if any	8. Check all appropriate:
	Patient died / dd / mm / yy Life threatening illness Required emergency room/doctor visit Required hospitalisation (_____days) Resulted in prolongation of hospitalisation Resulted in permanent disability None of the above

9. Patient recovered YES NO UNKNOWN	10. Date vaccinated	11. Adverse event onset
12. Relevant diagnostic tests/laboratory data	dd / mm / yy Time_____AM PM	dd / mm / yy Time_____AM PM

13. Enter all vaccies given on date listed in no. 10

	Vaccine (type)	Manufacturer	Lot number	Route/Site	No. Previous Doses
a.					
b.					
c.					
d.					

14. Any other vaccinations within 4 weeks of date listed in no. 10

	Vaccine (type)	Manufacturer	Lot number	Route/Site	No. Previous Doses	Date Given
a.						
b.						

15. Vaccinated at: Private doctor's office/hospital Military clinic/hospital Public health clinic/hospital Other/Unknown	16. Vaccine purchased with: Private funds Military funds Public funds Other/Unknown	17. Other medications

18. Illness at time of vaccination (specify)	19. Pre-existing physician-diagnosed allergies, birth defects, medical conditions (specify)

20. Have you reported this event previously? No To health department To a doctor To manufacturer	**Only for children 5 and under**	
	22. Birth weight _____lb. _____oz.	23. No. of brothers and sisters

21. Adverse event following prior vaccination (check all applicable, specify)	**Only for reports submitted by manufacturer/immunization project**

	Adverse event	Onset Age	Type Vaccine	Dose no. in series	24. Mfr. / imm. proj. report no.	25. No. of brothers and sisters
In patient						
In brother					26. 15 day report Yes No	27. Report type Initial Follow up
In sister						

Form HIRST –1

10 CAPSULES
FOR ORAL USE ONLY

VONGOLE™

Etoposide Ph.Eur. 100 mg

DAMIEN-HIRST
PHARMACEUTICALS

28 tablets

ZUCCHINI 2.5mg

Lisinopril dihydrate equivalent
to 2.5 mg anhydrous lisinopril

DAMIEN

**CAULIFLOWER
CHEESE 200mg**

**120 Tablets
in blisters of 24**

DSH®

ie Gras ®

Christ

Fumarate BP 140mg

200ml

Eggplant
tablets

400 mg

100 tablets

BACON

Sterile Solution
6 x 2ml single vials
for iv or im use

EGGS ®
ANY STYLE

2000 iU/ml

Cornish-Pasty 2 m

HIF

21 tabs. or

Fig. 12.1 – Stripteaser (detail). 1960 x 3660 x 510mm

12. Observations on fatal injuries to the brain stem and/or upper cervical spinal cord

Summary A retrospective study was performed on 149 forensic autopsy cases (12 in Kanazawa and 137 in Munich) of brain stem and/or upper cervical spinal cord (UCSC) injuries as a result of road-traffic accidents. Pedestrians were the most common type of victim, followed by car drivers. Eleven of the 12 Kanazawa victims were pedestrians. The total ratio of pedestrian victims gradually increased with age. The ponto-medullary junction was the most frequently injured site. A total of 146 cases demonstrated basal skull fractures and/or dislocation of the upper cervical joints: atlanto-occipital joint, atlanto-axial joint, or the joint between the 2nd and 3rd cervical vertebrae. However, in three cases, hyperextension of the neck unexpectedly caused brain stem injury neither associated with basal skull fracture nor with cervical dislocation. Intraventricular haemorrhage was found in 96 cases, suggesting a common feature associated with brain stem and/or UCSC injury. A tear of the basilar artery and that of the carotid artery was found in 17 and 20 cases respectively. A total of 39 victims demonstrated a blood alcohol concentration of 0.5 mg/ml, and hyperextension of the neck occurred more frequently in these cases. In spite of the marked predominance of immediate death (138 cases), 11 cases (nine of brain stem injury and two of UCSC injury) had unexpected survival times of from 45 min to 12 h.
T. Oshima, T. Kondo

In most countries, motor cars are indispensable for convenient daily life. However, it is, unfortunately estimated that more than a million people worldwide are killed annually as victims of road-traffic accidents, and some 15 million are injured. Therefore, prevention of road-traffic accidents is one of the most important social policies.

In road-traffic accidents, many kinds of injuries are observed. In particular, neck injuries are of great relevance for both physicians and forensic pathologists. Namely, dislocation of the atlanto-occipital (AO) joint and /or atlanto-axial (AA) joint can cause irrecoverable damage to the brain stem and/or upper cervical spinal cord (UCSC). According to Mason, such neck injuries are observed in approximately one-third of all fatal road-traffic accidents. The interdisciplinary and international importance of neck injuries has resulted in this retrospective study on the injuries of the brain stem and/or UCSC in road-traffic accidents, based on the forensic autopsy results in Kanazawa (Japan) and Munich (Germany).

Eighty-eight autopsies of road-traffic accident cadavers have been performed during 1980–1996 at the Department of Legal Medicine, Kanazawa University, Japan, and 1417 autopsies during 1990–1995 at the Institute of Legal Medicine, University of Munich, Germany. Among these 1505 autopsy cases, injuries of the brain stem and/or UCSC (C1–C3) were found in 149 cases (9.9%) (Kanazawa 12 cases and Munich 137 cases). Nine of the 12 cases in Kanazawa are previously reported.

Autopsy protocols and toxicological data, including blood alcohol concentration and police traffic accident reports, were reviewed in as much detail as possible for the 149 cases.

Sex and age distribution

The 149 victims included 93 males (62.4%) and 56 females (37.6%). Their ages ranged from 13 to 92 years (mean age 43.3 years). The largest number of victims was in the 20-29-year-old group, although in the Kanazawa cases 10 out

of the 12 victims were 40 or more years old, owing to the marked predominance of pedestrians.

Type of victim

Victims included 56 pedestrians (37.6%) and 48 car drivers (32.2%). In the Kanazawa cases, 11 out of 12 victims were pedestrians, and Munich accounted for all of the car drivers. In the combined group, in the age range of 20–39, car drivers accounted for more than 40% of the victims. However, as the age of victims increased, the total ratio of pedestrian victims gradually increased, and more than 50% of the victims were pedestrians in the age group of over 50 years.

Injured site of the brain stem and/or upper cervical spinal cord

Among the total 149 cases, 134 (89.9%) (including four cases of injuries to both the brain stem and UCSC) demonstrated brain stem injuries (cerebral peduncles, pons and/or medulla oblongata) and 98 (73.1%) of the 134 cases demonstrated injuries at the ponto-medullary junction. Nineteen cases demonstrated UCSC injuries (including four cases of injuries to both the brain stem and UCSC).

Fig. 12.2 – The ratio of victim type in each age group.

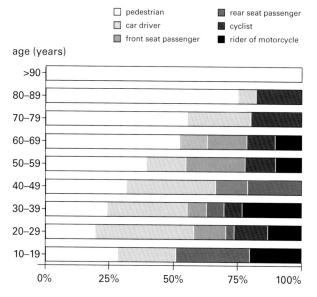

Fig. 12.3 – Age distribution of victims.

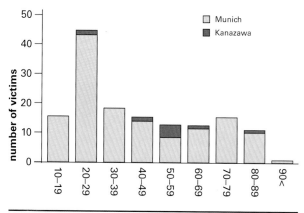

Fig. 12.4 – Type of victim.

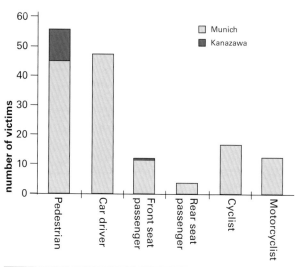

Basal skull fracture and/or dislocation of the upper cervical joint

Among 130 cases of brain stem injury alone, 46 demonstrated AO dislocation (including eight cases of basal skull fracture and AO dislocation), and 25 demonstrated ring fracture around the foramen magnum (including two cases of both ring fracture and AO dislocation, and two cases of both ring fracture and AA dislocation). Forty-nine demonstrated linear fracture of the base of the skull. Interestingly, three victims (2.3%) of the 130 cases of brain stem injury demonstrated neither basal skull fractures nor cervical dislocation. Among the 15 cases of UCSC injury alone, 11 demonstrated AA dislocation (including one case of both

Table 12.1 – Basal skull fracture (BF), ring fracture (RF) and/or dislocation of the upper cervical joint.

Injured region	BF	(RF)	AO	AA	C2/C3	BF+ AO	(RF+AO)	BF+ AA	(RF+AA)	(AO+AA)	N
Brain stem	70	(21)	38	7	0	8	(2)	4	(2)	0	3
UCSC	0	(0)	2	10	2	0	(0)	0	(0)	1	0
Brain stem and UCSC	0	(0)	0	2	0	1	(0)	0	(0)	1	0

You can have a perfectly fit compos mentis eighty-year-old driving her Mini, like she has done every day for the last twenty years to do her shopping, who has a traffic accident or falls over, say when she's shopping, and breaks her hip, and that can set off a cycle of events that within forty-eight hours renders her a 'geriatric'. This is because all body organs age, and you get a knock-on effect. It's like a car with 50 or 60,000 miles on the clock, things start going wrong.

Dr Gareth Beynon – Geriatrician

AO and AA dislocations), and three demonstrated AO dislocation (including one case of both AO and AA dislocations). There were two cases of dislocation of the joint between the 2nd and 3rd vertebrae. Among the remaining four cases of injuries to the brain stem and UCSC combined, two demonstrated AA dislocation, one both AO dislocation and basal skull fracture, and one both AO and AA dislocations.

Intraventricular haemorrhage and injury of basilar artery or carotid artery

'Intraventricular haemorrhage', which has occasionally been reported in association with injuries of the brain stem and/or UCSC, was found in 96 cases (64.4%), suggesting that it was frequently observed. Tears of the basilar artery and of the carotid arteries were found in 17 (11.4%) and 20 cases (13.4%), respectively.

Blood–alcohol concentration of the victims

At both institutes, blood–alcohol analysis was performed by the use of gas chromatography, and alcohol concentrations of more than 0.5 mg/ml were found in 39 victims (26.2%), including 35 males and four females (unlawful blood–alcohol concentration: ≥ 0.5 mg/ml in Kanazawa, ≥ mg/ml in Munich). All of the victims (six in Japan and 33 in Germany) were legal adults at the time of accident (≥ 20 years in Japan, ≥ 18 years in Germany). The 33 Munich victims (29 males, four females) included 13 pedestrians

(12 males, one female), 12 car drivers (nine males, three females), six car passengers and two motorcyclists. On the other hand, all of the six victims in the Kanazawa cases were pedestrians.

Survival time after traffic accident

Among the 149 victims, 138 (92.6%) died immediately after the road-traffic accident. Death for the remaining 11 victims (7.4%) was not immediate; two victims with UCSC injury survived for 3 or 5 h after the traffic accident and nine victims with brain stem injuries survived for 45 min to 12 h.

Discussion

This study shows that pedestrians were the most frequent victims followed by car drivers, and that the total ratio of pedestrian victims gradually increased with age. These

Fig. 12.5 – Injured site of the brain stem and/or upper cervical spinal cord. (a) Cerebral peduncle. (b) Ponto-medullary junction. (c) Medulla oblongata. (d) Upper cervical spinal cord.

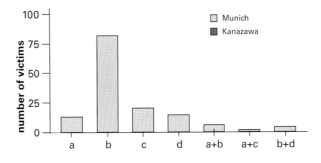

The operating room is lovely. The nicest three places are in bed, in the car and in the operating theatre, because the nature of surgery is such that it has to be extremely calm, quiet and well ordered. It's like an extremely posh restaurant. I mean, you can tell when you walk in, can't you, this is a well-organized place: the waiters are all in the right places, the tables are laid nicely, you just feel that it's all going to work properly. A well-run operating theatre is like that. You walk in, you immediately feel at ease, the team, which is all the nurses who are helping you, the anaesthetist, the porters, all the registrars, just have a calmness about them. Wonderful.

Mr James Scott – Orthopaedic Surgeon

results were similar to those of Gogler's investigation on fatalities or seriously injured victims of traffic accidents. The number of car driver victims was nearly equal to that of pedestrian victims in the Munich cases. In contrast, 11 out of 12 in the Kanazawa cases were pedestrians, and there were no car driver victims. Although the difference in the forensic autopsy systems in Munich and Kanazawa should be taken into consideration, it can at least be said that the injuries of the brain stem and/or UCSC were observed more in pedestrians than in car drivers in Kanazawa. In general, about 50% of pedestrian victims in the Japanese traffic accidents were elderly persons aged 65 years or more. This is possibly one of the reasons why injuries of the brain stem and/or UCSC were found in pedestrians in Japan. In addition, another reason for the predominance of elderly pedestrian victims in Japan is that many streets in the sidewalks for pedestrians are not distinctly separated from car and motorcycle roadways.

Fig. 12.6 – Arrow indicates a tear at the ponto-medullary junction in the mid-sagittal section (53-year-old female with a survival time of 12 hours).

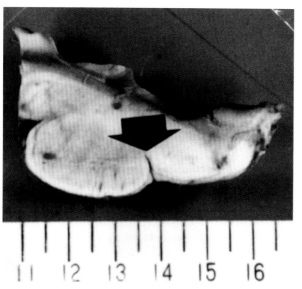

As reported by Walz, pedestrians should be protected by means of active measures such as speed limits or separation of traffic ways, as well as passive pedestrian-compatible car front structures.

The ponto-medullary junction was the most frequently injured site. Tears at the ponto-medullary junction were formerly misinterpreted as one of the artificial findings owing to the forceful removal of the brain from the cranium. However, in 1970, Lindenberg and Freytag reported 21 immediate death cases in which tears at the ponto-medullary junction resulted from hyperextension (hyperflexion) of the neck and demonstrated distinct vital reactions based on histological findings. The authors histologically examined six Japanese cases (five cases of immediate death and one of a 12 h survival time) of tears at the ponto-medullary junction; microscopic examination with haematoxylin–eosin staining showed fresh haemorrhage at the torn site, oedema in the perivascular space and neuronal cell pyknosis. Furthermore, Bodian's staining revealed axonal swelling and waving of disrupted axons, as well as axonal retraction balls, corresponding to histological findings of so-called diffuse axonal injury owing to an external shearing force to the brain. These findings were also consistent with those reported by Lindenberg and Freytag. Recent studies have shown that the axonal damage mentioned above resulted from axoplasmic transport failure caused by a misalignment of the intra-axonal cytoskeleton involving a disorganization of its focal neurofilament and microtubular network.

The incidence of cranio-cervical injury is reported to be higher in persons aged 65 years or more than in those aged under 65 years. As mentioned above, hyperextension (hyperflexion) of the neck is a causal mechanism of fatal injury to the brain stem and/or UCSC. According to the previous report by Tolonen et al., persons aged over 40 years are at higher risk of hyperextension and/or hyperflexion of the neck resulting in fatal neck injury; this is as a result of degenerative changes to the cervical spine. In the

Fig. 12.7 – Stripteaser. 1960 x 3660 x 510mm

We do unfortunately see a lot of death, and some of it is lingering. You are staving it off and trying to push it back, but at the end of the day in many of the situations we see, it is inevitable. But on the way, there is an awful lot you can do to improve the quality of patients' lives, albeit for a relatively short time. If they are pain free for the last few weeks of their life, then that is a very positive thing. If they can spend time at home for a few weeks, or if they can make a major event in their lives because you can control symptoms, even though you haven't increased their longevity, then there are tremendous rewards there. You know, time is terribly subjective. Where you and I would say, 'Hell, she has only got three or four weeks to live, why put her through treatment to give her those extra few weeks?' – when you talk with that patient and she says, 'My daughter is getting married in three weeks' time, you have got to get me right,' you can see that even short periods of time can be very important to patients.

Dr Bob Phillips – Radiotherapist

present study, 46.3% of the 149 victims were 40 years old or more. The decrease in the tone of the neck muscle is considered one of the reasons for the injury predominance in elderly people.

A few reports have shown that injuries to the brain stem and/or UCSC were often accompanied by dislocation of upper cervical joint. Leestma *et al.* also reported that 13 of 19 cases with ponto-medullary avulsion demonstrated dislocation of the upper cervical joint. According to the Adams reports 26 autopsied cases of AO or AA dislocation, 21 cases had brain stem and/or UCSC injury. The present study also indicates that injuries of the brain stem and/or UCSC were almost always accompanied by dislocation of the upper cervical joint and/or basal skull fracture, including the ring fracture around the foramen magnum. Unexpectedly, three victims had neither neck

Fig. 12.8 – Microscopic view of the torn part of the ponto-medullary junction (Bodian's staining, x 400). Arrows indicate waving and swelling of the disrupted axons. Arrow heads show axonal retraction balls.

joint dislocation nor basal skull fracture. In these cases, severe haemorrhage was observed in the neck muscles, indicating hyperextension or hyperflexion of the neck. Therefore, even hyperextension without neck joint dislocation can produce brain stem injury such as ponto-medullary avulsion.

There are two causal mechanisms of the ring fracture of the base of the skull: a pushing-up of the spine against the skull base, and an extraction force owing to the hyper-extension of the neck. According to previous reports, the extraction type of ring fracture was accompanied by brain stem injury. All 25 cases with ring fracture in this study were due to the extraction force by hyper-extension of the neck and were accompanied by brain stem injury.

Intraventricular haemorrhage results from primary intra-ventricular causes, such as arterio-venous malformation in the choroid plexus, or, more commonly, from the rupture of haematoma in the cerebral parenchyma into the ventri-cles. Several reports have shown traumatic intraventricular haemorrhage. Grcevic clearly indicated that there was a very high incidence of tears in the choroid plexus in the 3rd and the lateral ventricles when external forces acted along the longest diameter of the skull, indicating that the tears were almost always followed by cerebral intraventricular haemorrhages. Anatomically, the 4th ventricle is a rhom-boidal cavity located behind the pons and medulla oblon-gata, and it is speculated that severe hyperextension of the neck may result in tears of the 4th ventricle's choroid plexus.

The present study revealed that 37 victims demon-strated injuries of the basilar and or carotid artery owing to

over-stretching. Judging from the anatomical localization of the basilar artery and carotid artery, it is not difficult to appreciate that hyperextension of the neck can simul-taneously over-stretch the basilar and carotid artery. There-fore, injury of the basilar and/or carotid artery confirms hyperextension of the neck.

According to the report by Weinreich, 20.5% of pedes-trian victims aged 18 years or more involved in traffic acci-dents were under the influence of alcohol, and most of them were male. Based on the results of the present study, alcohol was also predominantly detected in male victims and approximately 50% of alcoholically intoxicated victims were pedestrians. This shows that, in fatal traffic accidents of pedestrians versus cars, blood-alcohol analysis should always be performed not only for car drivers but also for pedestrian victims. Leestma *et al.* reported that eight of 19 victims with fatal lacerations at the ponto-medullary junction demonstrated blood–alcohol concentrations between 0.72 and 4.26 mg/ml, but it has not been deter-mined how alcohol was associated with the occurrence of the brain stem and/or UCSC injury. In those intoxicated with alcohol, the tone of the muscles is decreased, as it is in elderly persons (as mentioned above). It is therefore specu-lated that severe hyperextension of the neck may be more likely to occur in the alcoholically intoxicated than in those who are sober.

According to the investigation of the deaths in traffic accidents involving bicycles or motor-cycles, by Althoff *et al.*, 42.6% of the victims died immediately. In this study, including car-drivers and pedestrians, 138 victims (92.6%)

Table 12.2 – Eleven survival cases after traffic accident.

Case	Sex	Age	Injured site	Survival time (h)
1	M	52	BS	30 min
2	F	19	BS	45 min
3	F	35	BS	1
4	M	61	BS	1
5	M	55	BS	1
6	F	26	BS	1
7	F	87	BS	2
8	F	33	BS	3
9	F	53	BS	12
10	M	27	UCSC	3
11	F	46	UCSC	5

BS: brain stem; UCSC: upper cervical spinal cord.

died immediately, showing that injuries to the brain stem and/or UCSC are fatal. However, 11 extraordinary cases (7.4%) demonstrated survival times ranging from 30 min to 12 hours after the traffic accidents. Pilz reported that four victims (10–67 years old) with injuries at the ponto-medullary junction survived for 8 to 26 days. Among them, a 12-year-old girl with a deep tear at the ponto-medullary junction survived for 26 days after the traffic accident. It is very important to understand that even injuries without obvious dislocation or fracture may be lethal. The authors experienced a case in which an 83-year-old male, with a very slight epidural bleeding at the cervical spinal cord without vertebral dislocation, suddenly fell into respiratory failure after a 20 min intact period, similar to a lucid interval in a case of epidural haematoma. From the viewpoints not only of clinical medicine but also forensic pathology, it is of great importance to appreciate that the injuries of the brain stem and/or UCSC do not always result in immediate death.

Finally, until now, injuries of the brain stem and/or UCSC were often diagnosed through an autopsy after death. Recently, magnetic resonance imaging (MRI) examination ihas been found to be more useful than computerised tomography examination for the observation of brain or spinal cord lesions, and it has already become widespread in clinical medicine; in particular, sagittal views of the head and neck are possible with MRI examination. The authors propose that MRI examination should be intro-duced as often as possible in forensic autopsy, so that the injuries of the brain stem and/or UCSC can be precisely evaluated for medico-legal purposes.

In fact every cell in the body has DNA, and in that DNA is the genetic information for the entire human being. And what they described was a chemical which could essentially reproduce itself extremely accurately – and that's what a gene is, a gene is a little section of DNA which has the chemical information for one particular characteristic.

One of the great things about DNA is that it's not perfect. If a chemist had made DNA, he would have made an absolutely perfect replicating molecule. But DNA makes mistakes, and because DNA makes mistakes, we can therefore have natural selection.

I think the next major step in human genetics will be the ability to correct genetic diseases to some degree…

probably in the next five to ten years. This is no different in principle to what they're doing already with organ transplants – at the moment we transplant healthy organs like kidneys and hearts, and in the future, if you've got a single gene that's wonky and makes you sick, the idea will be to transplant that with a healthy one.

Going from scientist to doctor is the hardest thing in the world actually. And if you're not careful, if you try and take the science into the wards too much, you become a kind of total nihilist. You do nothing because you know that the vast majority of medical treatment is still very much a kind of …well, it's a kind of educated guess.

Professor Sir David Weatherall – Molecular Biologist

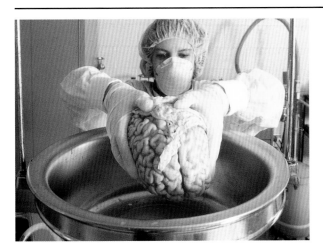

Fig. 12.9 – The brain is weighed prior to dissection. During an autopsy all major organs are weighed in this way.

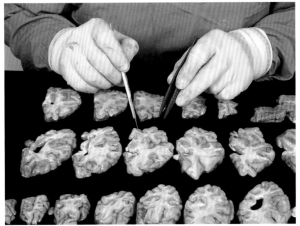

Fig. 12.10 – By studying the shape and structure of the brain, most brain disorders can be diagnosed.

Observations on fatal injuries to the brain stem and/or upper cervical spinal cord

+ .139 0011-8532/90 0.00

Fig. 13.1 – The procedure for disposing of a
medico-legal death.

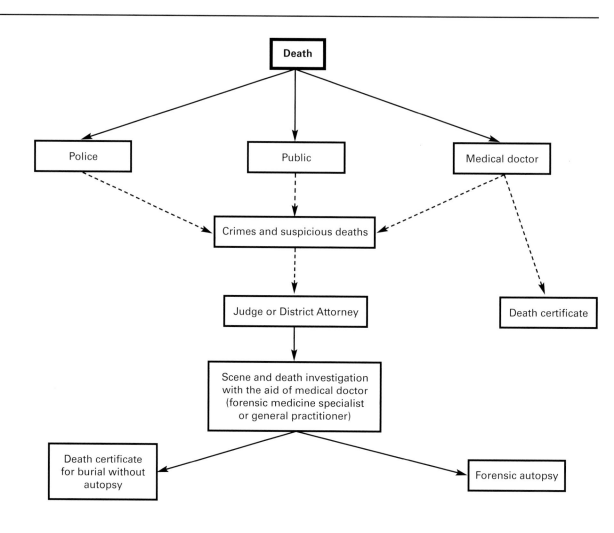

13. Medico-legal death investigations and autopsies in Istanbul, Turkey

Summary There are two different organizations in forensic medicine in Turkey; the universities and the Council of Forensic Medicine (CFM). The CFM is an official body of the Ministry of Justice and serves as an expert witness on technical and medical subjects. The basic duty of the universities is education in the medical schools, with the co-operation of the CFM.

This study examines 3064 medico-legal death investigations and 2548 autopsies performed in the CFM, Ministry of Justice, Istanbul and in the eleven units of CFM in Istanbul during 1996. The age and sex distributions, the incidence and causes of deaths were reviewed.
M. A. Inanici, N. Birgen, M. Ercòment Aksoy, N. Alkan, G. Batuk, O. Polat

The Republic of Turkey was established in 1923 after the decline of the Ottoman Empire. Turkey is a country of 300,000 square miles, with a population of approximately 60 billion, 95% of whom are Muslim and the remaining 5% mostly Christian and Jewish.

During the last period of the Ottoman Empire, medicine was under the influence of modern Western practice. This has arisen as a result of visiting foreign academics who came to work in Turkish universities. One such visitor was Dr Carl Ambros Bernard from Austria, who first lectured on forensic medicine in 1839 at the first medical school (Mekteb-I-Tibbyye-I Sahane) in Istanbul; he was followed by Dr Siymond Spitzer. In 1846, Dr Servi̧ en Efendi was appointed as the first Turkish professor of forensic medicine.

In 1846, the first autopsy was performed by Dr Bernard at the Austrian Hospital with the permission of the Sultan. Lectures of forensic medicine at the law schools had been given since 1910 and the first Turkish textbook of forensic medicine was published in 1910 by Dr Bahattin Ÿakir.

In 1857, Sultan Abdòlmecid established three committees. One of them was related to forensic medicine and was the predecessor to the Council of Forensic Medicine.

The Methods of Criminal Judgement Laws was accepted in 1879, and concerned medical doctors, death and autopsy.

In Turkey, there are currently two organizations involved in the forensic medicine field: the universities and the Council of Forensic Medicine. The basic duty of the forensic medicine departments of the medical schools and forensic medicine institutes in the universities is pre- and postgraduate education in forensic medicine and other sciences. There are about 23 forensic medicine departments and two forensic medicine institutes throughout the country. Some of the university members are involved in both the universities and the Council of Forensic Medicine.

Marmara University Faculty of Medicine was established in 1983. There are now 615 undergraduate and 169 postgraduate students. The Forensic Medicine Department was established in 1991. The department, has one professor, one associated professor, one assistant professor and eight postgraduate students. The basic duty of the department is education within the medical school. Sixteen lectures of 80 min each and 10 autopsy practices of one-half day each are given to the 5th grade students. Research in the forensic medicine field (especially in violence, family

Fig. 13.2

Well, people say life is a fatal disease. What are you trying to do? Prolong life a couple of extra years? But that's not the whole object of being a doctor. If an illness isn't amenable to current treatment in terms of survival, you can still help people. What we aim for with someone who's clearly dying, if we can't cure them, at least we can make sure that their last months and days are the best possible.

Dr Nick Thatcher – Oncologist

violence and child abuse; crime scene investigation; and assault and injury) is also carried out in the department.

The Institute of Legal Medicine and Forensic Sciences

The Institute of Legal Medicine and Forensic Sciences (LEMFOS), which was established in 1982, is a training and a research centre in Istanbul University. LEMFOS has three departments: Medical Sciences, Basic Sciences and Social Sciences. Multidisciplinary master and doctorate degrees are given in the field of forensic sciences.

The Council of Forensic Medicine

The Council of Forensic Medicine (CFM) is an official body of the Ministry of Justice; the headquarters are located in Istanbul. The CFM is responsible for providing expert witness reports on technical and scientific subjects related to forensic sciences when required by the courts and district attorneys. The duties and responsibilities of the CFM have been reconsidered with regard to the laws on forensic

medicine, No. 2659 dated April 14th 1982. Approximately 70,000 cases are handled each year by the CFM, which consists of five specialisation boards and six specialization departments. Specialization boards (SB) are numbered from one to five and have different duties. The specialization departments (SD) are in the areas of the Morgue, Chemistry, Biology, Physics, Forensic Psychiatry and Traffic. There is also a General Assembly at the CFM. All directors and members of the SBs and SDs make up this unit. There is no institution in Turkey to overrule the reports of the General Assembly of CFM.

Legislation about death investigation and forensic autopsy

Autopsies are categorized into two groups: clinical and forensic autopsies. Clinical autopsies are performed on non-criminal unusual deaths with the consent of the relatives, except in special cases. The General Health Law No. 70 says that if a medical doctor suspects that someone has died from an infectious disease, clinical autopsy can be performed without permission from the relatives.

Forensic autopsies are performed for the investigation of crimes and suspicious deaths. Upon receipt of notice of a death of any person (Methods of Criminal Judgement Act No. 152) a judge or district attorney shall immediately

Table 13.1 – The topics of the lectures in the education programme of the Forensic Medicine Department at Marmara University Faculty of Medicine.

Lectures (n=16)

1. Introduction of medico-legal systems and forensic science.
2. Medical and legal responsibilities of medical doctors.
3. Postmortem changes and time of death.
4. Crime scene investigation.
5. Postmortem examination.
6. Asphyxial deaths.
7. Wounds.
8. Sudden, unexpected natural deaths.
9. Deaths as a result of poisoning.
10. Sexual offences.
11. Family violence.
12. Abortion, infanticide and concealment of birth.

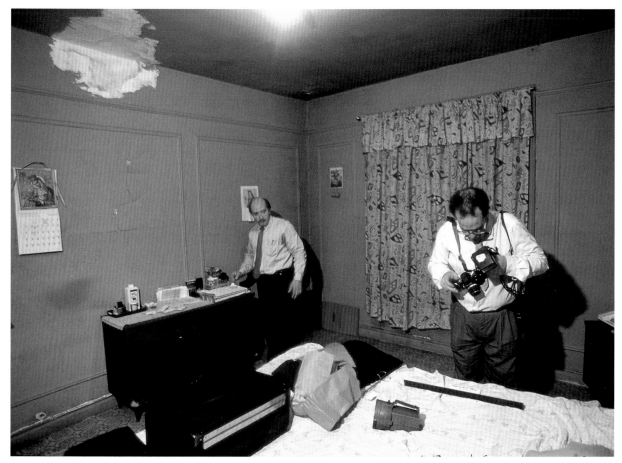

Fig. 13.3 – Forensic scientists at the scene of a homicide, collecting evidence. Everything of even the remotest importance must be photographed and catalogued before removal for forensic examination.

conduct an investigation into the cause and manner of death with the aid of a medical doctor. After this investigation, if the cause and/or manner of death could be determined, death certification is signed by the district attorney and medical doctor. If not, the body is referred for a medico-legal autopsy that is performed under the provisions of the Methods of Criminal Judgement Act No. 78-83. The articles regarding this subject are summarized in Box 1.

Materials and methods

In this study, the data were obtained from two sources: (i)- 3064 medico-legal death investigation cases in 1996 were obtained from the files of the eleven forensic units of the CFM in Istanbul (ii) although 2548 forensic autopsy cases in 1996 were performed by the headquarters of the CFM, but only 2069 forensic autopsy cases were obtained from the files of the Morgue Department. The data obtained were analysed for incidence and causes of death.

In the public's mind, cancer = death: that is it. In some of the chronic debilitating neurological diseases, there is very little that can be done to help, whereas the patients that come to us with cancer, even with some of the most advanced cancers, there is an awful lot that you can do. It may only be in the palliative sense rather than a curative sense, but you can actually improve the quality of their lives enormously.

We have to try and alleviate peoples' anxieties, we have to try and build up their morale and try to make them look positively, because as sure as night follows day, there is no future if they can't be positive. That is a lot of our work, to try and encourage people and pick them up when they are down and have been really kicked in the teeth.

Dr Bob Phillips – Radiotherapist

Table 13.3 – The cause of death frequencies in the forensic autopsy cases.

Cause of death	Frequency
Mechanical injury	891
Natural	297
Poisoning	256
Asphyxia	238
Thermal injury	57
To specialization board	180
Negative autopsy	135
Occupational accident	10
Starvation	5
Total	2069

Results and discussion

Complete investigation and examination of all cases was performed by a forensic medicine specialist. In 1996, there were 3069 medico-legally investigated deaths in Istanbul. Of these, 1487 were selected for forensic autopsies. Death certification was given in 1577 cases and 2548 forensic autopsies were performed in the same year; 1061 autopsy cases performed by the specialists of forensic medicine, were not medico-legally investigated by them. As there is no nationwide medical examiner system in Turkey, these investigations were performed by general practitioners. Apart from the examination of the death at the crime scene, general practitioners have duties concerning other forensic medicine problems: autopsy and clinical forensic medicine, etc. and because of this, all medical students are educated in forensic medicine.

Of the medico-legally investigated cases, 2343 (76.5%) were male and 671 (21.9%) were female. Of the forensic autopsy cases, 1665 (80.5%) were male and 404 (19.5%) were female. In both cases the overall ratio of males to females was approximately 4:1, and over one-half of the cases were in between the third and fifth decades (50.01% and 62.5%). Previous data obtained in the same council show similar results.

The leading unit in investigating deaths is the Fatih Unit of Forensic Medicine (28%), as this area has the two biggest medical faculties in Turkey. The distribution of the constituent units of the CFM and the causes of death are shown in Table 2. In some counties, some causes of death were much more common than the others. Traffic accidents (180; 49%), for example, were the most common cause of deaths in Kartal. The reason being that Kartal county is located around the two most crowded highways in Turkey.

The cause of death frequencies of the forensic autopsy cases are defined in Table 3. Although traffic accident is the leading cause of medical death in mechanical injuries in units of CFM (1077; 35.2%), firearms are the leading cause of death in autopsies (384; 18.6%), the reason being that the majority of traffic accident deaths are not autopsied and death certificates are issued after the initial investigation.

In both medico-legally investigated cases and forensic autopsy cases, coronary artery lesions were (105; 3.4% and 159; 7.7%) found to be the most common natural cause of death. Cardiovascular disease was the most common cause of natural death in cities in Turkey.

Mechanical injuries were most frequent in almost all cities. However, poisonings in Izmir and traffic accidents in Adana and Sivas were more common.

Table 13.2 – The frequencies of the causes of death in some cities.

Cause of death	Ist	Iz	Ad	B	E	T	S	Ant
Mechanical injury	891	545	597	117	86	60	441	288
Natural	297	536	–	183	46	32	107	79
Poisoning	256	211	39	38	16	15	22	–
Asphyxia	238	220	103	72	37	16	36	22
Other thermal injury	57	15	102	–	3	2	33	6
To specialization board	180	–	–	–	–	–	–	–
Negative autopsy	135	–	–	–	5	–	–	–
Occupational accident	10	–	–	–	1	–	–	–
Other	5	94	–	–	1	8	75	5

Ist: Istanbul; Iz: Izmir; Ad: Adana; B: Bursa; E: Edirne; T: Trabzon; S: Sivas; Ant: Antalya

Fig. 13.4 – Reasons for death from ruptured abdominal aortic aneurysms.

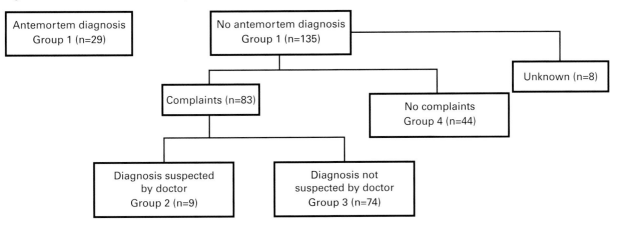

Group 1: Antemortem diagnosis of aneurysm was made, but no treatment offered.

Group 2: No antemortem diagnosis was made, patient complained of RAAA symptoms (Table 5) and doctor suspected RAAA but the patient had presented too late for treatment.

Group 3: No antemortem diagnosis was made; patient complained of RAAA symptoms but doctor did not suspect RAAA (and other treatment was given or patient was discharged home from hospital).

Group 4: No antemortem diagnosis was made, and patient made no complaints before collapsing, or being found dead.

Fig. 13.5 – Trinity – Pharmacology, Physiology, Pathology. Two parts 2130 x 1520 x 350, one part 2740 x 1830 x 350mm

Table 13.4 – The distribution of the units of Council of Forensic Medicine and causes of death.

Cause of death	The units of the Council of Forensic Medicine										
	ba	be	e	f	g	i	kad	küc	s	ü	total
Mechanical injury	222	107	14	538	19	8	150	79	222	216	1856
Thermal injury	15	6	5	80	1	1	6	6	7	15	147
Poisoning	20	19	6	32	1	–	11	2	16	17	138
Asphyxia	27	5	9	13	5	2	12	9	9	17	125
Natural	12	16	5	25	–	4	16	6	32	1	119
Suspicious	85	77	17	152	11	30	34	32	38	51	551
Immersion	9	6	1	9	–	14	13	2	2	5	66
Occupational accident	9	3	1	15	–	–	7	3	1	6	61
Malpractice	–	–	–	–	–	–	–	–	–	1	1
Total	399	239	58	864	37	59	249	364	327	329	329

ba: Bakiyöy; be: Beyoglu; e: Eyüp; f: Fatih; g: Gaziosmanpasa; i: Istanbul; kad: Kadiköy; kuc: Küçükçekmece; s: Sisli; ü: Üsküdar

Figs. 13.6–13.7 – Trinity – Pharmacology, Physiology, Pathology. Two parts 2130 x 152 x 350, one part 2740 x 1830 x 350mm

To get in for an operation, we actually have to make a drill hole and then use some form of power saw to lift a piece of skull out of the way to get in and look at it. So you need skills of carpentry, which require a degree of physical strength, and then when you're handling the brain, there has to be a degree of delicacy because of the material with which you're working.

Mr Alan Crockard – Neurosurgeon

Medico-legal investigation and forensic autopsies play a vital role in Turkish court proceedings, especially in deaths as a result of mechanical injuries and suspicious deaths. According to Turkish legislation regarding death investigation and forensic autopsy, a medical doctor who is authorized by a judge or district attorney has to perform the medico-legal examination of the body at the death scene. Because there are only approximately 200 forensic medicine specialists in Turkey, they are unable to perform all the examinations, therefore, general practitioners also perform these postmortem examinations. Although undergraduate forensic medicine education was given to students in every medical school, no harmonization had previously been established. However, a course on forensic medicine has now been organized by the Turkish Medical Association and the Society of Forensic Medicine Specialists, and has been programmed for general practitioners all over Turkey. This course runs for 1 week and includes 26 lectures of 45 min each, with a demonstration of an autopsy.

Performing an accurate and proper postmortem examination is necessary for the correct judicial procedures. For accurate medico-legal investigation and forensic autopsy cases statistical data must be available in order to plan public health and safety programmes.

References

1. Özen C. The history and developments of forensic medicine in Turkey. J Istanbul Faculty of Medicine 1981; 44: 361-378 (printed in Turkish).
2. Özen C. Forensic Medicine in: Unat EK, ed. The history of medical sciences in the world and Turkey after 1850, 1st edn. Istanbul, Gòrtaê Publisher 1988: 14-25 (printed in Turkish).
3. The law and regulations about forensic medicine, Istanbul 1984: 9–22 (printed in Turkish)

Fig. 13.7

Box 13.1

No. 78 – Crime scene investigation: this should be performed by a judge or a district attorney.

No. 79 – Postmortem external examination and autopsy: medico-legal examination of the body is performed by a medical doctor. During this examination, the external signs of the body are determined for identification of a victim, time of death and cause of death.

Autopsy is performed by two medical doctors. One of them has to be a forensic specialist or a pathologist. When performing an autopsy, the judge or district attorney has to attend.

If there is an obligation, autopsy can be performed by a medical doctor. But this obligation has to written in the autopsy report (for example, a medical doctor can perform an autopsy in the absence of a forensic specialist or a pathologist).

Although the medical doctor who most recently treated the person before his death cannot perform the autopsy, this doctor can be summoned to the autopsy room to give information about recent illnesses.

If exhumation is required, the district attorney permits postmortem examination.

No. 80 – Identification of the body: if it is possible, identification of the body should be done by the family member/friend before the autopsy is performed.

No. 81 – Autopsy: at autopsy, three body cavities (head, thorax and abdomen) must be examined. Specimens must be sent for toxicological analysis.

Extract from a conversation with Dr Gordon Lebrun 6.9.00

Dr. G. Lebrun: The best way to measure a tree is when it's down. True?

Damien Hirst: Cut me in half and count the rings. I had a landslide in Devon, and it shocked me. If a tree falls down unexpectedly it seems much bigger – you become acutely aware of its massive size, but I think there's an infinite number of ways to measure a tree up or down.

Do you think Francis Bacon should stay in the fucking grave?

Artists make art for people who haven't been born yet, but I suppose we could dig him up and put his art in the grave for a couple of weeks. I know I'm not going to get in my grave, well, not without kicking and screaming and generally making a fuss.

Don't stop me now – Why? Because I'm having a good time. Can this be a philosophy of life?

If you or someone near to you is on a roll then the greatest benefits come from bathing in their glory, but unfortunately there's two ways to be good – do great things or put other people down. I don't go in for the latter, it's a mug's game and always ends in misery.

Youth can perhaps be described as the illusion of your own durability. Are you still young?

I always like to use that Brancusi quote: 'When we are no longer children we're already dead'. My sense of humour is still intact but my sense of fun has taken a battering over the years. I don't think my curiosity has or will ever change, so it's fundamentally childish or childlike, I don't mind either. When you get to my age you'll understand [*Laughs*]. Death = Schmeth. You've just got to keep knocking on doors and running away, no matter how many times you get caught.

What are your convictions?

Burglary – going equipped to steal – shoplifting – and various cycling offences. Oh, and fraud, but the charges were dropped.

Is life too short to be honest?

To be honest, it is, I'd like to live forever, well, for a while at least. I don't give a fuck about you or anyone else. Do what you like.

Have you become enthralled by your lower nature?

I've always been, I mean, the best answer or most powerful answer to any question I can think of is FUCK OFF CUNT! And if they come back with any other question, just repeat it, it's an invincible position, if you hold your ground.

The film 'Boiler Room' treats investment and business as the pop culture of the current moment. Is it? (Anybody that tells you that money is the root of evil doesn't fucking have any).

I don't think money and evil are connected; too much or not enough of either can cause life-threatening problems.

If you got to make a fool of somebody who would it be?

God.

Do all men secretly desire other men?

I'm from Leeds, we're not into shit like that, it's a coward's way out.

How do you think you're gonna die?

Hit by a bus on the way to Chemo. There's a club if you'd like to go, you could meet somebody who really loves you. So you go, and you stand on your own and you leave on your own and you go home and you want to die. When you say it's gonna happen 'now'. Well, when exactly do you mean? See, I've already waited too long and all my hope is gone.

You're an ardent joke maker. Why do you like jokes so much?

Hunchback has a shit. Dog fucks it. Mum wanks.

Illustrated works

Measurements are given as Height x Length x Depth.

p.93, 96
A Way of Seeing
2000
Anamatronic man with microscope, glass and steel vitrine, table, chair, ashtray, newspaper, slides, cup of tea, sponges, sand, glasses of water.
2440 x 3960 x 3050mm

p.36, 43
Adam and Eve
(Banished From the Garden)
1999
Glass and steel vitrine, canvas dummies x 2, medical trolleys, sheets, surgical equipment, buckets, bones.
2210 x 4270 x 1220mm

p.35, 65
An Unreasonable Fear of Death and Dying
2000
Glass and steel vitrine, TV monitor, video player showing CNN News Live, sheepskin rug, standard lamp, chainsaw, toilet vitrine, faeces, pig's blood, pornographic magazines, books, cup of tea.
1: 2130 x 2130 x 1060mm
2: 2130 x 2130 x 2130mm

p.48, 49
Concentrating on a Self-Portrait as a Pharmacist
2000
Glass and steel vitrine, self portrait, artists easel, table, chair, bedside locker, tubes of paint, brushes, ashtray, cup, large mirror, rags, doctors coat, shoes, lipstick.
2440 x 3050 x 2740mm

p.52, 54
Death is Irrelevant
2000
Glass cross, skeleton, ping-pong balls, compressors.
914 x 2743 x 2133mm

p.32
Figures in a Landscape
2000
Glass and steel vitrine, clothes in refuse sacks, wardrobe, air fresheners, lipstick.
2210 x 2740 x 2740mm

p.86, 87
From the Cradle to the Grave
2000
Glass and steel vitrine – Office section: half a chair, half a table, half a clock, half a suit, phone, newspaper, credit card, pen, pencil, half a cup. Home section: half a cardigan, half a tea cup, jam sandwich, biscuit box, glasses, news-papers, books, half a clock, glass, false teeth. Third section: wooden walking stick, half a chair.
2130 x 3050 x 2440mm

p.12, 15
Hymn
2000
Painted bronze.
6096 x 3352 x 2133mm

p.29
Looking Forward to the Total and Absolute Suppression of Pain
1999
Glass and steel vitrine, 4 x TV monitors 4 x video players, showing various pain killer adverts.
3050 x 3050 x 3050mm

p.20, 21
Lost Love
2000
Aquatic tank, tropical river fish, filtration unit, couch, table, stool, surgical instruments, coat stand with coat, jewellery, African river fish.
2740 x 2130 x 2130mm

p.8, 9
Love Lost
1999
Aquatic tank, large river fish, filtration unit, couch, table, gynaecological stool, surgical instruments, computer, jewellery, cup.
2740 x 2130 x 2130mm

p.118
Naja Flava
2000
Household gloss on canvas.
686 x 533mm

p.119
Naja Haje
2000
Household gloss on canvas.
1524 x 1320mm

p.117
Naja Hannah
2000
Household gloss on canvas.
2336 x 1727mm

p.119
Naja Melanoleuca
2000
Household gloss on canvas.
1930 x 2946mm

p.120
Naja Mocambique Mocambique
2000
Household gloss on canvas.
457 x 1879mm

p.120
Naja Naja
2000
Household gloss on canvas.
482 x 533mm

p.118
Naja Naja Atra
2000
Household gloss on canvas.
635 x 685mm

p.116
Naja Naja Kaouthia
2000
Household gloss on canvas.
2463 x 2514mm

p.121
Naja Naja Oxiana
2000
Household gloss on canvas.
2971 x 3124mm

p.121
Naja Naja Siamensis
2000
Household gloss on canvas.
1168 x 1066mm

p.117
Naja Naja Sputatrix
2000
Household gloss on canvas.
2336 x 2946mm

p.119
Naja Nigricollis Crawshawii
2000
Household gloss on canvas.
1930 x 1828mm

p.120
Naja Nigricollis Nigricollis
2000
Household gloss on canvas.
1498 x 1549mm

p.119
Naja Nigricollis Pallida
2000
Household gloss on canvas.
1574 x 863mm

p.118
Naja Nivea
2000
Household gloss on canvas.
1524 x 2743mm

p.120
Notechis Ater Humphreysi
2000
Household gloss on canvas.
2514 x 3733mm

p.60, 61
Skullduggery
2000
Glass cross, plastic skull, compressors with hose, 2 x ping-pong balls.
2130 x 2130 x 2130mm

p.58, 59
Something Solid Beneath the Surface of Several Things Wise and Wonderful
2000
Stainless steel and glass cabinet, 37 animal skeletons on wooden bases.
2060 x 3760 x 1220mm

p.132, 137
Stripteaser
1996
Stainless steel and glass cabinets with 2 x skeletons and medical instruments.
1960 x 3660 x 510mm

p.66, 69
The History of Pain
1999
Wooden box, gloss paint, knives, blower, beach ball.
960 x 2510 x 2510mm;
ball: diameter = 300mm

p.130
The Last Supper
2000
Silkscreen prints on aluminium panels x 13, edition of 4.
1525 x 9800 x 53mm

p.75, 77
The Void
2000
Stainless steel and glass cabinet with resin, metal and plaster pills.
2360 x 4710 x 110mm

p.72, 78, 122
The Way We Were
2000
Glass and steel vitrine – table, charity box, laboratory equipment, 2 x electric heater, ping pong balls, 5 x swords, cup of tea.
2440 x 2740 x 2740mm

p.26, 27
Theories, Models, Methods, Approaches, Assumptions, Results and Findings
2000
Glass and steel vitrines x 2, ping pong balls, blowers.
2 x 1220 x 1800 x 1140mm

p.145, 146, 147
Trinity – Pharmacology, Physiology, Pathology
2000
3 x wooden, formica and glass cabinets, anatomical models.
Two parts 2130 x 152 x 350mm; one part 2740 x 1830 x 350mm

Glossary of terms

Adenoma gland-like benign tumour.

Amyloid rare case of organ degeneration.

Anemia lack of red blood corpuscles or of haemoglobin. A condition marked by paleness and languor.

Aneurysm dilation of the blood vessel.

Anoxia no oxygen to body.

Antemortem before death.

Atrophy degeneration; wasting away.

Avulsed torn away from.

Barbiturate a derivative of barbituric acid; acts as a depressive to the central nervous system.

Bifurcation having two prongs or branches.

Bilirubin a breakdown product of red blood cells which is excreted in the bile.

Bulbar conjunctiva the thin membrane which coats the eyeball.

Cancer malignant growth; biggest killer in western society.

Cardiac tamponade the restriction of the heart function, usually by blood clot.

Cardiorespiratory pertaining to the heart and lungs.

Cirrhosis diffuse fibrosis, usually of the liver, with nodular regeneration.

Clot stagnant blood within the body which clumps together.

Codeine an alkaloid obtained from opium or synthetically obtained from morphine. Commonly used to surpress coughs.

Colon the bowel between the small bowel and the anus.

Cyanosis morbid blueness of the skin caused by lack of oxygen in the blood.

Cytase an enzyme that breaks down cellulose.

DNA (deoxyribonucleic acid) the genetic make-up of most organisms.

Diagnose determine the cause of the disease.

Diaphragma sellae the fibrous lid covering the sella turcica.

Diastolic the lower of the two values in blood pressure.

Disinfect to free from infection; to purify from infectious germs.

Distal far apart; often used in medical terms to mean away from the point of insertion.

Ductus arteriosus the vessel which connects the aorta and the pulmonary artery to the feotus.

Dura mater the tough exterior membrane of the brain and spinal column distinguished from the other two, the arachnoid and the pia mater.

Ecchymoses hemorrhages that develop under the skin.

Edema or **oedema** an accumulation of fluid in the cells and tissues.

Electrolyte a substance that admits of electrolysis; chemical found in body fluids, for example sodium chloride.

Embolus a thrombosis that has moved from one part of the body to lodge in another part.

Endemic disease constantly or generally present in a place or population.

Enzyme a biological agent that allows chemical reactions to occur in the living body.

Epidural over the dura mater.

Etiology the cause of a disease.

Exsanguinous without blood; a marked loss of blood from the body.

Exsiccator a drying agent or apparatus.

Exsect to cut out.

Fascis the broad ligament on the ouside of the thigh.

Fibrillation irregular and rapid heart beat.

Fibrosis the forming of scar tissue over an open wound.

Flexion a bend or fold; a muscle that bends a joint, as opposed to extensor.

Fungus a fast-growing organism that forms filaments; may infect humans.

Fusion joining together; to fuse two elements.

Gangrene death of an isolated part of the body due to deficiency or cessation of the blood supply.

Gland a structure made of cells which secrete substances.

Granuloma a tumor-like growth, caused by infection.

Glans penis the rounded end of the penis.

Hemosiderin iron–protein complex in tissues.

Hepatitis B a virus causing liver disease. Found in body fluids and therefore a hazard in postmortem procedures.

Hiatus hernia in which the stomach passes into the chest cavity through the esophageal hiatus.

Ileum the posterior part of the small intestine.

Ileus obstruction of the intestine with severe pain and vomiting.

Incision the act of cutting in.

Infarction death of tissue from a lack of blood.

Intra inside.

Ischemia decreased blood flow.

Jaundice a condition in which there is a yellowing of the skin and eyes from a build-up of bilirubin in the body.

Jugular pertaining to the neck. One of the large veins on either side of the neck.

Kinesipathy a mode of treating disease by muscular movements

Lacerate to tear with edges cut into irregular segments.

Lachrymal a bone near the tear gland.

Lachrymatory causing tears to flow.

Lassa fever an acute, infectious disease from West Africa, spread by food that has been contaminated by rodents.

Leukemia cancer in which the blood-forming organs and cells overproduce white blood cells.

Ligament the bundle of fibrous tissue joining bones bones or cartilage.

Ligature a cord for tying the blood vessels.

Lipid a fatty substance like cholestrol.

Lymph clear fluid which drains from the body's tissues.

Lymphangitis inflammation of a lymphatic vessel.

Lymphoma cancer of the lymph gland.

Mastoid skull area behind the ear.

Metazoa multicelled creatures like tapeworm.

Mucosa the soft lining of an organ such as the stomach.

Myelitis inflammation of the spinal cord or sometimes of the bone marrow.

Myxoma a tumour of jelly-like substance.

Myxoedema a diseased condition, caused by deficiency of the thyroid secretion, characterized by loss of hair and dryness of the skin.

Necrosis degeneration and death of cells and tissues during life.

Neoplasia growth; tumour.

Obturator a tapering measuring rod of circular section.

Occipital the area of the back of the head.

Oedema or edema excess of fluid within the tissues.

Omentum a fold of peritoneum proceeding from one abdominal viscera to another.

Parietal bone a bone forming with its fellow part of the sides and top of the skull, between the frontal and occipital bones.

Paring act of trimming or cutting off.

Pancreas the organ behind the stomach; it produces insulin.

Perineum the area including the anus and vulva.

Pericardial sac protects the heart.

Periosteum the membrane that surrounds a bone.

Petechiae pinpoint hemorrhages.

Pleura lining the lung or within the chest.

Posterior hind parts; buttocks.

Protozoa single-celled uninucleate creatures; cause of amoebic dysentery.

Pus thick liquid formed by degeneration at the site of an infection.

Renal pertaining to the kidney.

Rickettsia infective organisms that live in cells.

Rigor mortis stiffening of the muscles after death.

Sagittal suture between the parietal bones of the skull.

Sella turcica Turkish saddle; the bony structure that surrounds the pituitary gland

Septicemia a serious condition where bacteria grows in the bloodstream.

Smallpox a viral infection of the skin.

Staphylococcus bacteria causing boils on the skin surface, bone infection, septicemia and pneumonia.

Streptococcus bacteria causing serious infection.

Supine lying on the back, facing upwards.

Tentorium cerebelli the dural membrane over the cerebellum.

Tetanus fatal spasm caused by a soil bacterium that gets into a wound.

Therapeutic pertaining to treatment for disease.

Thrombosis blood clotting in moving blood.

Toxicological concerned with poisons.

Toxoid a vaccine produced by a poisonous organism, e.g. tetanus toxoid used to protect against tetanus.

Tuberculosis a chronic infection of the lungs, produced by inhaling certain bacteria.

Ureter the structure which takes urine from the kidney to the bladder.

Varicose veins thickened, blue veins caused by failure of the venous valves and resulting in increased pressure within the veins.

Vegetation a deposit of thrombus sometimes seen in endocarditis, often containing micro-organisms.

Visceral pertaining to the inner lining of the cavities of the body.

Index

The index covers the main text and glossary. Works (in italics) are by Damien Hirst unless otherwise stated. Glossary terms are indicated by a 'g', figures by an 'f' and tables by a 't' after the page number. Page references may also contain textual material.

Notes

+ .155 0011-8532/90 0.00

Acknowledgments

This book is for Maia

With special thanks to:

Hugh Allan, Frank Dunphy, Jude Tyrrell,
Jason Beard, Jonathan Barnbrook,
Dr George Poste, Gordon Burn,
Larry Gagosian, Mollie Dent-Brocklehurst,
Lisa Kim, Andy Avini, Graham Stewart
and Art & Crating, Ealan Wingate, Jay Jopling,
Clare O'Leary, Sian Thomas, Bradley Hirst,
Rupert Bound, Nick Lumb, Tom Ormond,
Sophia Please, Anika Carpenter, George Taylor,
Colin Glenn, Mike Parsons, Andy Rudak,
Steve Warner, Emily Mayer, Richard Wadham,
Sue Lukas, Jason Payne-James, Ian Wall,
Andrew Stevenson

Reprinted from Journal of Clinical Forensic Medicine Volume 5, Issue 1. O. Brink. The epidemiology of violence in Denmark. Pages 38–44, © 1998, by permission of the publisher Churchill Livingstone

Reprinted from Journal of Clinical Forensic Medicine Volume 2, Issue 2. T. Kondo, T. Ohshima. The role of an operating microscope in medico-legal practice. Pages 73–79, © 1995, by permission of the publisher Churchill Livingstone

Reprinted from Journal of Clinical Forensic Medicine Volume 5, Issue 1. M. A. Elfawal, M. H. M. Higazi. Examination and significance of 'tied up' dead bodies. Pages 27–31, © 1998, by permission of the publisher Churchill Livingstone

Reprinted from Journal of Clinical Forensic Medicine Volume 4, Issue 1. T. Kahuna, J. Hiss. Identification of human remains: forensic radiology. Pages 7–15, © 1997, by permission of the publisher Churchill Livingstone

Reprinted from Journal of Clinical Forensic Medicine Volume 4 Issue 3. T. Ohshima, T. Kondo. Eight cases of Suicide by self-cutting or self-stabbing: consideration from medico-legal viewpoints of differentiation between suicide and homicide. Pages 127–132 © 1997, by permission of the publisher Churchill Livingstone

Reprinted from Journal of Clinical Forensic Medicine Volume 2, Issue 4. K. Blaho, K. Merrigan, S. Winbery. Determining the true cause of death in a dermatological disaster. Pages 205–211, © 1995, by permission of the publisher Churchill Livingstone

Reprinted from Journal of Clinical Forensic Medicine Volume 1, Issue 3. F. Patel. Artefact in Forensic medicine: non-missile penetrating injury. Pages 149–150, © 1994, by permission of the publisher Churchill Livingstone

Reprinted from Journal of Clinical Forensic Medicine Volume 5, Issue 3. F.T. Zugibe, M. Breithaupt, J.Costello. Cardiotoxic mechanisms and interrelationships of cocaine: including a single case depicting several of these mechanisms. Pages 140–145, © 1998, by permission of the publisher Churchill Livingstone

Reprinted from Journal of Clinical Forensic Medicine Volume 6, Issue 1. B.-B. Ong. The pattern of homicidal slash/chop injuries: a 10 year retrospective study in University Hospital Kuala Lumpur. Pages 24–29, © 1999, by permission of the publisher Churchill Livingstone

Reprinted from Journal of Clinical Forensic Medicine Volume 5, Issue 3. T. Ohshima, T. Kondo. Forensic pathological observations on fatal injuries to the brainstem and/or upper cervical spinal cord in traffic accidents. Pages 129–134, © 1998, by permission of the publisher Churchill Livingstone

Reprinted from Journal of Clinical Forensic Medicine Volume 5, Issue 3. M. A. Inanici, N. Birgen,

M.Ercüment Aksoy, N. Alkan, G. Batuk, O. Polat Medico-legal death investigations and autopsies in Istanbul, Turkey. Pages 119–123, © 1998, by permission of the publisher Churchill Livingstone

Reprinted from Journal of Clinical Forensic Medicine Volume 6, Issue 2. M. Okoye, E. H. Kimmerle, K. Reinhard. An analysis and report of custodial deaths in Nebraska, USA. Pages 77–84, © 1999, by permission of the publisher Churchill Livingstone

Reprinted from Journal of Clinical Forensic Medicine Volume 7, Issue 1. J. P. Wyatt, J. P. Beagle, C. A. Graham, D. Beard, A. Busuttil. Suicidal high falls. Pages 1–5, © 1998, by permission of the publisher Churchill Livingstone

Reprinted from Journal of Clinical Forensic Medicine Volume 5, Issue 2. C. M. Milroy. Homicide followed by suicide: remorse or revenge? Pages 61–64, © 1998, by permission of the publisher Churchill Livingstone

Quotes that appear throughout this publication are extracted from The Noble Tradition by Danny Danziger. By kind permission of Curtis Brown UK. © Danny Danziger.

Photographs pp: 10, 11, 13, 17, 19, 22, 54, 79, 94, 139, 142, 143. © Science Photo Library.

Diagrams and illustrations pp: case, 2, 6, 24, 48, 59. © Jason Payne-James/ Ian Wall.